WHERE ARE THE LESSON FIL

Purchasing this Classroom in a Book gives you access to the lesson files you'll need to complete the exercises in the book.

You'll find the files you need on your **Account** page at peachpit.com on the **Lesson & Update Files** tab.

For complete instructions, see "Accessing the Classroom in a Book files" in the Getting Started section of this book.

The example below shows how the files appear on your **Account** page. The files are packaged as ZIP archives, which you will need to expand after downloading. You can download the lessons individually or as a single large ZIP file if your network connection is fast enough.

Peachpit

Publishers of technology books, eBooks

Home > Account

Account

| Digital Purchases | **Lesson & Update Files** | Registered Products |

Lesson & Update Files (What is this?)

Adobe Lightroom and Photoshop for Photographers Classroom in a Book

Hide Lesson Files

- All-Lessons.zip
- Lesson_extras.zip
- Lesson00.zip
- Lesson01.zip
- Lesson02.zip
- Lesson03.zip
- Lesson04.zip
- Lesson05.zip
- Lesson06.zip
- Lesson07.zip

CONTENTS

Adobe

Lightroom and Photoshop for Photographers

CLASSROOM IN A BOOK®

The official training workbook from Adobe

Jan Kabili

Author: Jan Kabili
Contributing Author: Seán Duggan
Project Editor: Nancy Peterson
Development Editor: Robyn G. Thomas
Copyeditor and Proofreader: Scout Festa
Production Editor: Tracey Croom
Compositor: Danielle Foster
Technical Reviewers: Rocky Berlier, Scott Martin, and Gene McCullagh
Indexer: Rebecca Plunkett
Cover Designer: Eddie Yuen
Interior Designer: Mimi Heft

Printed and bound in the United States of America

ISBN-13: 978-0-133-81671-6
ISBN-10: 0-133-81671-0

9 8 7 6 5 4 3 2 1

GETTING STARTED

Adobe Photoshop and Adobe Lightroom are natural partners in any photographer's workflow. The question for photographers is not which of these powerful programs to use, but how best to use them together. That is the question this book is designed to answer.

This section is important to read before diving into the rest of the book. It includes instructions for a few things you'll have to do to work along with the lessons in this book:

- Downloading and storing the lesson files for this book
- Creating a new Lightroom catalog for use with this book

This section also covers topics that are critical to understanding when to use Lightroom and Photoshop together, including:

- How Lightroom and Photoshop differ
- Where Lightroom excels in a photographer's workflow
- Where Photoshop excels in a photographer's workflow

If you need additional help with Lightroom and Photoshop, you'll also find useful resources in this section.

Why to use both Lightroom and Photoshop

There are solid reasons to use both Lightroom and Photoshop in your photo workflow. The two programs differ in significant ways, and each program excels at particular tasks.

How Lightroom and Photoshop differ

At first glance, you might think that Lightroom and Photoshop do the same thing, which is to provide tools for enhancing your photographs. Of course, there is some overlap in that sense, but a closer look reveals that Lightroom and Photoshop differ in two important ways: what they do and how they do it.

When it comes to what the two programs do, Lightroom is broader and Photoshop is deeper. Lightroom was designed to cover a photographer's entire

post-capture workflow. So Lightroom includes features for doing all the following to photographs and video clips: offloading from camera to computer, organizing, finding, editing, sharing, and outputting in various ways. Photoshop is focused on a single task: editing.

When it comes to how the two programs operate, Photoshop and Lightroom are quite different under the hood. Photoshop is a pixel editor. It works by altering pixels. Workarounds (like adjustment layers and Smart Objects) have been developed for editing nondestructively inside Photoshop. But ultimately, Photoshop operates by changing pixels.

Lightroom's Develop module works in a very different way. It is a parametric editor, which means that it operates by recording instructions rather than by altering pixels. When you change any parameter in Lightroom, that change is recorded as an instruction in a database (the Lightroom catalog) and is reflected in the image preview in Lightroom. But that change is not actually applied to a photograph unless and until you output a copy of the photograph. Even then, the master photograph remains unchanged. So Lightroom, unlike Photoshop, is a truly nondestructive editor. You'll learn more about how Lightroom's Develop module works in Lesson 4, "Processing Photos in Lightroom's Develop Module."

Understanding these underlying ways in which Photoshop and Lightroom differ leads to a more practical issue—which of the two programs you should use for which tasks. That subject, which is addressed throughout this book, is summarized in the next two sections.

Where Lightroom excels

Lightroom shines at performing many essential tasks in a photographer's workflow, including the following:

- Photo management

 Lightroom's Library module is a sophisticated data asset manager. It is a database that contains a record of every photograph and video clip you import into Lightroom. That record includes metadata from the camera, information you add in Lightroom (like copyright, ratings, and keywords), and your Develop adjustments. Lightroom's Library module has many features to help you import, organize, and find photographs and video clips, as detailed in Lesson 3, "Managing Photos in Lightroom's Library Module."

 Photoshop does not include an asset manager. You can use Photoshop with another application, Adobe Bridge, but Bridge is just a file browser. It is not a database like Lightroom and does not have all the photo organizing capabilities that Lightroom offers.

- Raw processing

 Lightroom excels at processing raw files (although you can edit TIFFs, PSDs, JPEGs, and PNGs in Lightroom's Develop module too). Lightroom's built-in raw converter translates the raw data captured by your camera into a form that you can view and work with onscreen.

 Lightroom maintains the high bit depth captured in a raw file and applies its edits to your raw files nondestructively. Therefore, it makes sense to do as much processing to a raw file in Lightroom as you can. Then, if there is something to add that you can do only in Photoshop (like compositing) or that you can do better in Photoshop (like high-level portrait retouching), hand off the file to Photoshop for those purposes.

 Photoshop has a plug-in, Adobe Camera Raw, that also processes raw files, using the same underlying engine as Lightroom. You'll learn how Camera Raw integrates with Lightroom in Lesson 2, "Lightroom–Photoshop Roundtrip Workflow."

- Simplified photo adjusting

 Common photo adjustments (to color, tone, noise, sharpness, and lens distortions) are relatively simple to perform in Lightroom. That's because the controls in Lightroom's Develop module are discoverable, fairly easy to operate, and logically arranged so as to suggest a workflow. You'll learn more about the ease of use of these controls in Lesson 4.

 Photoshop is a more mature application. It has many more features and options than Lightroom, and it requires knowledge of techniques that are not necessarily obvious on the surface.

- Processing multiple photographs

 Lightroom is designed to minimize time and effort for high-volume photographers. The Lightroom workflow accommodates processing a lot of photographs relatively quickly, and Lightroom includes synchronizing features that simplify applying the same adjustments to multiple photographs. Batch-processing multiple photographs in Photoshop is more complex.

- Sharing and outputting

 Lightroom includes many features for sharing photographs (like Publish Services, in the Library module) and for outputting photographs (including the Book, Slideshow, Print, and Web modules). These features are outside the scope of this book, but you can learn more about some of them in *Adobe Lightroom 5 Classroom in a Book*.

Where Photoshop excels

Photoshop is unmatched when it comes to creative editing and precise corrections. There is no need to bring every photograph you manage in Lightroom into Photoshop, but a round-trip from Lightroom to Photoshop and back will pay off in the situations covered in detail in Lessons 5 through 8 of this book.

• Combining photographs

 Techniques that involve combining multiple photographs cannot be performed in Lightroom. Making layered composites, merging bracketed exposures into a single high dynamic range (HDR) photograph, blending photographs into a panorama, and using linked Smart Objects are all done in Photoshop. Lesson 5, "Lightroom to Photoshop for Combining Photos," includes compositing projects like these.

• Making precisely targeted adjustments

 Lightroom offers some useful local adjustment tools: the Adjustment Brush, Graduated Filter, Radial Filter, and Spot Removal tools, all covered in Lesson 4. But when you want to get precise about local adjustments, you'll pass images to Photoshop to take advantage of selections, masks, and adjustment layers. Lesson 6, "Lightroom to Photoshop for Selecting and Masking," covers common situations in which you'll use these Photoshop features, including replacing a dull sky, isolating a complex object using a channel mask, and selecting hair.

• Photo retouching

 Photoshop is the place to go to alter pixels, whether your goal is to remove an item from a photograph or to perform intricate portrait retouching. Photoshop offers a variety of content-aware tools, tool options, layers, and other features for casual as well as professional photo retouching. You'll practice using these features in Lesson 7, "Lightroom to Photoshop for Retouching."

• Adding non-photographic elements

 Embellishing photographs with non-photographic elements is a task for Photoshop. In Photoshop you can add text effects, graphics, filters, layer styles, and other non-photographic elements. You'll work with some of these capabilities in Lesson 8, "Lightroom to Photoshop for Special Effects."

Accessing the Classroom in a Book files

In order to work through the exercises in this book, you'll need to download the sample image files from your Account page at peachpit.com. You can either download the entire Lessons folder before you begin, or download the files for individual lessons as you need them.

Your Account page is also where you'll find any updates to the lesson files or to the book content. Look on the Lesson & Update Files tab to access the most current content.

Downloading the lesson files

1 Go to www.peachpit.com/redeem, and enter the code found at the back of this book. If you don't yet have a Peachpit.com account, follow the prompts to create one.

2 Click the Lesson & Update Files tab on your Account page to see a list of downloadable files. Click the links to download either the entire Lessons folder or the work folders for individual lessons to your computer.

3 Create a new folder inside the Users/*username*/Documents folder on your computer. Name the new folder **LPCIB**.

4 If you download the entire Lessons folder, drag that Lessons folder into the LPCIB folder you created in step 3.

Alternatively, if you download work folders for one or more individual lessons, first create a Lessons folder inside your LPCIB folder; then drag the individual lesson folder[s] into your LPCIB/Lessons folder.

5 Keep the lesson files on your computer until you've completed all the exercises.

The downloadable sample images are practice files, provided for your personal use in these lessons. You are not authorized to use these files commercially, or to publish or distribute them in any form without written permission from Adobe Systems Inc. and the individual photographers who took the pictures, or other copyright holders.

Creating a Lightroom catalog for use with this book

A Lightroom catalog is a database that stores information about the photographs and video clips you import into a Lightroom library. Many photographers use a single catalog for all their Lightroom photographs, but you can make a separate catalog for a special purpose, like managing the lesson files for this book.

1 Launch Lightroom.

When you first launch Lightroom, a default Lightroom catalog is created in Users/*username*/Pictures/Lightroom. If you're using Lightroom 5, the name of the default catalog file is Lightroom 5 Catalog.lrcat. If you want to see the name of the current catalog at the top of Lightroom, press Shift-F several times to cycle to Normal screen mode.

2 Choose File > New Catalog in the menu bar at the top of the Library module.

3 In the Create Folder with New Catalog dialog that opens, navigate into the LPCIB folder in your Documents folder (Users/*username*/Documents/LPCIB) and enter **LPCIB Catalog** as the name of the new catalog.

4 Click Create. If you see a Back Up Catalog message, click the button labeled Skip this time.

This opens your new, empty LPCIB catalog.

Under the hood, you've created an LPCIB Catalog folder inside your Documents/ LPCIB folder that contains the catalog files for your new LPCIB catalog.

You will import the lesson files into this LPCIB catalog lesson by lesson, start-ing in Lesson 1, "Getting Ready to Use Lightroom with Photoshop," in the section "Importing from a drive." That section contains a detailed explanation of the import process you'll use throughout the book and when you're working with your own photographs. It walks you through the process of importing any files from a com-puter drive into Lightroom, using the Lesson 1 files as an example.

In each subsequent chapter (Lessons 2 through 8) you'll import the lesson files for that particular lesson by following the short instructions in the section "Preparing for this lesson," which you'll find at the beginning of Lessons 2 through 8. If at any time you want more information about how to import any lesson files, review the section "Importing from a drive" in Lesson 1.

About Classroom in a Book

Adobe Lightroom and Photoshop for Photographers Classroom in a Book® is part of the official training series for Adobe graphics and publishing software, developed with the support of Adobe product experts. The lessons are designed to let you learn at your own pace. If you're new to Adobe Lightroom or Adobe Photoshop, you'll learn the fundamental concepts and features you'll need to work with these programs together. If you've been using Lightroom or Photoshop for a while, you'll find that Classroom in a Book teaches advanced features too, focusing on tips and techniques for using the latest versions of the applications together.

Although each lesson provides step-by-step instructions for creating a specific project, there's room for exploration and experimentation. You can follow the book from start to finish, or do only the lessons that match your interests and needs. Each lesson concludes with review questions highlighting important concepts from that lesson.

Prerequisites

Note: Throughout this book, if an instruction differs for a Windows or Mac operating system, you'll see both commands separated by a forward slash (/): Windows command/Mac OS command.

Before starting on the lessons in this book, make sure you have a working knowledge of your computer and its operating system. Also make sure that your system is set up correctly and that you've installed the required software and hardware. You must purchase the software separately from this book.

To complete the lessons in this book, you'll need to have installed Adobe Lightroom, Adobe Photoshop, and the latest update to Adobe Camera Raw for your version of Photoshop. At the time of this writing, Lightroom 5.4 and Photoshop CC 14.2.1 are the current versions of the applications. You are welcome to follow along with versions of the programs as far back as Lightroom 4 and Adobe Photoshop CS6, but in that case some exercises in the book may not work for you exactly as written.

For system requirements and complete instructions for downloading, installing, and setting up the software, see the topics listed under the "Up and running" section of helpx.adobe.com/photoshop.html and helpx.adobe.com/lightroom.html.

Getting help

Help is available from several sources, each one useful to you in different circumstances:

Help in the applications

Note: If you've downloaded the Help PDFs, you don't need to be connected to the Internet to view Help in Lightroom or Photoshop. However, with an active Internet connection you can access the most up-to-date information.

The complete user documentation for Adobe Lightroom and Adobe Photoshop is available from the Help menu in each program. This content will display in your default web browser. This documentation provides quick access to summarized information on common tasks and concepts, and can be especially useful if you are new to Lightroom or if you are not connected to the Internet.

The first time you enter any of the Lightroom modules, you'll see module-specific tips that will help you get started by identifying the components of the Lightroom workspace and stepping you through the workflow. You can dismiss the tips if you wish by clicking the Close button (x) in the upper-right corner of the floating tips window. Click the Turn Off Tips check box at the lower left to disable the tips for all of the Lightroom modules. You can call up the module tips at any time by choosing Help > *Module name* Tips. In the Lightroom Help menu you can also access a list of keyboard shortcuts applicable to the current module.

Help on the web

You can also access the most comprehensive and up-to-date documentation on Lightroom and Photoshop via your default web browser. Point your browser to helpx.adobe.com/lightroom.html or helpx.adobe.com/photoshop.html.

Help PDFs

Download PDF help documents, optimized for printing, at helpx.adobe.com/pdf/lightroom_reference.pdf or helpx.adobe.com/pdf/photoshop_reference.pdf.

Additional resources

Adobe Lightroom and Photoshop for Photographers Classroom in a Book is not meant to replace documentation that comes with either program or to be a comprehensive reference for every feature. Only the commands and options used in the lessons are explained in this book. For comprehensive information about program features and tutorials, please refer to these resources:

Adobe Lightroom 5 Help and Support: You can search and browse Lightroom Help and Support content from Adobe at helpx.adobe.com/lightroom.html.

Adobe Photoshop CC Help and Support: You can search and browse Photoshop Help and Support content from Adobe at helpx.adobe.com/photoshop.html.

Adobe Forums: forums.adobe.com lets you tap into peer-to-peer discussions, questions, and answers on Adobe products.

Adobe Creative Cloud Learn: helpx.adobe.com/creative-cloud/learn/tutorials.html provides inspiration, key techniques, cross-product workflows, and updates on new features.

Adobe TV: tv.adobe.com is an online video resource for expert instruction and inspiration about Adobe products, including a How To channel to get you started with your product.

Resources for educators: www.adobe.com/education and edex.adobe.com offer a treasure trove of information for instructors who teach classes on Adobe software. Find solutions for education at all levels, including free curricula that use an integrated approach to teaching Adobe software and that can be used to prepare for the Adobe Certified Associate exams.

Also check out these useful links:

Adobe Photoshop Lightroom 5 product home page:
www.adobe.com/products/photoshop-lightroom.html

Adobe Photoshop CC product home page:
www.adobe.com/products/photoshop.html

Adobe Authorized Training Centers

Adobe Authorized Training Centers offer instructor-led courses and training on Adobe products, employing only Adobe Certified Instructors. A directory of AATCs is available at partners.adobe.com.

1 GETTING READY TO USE LIGHTROOM WITH PHOTOSHOP

Lesson overview

This lesson covers the steps you'll take as you prepare to use Adobe Photoshop Lightroom and Adobe Photoshop together to edit photographs. You'll start off reviewing the relationship between a Lightroom catalog and the photographs you'll import, and you'll give some thought to where to store your Lightroom photographs. Then you'll walk through importing photographs into a Lightroom catalog. The lesson then turns to the direct preparation you'll do in Lightroom and in Photoshop to smooth the way for using the programs as a team. Topics covered include:

- Understanding Lightroom's catalog system
- Considering where and in what folder structure to store your photographs
- Importing photographs into a Lightroom catalog from a camera
- Importing photographs into a Lightroom catalog from your computer drives
- Setting Lightroom's External Editing preferences for use with Photoshop
- Configuring Photoshop's Color Settings dialog to match Lightroom
- Setting Photoshop's Maximize Compatibility preference
- Keeping Lightroom and Camera Raw in sync

 You'll probably need from 1 to 2 hours to complete this lesson.

Photograph © John M. Lorenz 2013

Setting up Lightroom and Photoshop to work well together will facilitate the Lightroom–Photoshop workflows you'll practice throughout the rest of this book.

Preparing for this lesson

Do the following to prepare for this lesson:

1 Make sure you've followed the instructions in the Getting Started lesson at the beginning of this book for setting up an LPCIB folder on your computer for the lesson files, downloading the lesson files to that LPCIB folder, and creating an LPCIB catalog in Lightroom.

2 If the Lesson 1 files are not already on your computer, download the Lesson 1 folder from your account page at www.peachpit.com to *username*/Documents/LPCIB/Lessons.

3 Open the LPCIB catalog you created in the Getting Started lesson by doing the following: Hold the Alt/Option key as you start Lightroom; then in the Select Catalog dialog, select the LPCIB Catalog.lrcat file and click Open.

This will ensure that you're working in the LPCIB catalog as you progress through this lesson.

Later in this lesson, in the section "Importing from a drive," you'll learn how to import the Lesson 1 files you've downloaded into this LPCIB catalog.

Understanding catalogs

Lightroom is built on a database system. A database, called a *catalog* in Lightroom, maintains a record of each photograph you import into that catalog. The catalog includes information from the digital camera that captured a photograph, as well as information that you can add by managing and processing the photograph in Lightroom.

LPCIB Catalog.lrcat

A Lightroom catalog is composed of a set of database files. The two most important database files are the file ending in .lrcat, which contains the catalog and its data, and the file ending in Previews.lrdata, which contains photo previews and is the largest in file size of the database files. Additional database files are created when Lightroom generates Smart Previews, a feature that enables develop adjustments when photographs are offline or when a catalog is open in Lightroom.

LPCIB Catalog
Previews.lrdata

A default catalog is created automatically the first time you launch Lightroom. Its catalog files are located in *username*/Pictures/Lightroom. When you're working with your own photographs, you can use the default catalog or any other catalogs you create by choosing File > New Catalog and specifying a name and location for a new catalog. When you're working through the lessons in this book, use the LPCIB catalog you created in the Getting Started lesson. Its catalog files are located in *username*/Documents/LPCIB/LPCIB Catalog. To switch between catalogs, choose File > Open Catalog and select the .lrcat file for the desired catalog.

Lightroom catalog files are separate and distinct from the photographs they reference. The catalog files can be stored on any drive and in any folder irrespective of the location of the photographs. Where to store photographs is covered in more detail later in this lesson.

Lightroom's catalog system makes it possible to adjust photographs nondestructively. When you apply develop adjustments in Lightroom to correct or enhance a photograph, those adjustments are stored as text-based instructions in a Lightroom catalog, not as actual modifications to image data in the original photograph. This nondestructive approach to photo processing is one of the major benefits of using Lightroom. It gives you the flexibility to modify adjustments you've made in Lightroom without degrading your photographs.

How many catalogs to use

The simplest option for many Lightroom users is to index all photographs in a single catalog. A single catalog is easiest to manage, and it facilitates finding particular photographs, since Lightroom can open and search only one catalog at a time.

On the other hand, there may be some circumstances in which multiple catalogs make sense. If multiple users share one computer, each user can have a separate catalog. If you have a special reason to keep a set of photographs separate from your main catalog—for example, to keep the lesson files for this book from mixing in with your own photographs—separate catalogs may come in handy.

Storing your photographs

The photographs included in a catalog need not be stored in the same folder or even on the same drive as the catalog files. It's common, for example, to keep Lightroom catalog files on a computer's internal drive, but store the associated photographs on one or more external drives that can accommodate a growing photo library.

Note: This book focuses on photographs, but much of what you'll learn here applies to video too. You can import video into a Lightroom catalog and manage video clips in Lightroom's Library module. You can even perform limited edits to video in Lightroom. For more on working with video in Lightroom, see *Adobe Photoshop Lightroom 5 Classroom in a Book*.

The simplest approach to storage is to keep all your Lightroom photographs on one large, dedicated drive. You can create a top-level folder on that drive, give it an inclusive name like Lightroom Photos, and put subfolders containing your photos inside that top-level folder. The advantage of this setup is that when it comes time to transfer your photos to a larger or faster drive, you'll be able to accomplish that by moving just the top-level folder.

If you're a high-volume photographer whose photographs fill many drives, you may prefer another approach to photo storage. A single Lightroom catalog can access more than one drive. So you could store photographs on multiple drives associated with the same catalog, adding more drives as needed.

Beginning Lightroom users often start out storing their Lightroom photographs on their computers, which may be fine as long as you have sufficient storage capacity there. Before you go too far down this road, consider whether there is, and will continue to be, enough space on your computer for an expanding photo library.

Building a folder structure for your photographs

Folders are one of the primary ways that Lightroom users keep track of their photographs inside Lightroom. If you already have an effective folder structure for your photographs on your computer drive, you can continue to use that structure within Lightroom. If not, take the time to build a coherent set of folders and subfolders that will accommodate your existing photographs, as well as photographs you add in the future.

Here are two important tips for building a folder structure for your own photographs:

- Work in Windows Explorer or Mac OS to build and populate your initial folder system. This is simpler than doing it from inside Lightroom, and is safer for your photographs if it involves moving many photographs between folders.

- Before you import your existing photographs into Lightroom, gather them from their current locations and get them organized inside the folder structure you are building in your operating system.

There is no required blueprint for the folder structure you build. One suggestion is to use a date-based folder structure that consists of a top-level Lightroom Photos folder, containing a folder for each year and subfolders for each shoot. The subfolders are labeled by year and then month, so they stay in chronological order, followed by a word about the location or subject of the shoot, so you can identify each subfolder at a glance.

Creating and populating your folder structure may seem arduous, but it's a worthwhile foundation for the well-organized library you'll have later in Lightroom after you import these photographs into your Lightroom catalog.

Importing your photographs into your folder structure

When you're working with your own photographs and your own catalog, the next steps are to:

1 Import the organized photos on your drive(s) into Lightroom, as outlined in the next section. This will cause the folder structure you created outside of Lightroom to be reflected in the Folders panel in Lightroom's Library.

2 Import any new photos that are on your camera's memory card, as described later in this lesson. Photographs imported from your camera will fit right into the folder structure you created for your existing photographs.

Importing photographs into Lightroom

Importing is a critical step in any Lightroom workflow, because the only photographs you can view and work with in Lightroom are those you've imported into a Lightroom catalog.

When you're importing photographs from a computer drive, the primary function of importing is to create a record of those photographs in the catalog. When you're importing from a camera, importing not only creates a record in the catalog, it also

downloads the photographs from the camera's memory card. Importing never brings an actual photograph into Lightroom, as the term *import* might suggest. That's impossible, because Lightroom is not a container for photographs; it's a database that indexes photographs.

Importing from a drive

Follow the steps in this section to import the Lesson 1 files. These are the same steps to follow when you are importing your own photographs from a computer drive into a Lightroom catalog.

1 Press G on your keyboard to make sure you're working in Grid view of the Library module.

Tip: Work through the settings in the Import window from left to right. The settings on the left tell Lightroom which photographs to import, those in the center control how photographs are imported, and those on the right offer import options.

2 Click the Import button at the bottom of the left panel group, or choose File > Import Photos and Video. This opens a separate Import window.

3 To identify the photographs to import, go to the Source panel on the left side of the Import window, which displays in the Files section the volumes and folders in your computer system. Expand the triangles to the left of folders to navigate to Users/*username*/Documents/LPCIB/Lessons, and select the Lesson 1 folder.

Thumbnail previews of the 15 photographs in the Lesson 1 subfolders appear in the center of the Import window. If they don't, check the Include Subfolders check box at the top of the Source panel.

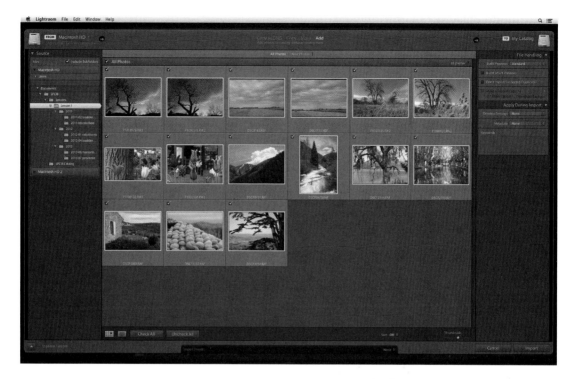

4 Make sure Add is selected as the import method in the workflow bar at the top of the Import window. This option tells Lightroom to add information about these photographs to the catalog, but to leave the actual photographs in the folders and on the drives where they are currently located.

● **Note:** Add is the best choice of import method if you have organized and stored existing photographs before importing them into Lightroom, as suggested earlier in this lesson. In that case, there is no need to choose Move or Copy, because the photographs are already where you want them.

Copy as DNG

One of the choices in the import workflow bar is Copy as DNG. DNG, which stands for Digital Negative format, is a standardized, open-source raw format that Adobe developed in response to the proliferation of proprietary raw file formats by camera manufacturers. When you import proprietary raw files, like NEF files from a Nikon camera or CR2 files from a Canon, choosing Copy as DNG in the Import window converts copies of the files to DNG format and includes the DNG files in the Lightroom catalog. You'll choose the location of the resulting DNG files in a Destination panel that will appear in the right panel group in the Import window. Converting to DNG will slow down the import process; so if you want to convert to DNG, you may prefer to do it after importing, using the Convert Photos to DNG command in the Library module's Library menu.

5 Leave all the thumbnails in the Import window checked. A photograph will not
 be imported if its thumbnail does not show a check mark.

6 If the File Handling panel on the right side of the
 Import window is not open, click its header to
 expand it. In the Build Previews menu in that
 panel, choose Standard. This determines the size
 of the previews with which these photographs
 will be displayed in the Library module. See the
 sidebar "What the Build Previews options mean"
 for more information.

7 Leave the other options in the File Handling panel unchecked.

 You can choose to have Lightroom build Smart Previews of all the files you are
 importing, or you can wait to generate Smart Previews of selected photographs
 in the Library module when and if you need them. Smart Previews allow you to
 perform develop adjustments on images even when the original photographs
 are on a drive that is unconnected. Leave Build Smart Previews unchecked for
 this lesson.

 The Don't Import Suspected Duplicates option in the File Handling panel
 prevents Lightroom from importing a photograph it recognizes as a duplicate
 of one already in the catalog, even if the duplicate is located in a different folder.
 Leave this box unchecked for this lesson.

 The Make a Second Copy To option creates an additional copy of the original
 photographs during import, but without the structure that the catalog will
 give to your working photographs. This copy is suitable for archiving and
 safekeeping your original photographs; it is not a substitute for backing up your
 Lightroom catalog and your working Lightroom photos regularly. This option is
 available only if an additional drive is connected and turned on, so you may not
 have access to it now.

8 If the Apply During Import panel on the right
 side of the Import window is not open, click its
 header to expand it. Click one thumbnail in the
 Import window, and then press Ctrl-A/
 Command-A to select all the thumbnails of
 photographs in the Lesson 1 folder. In the
 Keywords section of the Apply During Import
 panel, type **Lesson 1** to apply that keyword tag
 to all the photographs upon import.

 The Keywords field and the Develop Settings menu in the Apply During Import
 panel are useful only for keywords and develop settings that apply globally to all
 the photographs in an import batch. Later, in the Library module, you can add
 keywords and develop settings that are specific to individual photographs.

What the Build Previews options mean

- Minimal and Embedded & Sidecar: These options make use of previews embedded in the original photographs. These relatively small previews will be used to quickly display initial Library module thumbnails. They soon will be replaced in the Library module by previews that Lightroom generates. The Minimal option uses the small non-color-managed JPEG preview embedded in a file by a camera during capture. The Embedded & Sidecar option looks for and uses any larger preview that might be embedded in a file. If you're importing lots of photographs and want the import to be as fast as possible, choose the Minimal import option, and later in the Library module generate larger previews for selected photographs by choosing either Library > Previews > Build 1:1 Previews or Library > Previews > Build Standard-Sized Previews.

- Standard: Standard is a useful import option that will speed up your browsing in the Library module, without slowing down importing as much as the 1:1 option will. This option builds standard-sized previews during import that are useful for viewing photographs in Loupe view in the Library module. The size of a standard-sized preview is governed by a Catalog Setting you access by going to Edit (Windows) / Lightroom (Mac OS)/Catalog Settings/File Handling/Standard Preview Sizes. There you can choose a size up to 2880 pixels on the long edge. Ideally, choose a standard preview size that is equal to or slightly larger than the screen resolution of your monitor.

- 1:1: This option builds additional previews that are the same size as the original photographs. 1:1 previews are useful for zooming in to check sharpness and noise in the Library module. If you choose to have Lightroom build these previews upon import, you won't have to wait for a 1:1 preview to generate when you zoom in to an image in the Library module. However, 1:1 previews take the longest time to import and are the largest in file size in the Previews.lrdata catalog file. You can manage the size issue either by selecting thumbnails in the Library module and choosing Library > Previews > Discard 1:1 previews, or choosing to discard 1:1 previews automatically after a particular number of days in Edit (Windows) / Lightroom (Mac OS)/Catalog Settings/File Handling. Lightroom will rebuild those 1:1 previews when you ask for them by zooming in.

Adding copyright during import

The Metadata menu in the Apply During Import window offers a practical opportunity to add your copyright to the metadata of all your photographs during import.

When you're importing your own photographs, choose New from the Metadata menu. In the New Metadata Preset dialog that opens, scroll to the IPTC Copyright section. In the copyright field, enter a copyright symbol by pressing Alt-0169 on a numeric keypad (Windows) or pressing Option-G (Mac OS), followed by the copyright year and your name. In the Copyright Status menu, choose Copyrighted. You can add Rights Usage terms and, if you have a website with more copyright information, the URL to that website. Scroll to the IPTC Creator section, and enter any identifying information you choose to include.

To save this information as a metadata preset that you can quickly apply to other photographs, go to the Preset menu at the top of the New Metadata Preset dialog and choose Save Current Settings as New Preset. In the New Preset dialog that appears, enter a name for this preset and click Create. Click Create again in the New Metadata Preset dialog.

To apply this copyright to an entire batch of photographs as you import them, select all the thumbnails in the Import window by clicking one thumbnail and pressing Ctrl-A/Command-A. In the Apply During Import panel on the right side of the Import window, go to the Metadata menu and choose this metadata preset by name. This preset can also be applied from the Metadata panel in the Library module.

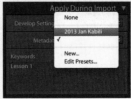

9 To save all the settings you made in this section as an Import preset, go to the Import Preset bar at the bottom of the Import window and choose Save Current Settings as New Preset. In the New Preset dialog that appears, give the preset a name and click Create.

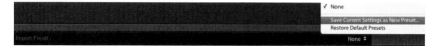

The next time you import photographs from a drive, rather than choosing Import settings one by one, you can apply this Import preset by selecting the thumbnails in the Import window and choosing this preset from the menu on the right side of the Import Preset bar.

10 Click the Import button in the lower-right corner of the Import window to import the photographs with all your Import settings applied. The Import window closes.

Back in the Library module, progress bars in the upper-left corner display Lightroom's progress as it creates records and builds previews of the photographs it is importing. In the Catalog panel in the left panel group, the Previous Import collection is selected, displaying the 15 photographs just imported in the center work area. The Folders panel in the left panel group displays the drive and folders that contain the imported photographs. Clicking any of those folders will display the contents of that folder in the work area.

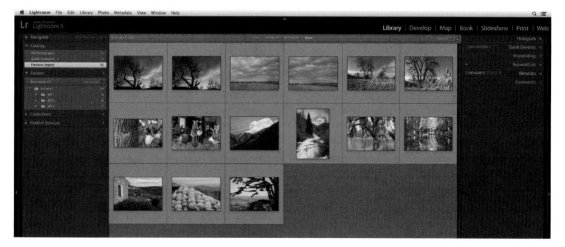

Importing from a camera

Importing photographs from a digital camera after a shoot is similar to importing from a drive, but it involves more settings because Lightroom is doing two jobs. It is copying the photographs from your camera's memory card to your computer, and it is creating a record of those photographs in a catalog.

Use a memory card containing photographs from your own digital camera to work through this section.

1 Insert the memory card from the camera into a memory card reader attached to your computer.

2 Click the Import button or choose File > Import Photos and Videos to open the Import window.

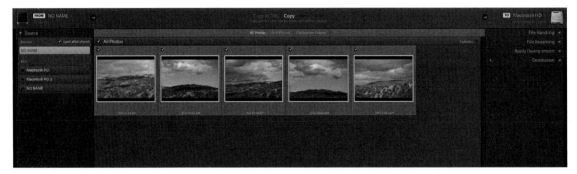

3 In the Devices section of the Source panel on the left of the Import window, your memory card should be automatically selected, identifying the source of the photographs to be imported. The memory card in the following image has no particular name. Your memory card may bear the name of your camera or the card manufacturer.

4 In the Source panel, leave Eject After Import checked so you can safely remove the memory card from the computer when you're finished importing.

5 Make sure the thumbnails of all photographs you want to import are checked in the center work area.

6 In the Import Method bar at the top of the Import window, choose Copy.

The only other choice of import method when you're importing from a camera memory card is Copy as DNG, discussed in the sidebar "Copy as DNG."

The Copy method tells Lightroom to copy photographs from the camera memory card to a drive *and* to add them to the catalog. Recall that you used a different import method—Add—to import photographs already stored on a drive in the last section, "Importing from a drive." In that case, you were telling Lightroom to just add those photographs to the catalog.

7 Choose the location to which the photographs will be copied. Start by clicking the To icon in the upper-right corner of the Import window and then choosing Other Destination.

8 In the Choose Destination Folder dialog that opens, navigate to the drive and folder in which you want to store these photographs, and click Choose.

For example, if the photographs on the memory card were shot in March 2013 in Santa Fe, the logical destination in the folder structure you built earlier in this lesson is the 2013 folder, which is located in *username*/Documents/LPCIB/Lessons/Lesson 1.

9 In the Destination panel, go to the Organize menu and choose Into One Folder. (Into One Folder refers to the folder selected in the last step—the 2013 folder.) Click the Into Subfolder check box and enter a name for a new subfolder that will contain these photographs—such as **2013-03 santa fe**, which is consistent with the way subfolders are named in the folder structure built earlier in this lesson in the "Building a structure for your photographs" section.

▶ **Tip:** The default choice in the Destination panel's Organize menu is By Date. The dated subfolders created by that option can be confusing, particularly if you've already set up a different folder structure, as suggested earlier in this lesson. The options suggested here are simpler.

10 The File Handling and Apply During Import panels in the right panel group are the same as when you imported photographs from a drive in the last section. Leave the fields in these two panels at their default values.

11 Open the File Renaming panel by clicking its header. Check the Rename Files check box. In the Template menu, choose one of the existing templates or choose Edit, which opens the Filename Template Editor.

You can rename files either in the File Renaming panel during import or later in the Library module. When renaming files in the Library module, select their thumbnails and choose Library > Rename Photos, which opens the same Filename Template Editor.

12 In the Filename Template Editor, you'll build a custom template by inserting tokens and text into the white box near the top of the dialog:

- First, select any items already in the white box, and press Backspace/Delete to delete those items.

- In the Additional section of the dialog, choose Date > Date (YYYYMMDD), and click the Insert button to the right of that menu. This inserts a Date (YYYYMMDD) token in the white box.

- In the white box, type a hyphen to the right of the date token.

- In the Image Name section of the dialog, choose Filename > Filename Number Suffix, and click the Insert button to the right of that menu to insert a Filename Number Suffix token in the white box.

 An example filename is displayed above the white box. This custom-built template will rename each photograph during import with its capture date, followed by the file number from the original filename generated by the camera. The original file number or filename is an important identifier to include in any file-renaming scheme.

13 In the Preset menu at the top of the Filename Template Editor, choose Save Current Settings as New Preset. In the New Preset dialog that opens, enter **date-file number** in the Preset Name field, and click Create.

14 In the Filename Template Editor, click Done. That dialog closes, and back in the Import window's File Renaming panel, the date-file number preset appears in the Template menu, ready to be applied upon import.

You can apply this preset to other photographs in the future, either from the File Renaming panel when you're importing photographs with the Copy, Copy as DNG, or Move import method, or in the Library module by selecting thumbnails, choosing Library > Rename Photos, and choosing this preset from the File Naming menu.

15 Click the Import button in the lower-right corner of the Import window to start the Import process. Lightroom will copy the photographs from your camera memory card to the destination you specified in the Import window and create a record of each of these photographs in the Lightroom catalog.

> **Tip:** When you're satisfied that all photographs have been copied off the memory card and, ideally, backed up, insert the memory card back into your camera, and use the camera controls to reformat it.

Preparing Lightroom and Photoshop for integration

Before you start passing photographs back and forth between Lightroom and Photoshop, there are some settings to tweak in both programs to make integration between Lightroom and Photoshop as smooth as possible. This section covers these preliminaries:

• Setting Lightroom's External Editing preferences

• Setting Photoshop's Color Settings to match Lightroom

• Setting Photoshop's Maximize Compatibility preference

• Keeping Lightroom and Photoshop's Camera Raw plug-in in sync

Setting Lightroom's External Editing preferences

Lightroom's External Editing preferences determine image properties—like file format, bit depth, and color space—with which files are passed from Lightroom to Photoshop or other applications for pixel-based editing. These preferences also establish rules for naming and stacking the resulting files back in Lightroom.

Configuring primary external editor preferences

The primary external editor preferences, which are in the top section of Lightroom's External Editing preferences, determine the properties with which files will be handed off from Lightroom to Photoshop in its role as primary external editor.

1 In Lightroom, choose Edit > Preferences (Windows) or Lightroom > Preferences (Mac OS), and click the External Editing tab to display Lightroom's External Editing preferences.

Lightroom automatically designates the latest version of Photoshop installed on your computer as its primary external editor. The settings in the top section of Lightroom's External Editing preferences determine the properties with which a file will open into Photoshop as primary external editor, when you later choose the first menu item in Lightroom's Photo > Edit In menu. If you don't change these settings, their default values will apply.

● **Note:** Throughout this book, the terms *RGB file* and *RGB image* refer to non-raw files—specifically, TIFF, PSD, and JPEG files.

2 Choose TIFF from the File Format menu in the top section of Lightroom's External Editing preferences.

This setting establishes the file format, TIFF or PSD, in which both raw and RGB files handed off from Lightroom will open in Photoshop.

You can't go wrong by choosing either TIFF or PSD in this File Format menu, because both formats retain Photoshop enhancements, like layers, and both are lossless. PSD often produces smaller files than TIFF. On the other hand,

TIFF is a more universal format, which can come in handy if you plan to send out photographs for printing or collaboration. If you ever do choose PSD as the file format here, also set Photoshop's Maximize Compatibility preference, as explained in the "Configuring Photoshop's Maximize Compatibility preference" section.

3 Choose ProPhoto RGB from the Color Space menu in the top section.

This controls the color space in which raw files will be passed from Lightroom to Photoshop. Lightroom's built-in working color space is a variation of ProPhoto RGB, which encompasses the widest possible range of colors and protects colors captured by your camera from being clipped or compressed. Choosing ProPhoto RGB in this External Editing menu preserves that broad color range when you continue editing a file in Photoshop.

A raw file doesn't have a conventional color profile until it is rendered by handing it off to a pixel editor like Photoshop or otherwise outputting it from Lightroom. If you set this preference to ProPhoto RGB, when you use the first item in Lightroom's Photo > Edit In menu to pass a raw file to Photoshop, the ProPhoto RGB color profile will be embedded in the rendered image.

Adobe RGB is not as wide a color space as ProPhoto RGB, but it is a viable file format to choose here if you are planning to send an edited image out to a printer or collaborator who requests Adobe RGB. sRGB is the best file format for photographs you're editing for online use.

4 Choose 16 bits/component from the Bit Depth menu in the top section.

This setting controls the amount of information per channel in a file passed from Lightroom to Photoshop. A 16-bit image has many more potential tonal values and more editing latitude than an 8-bit image. It makes sense to set bit depth to 16 bits whenever you choose ProPhoto RGB as the color space, because ProPhoto RGB offers such a wide range of potential colors. The disadvantages of choosing 16 bits in this menu are that some Photoshop

features aren't available for 16-bit editing and that 16-bit files are larger in file size.

5 Leave Resolution set to its default of 240 in the top section.

The value in this Resolution field is not critical. It refers to the number of pixels that would be assigned to a printed inch should the photograph be printed. It does not affect the total number of pixels in the file, and it can be changed later. The default, 240 ppi (pixels per inch), is a reasonable starting point, since it approximates the print resolution of a typical inkjet printer.

6 Leave Compression set to None in the top section. Compression is an option only if you choose TIFF in the File Format menu.

The options you chose in this section affect the way a photograph will open into Photoshop when you select a thumbnail in Lightroom's Library module, choose Photo > Edit In, and choose the first menu item: Edit in Adobe Photoshop CC (or when you press the keyboard shortcut Ctrl-E/Command-E).

Configuring additional external editor preferences

You can designate one or more additional external editors that will appear in Lightroom's Photo > Edit In menu along with the primary external editor. These will give you a choice of pixel editors to which to pass a file from Lightroom.

Additional editors can be third-party pixel-editing programs or plug-ins like Google's Nik Collection, other Adobe pixel editors like Adobe Photoshop Elements, or other configurations of Photoshop than the one you set up as primary external editor. If you have an older version of Photoshop installed, you can set that up as an additional external editor. You can even create multiple additional configurations for your latest version of Photoshop—each with settings geared toward particular kinds of photographs.

In this section, you'll configure your latest version of Photoshop as an additional external editor with options suitable for photographs destined for the web.

1 If your External Editing Preferences window is not open in Lightroom, choose Edit > Preferences (Windows) or Lightroom > Preferences (Mac OS), and click the External Editing tab.

2 In the External Editing Preferences window, go to the second section, labeled Additional External Editor, and click the Choose button to the right of the Application field.

3 In the operating system window that opens, navigate through your file structure to Photoshop's .exe program file (Windows) or Photoshop's .app application file (Mac OS).

 If the same version of Photoshop you selected here is also your primary external editor, you'll see a warning that Lightroom has already chosen this version of Photoshop as an editor automatically.

4 Click the Use Anyway button in the warning dialog.

 Clicking Use Anyway dismisses the warning dialog and allows you to use the same version of Photoshop, with different settings, as an additional external editor and the primary external editor.

5 Choose PSD from the File Format menu in the Additional External Editor section of the External Editing preferences.

 This will cause a photograph to open into Photoshop in the PSD format when you apply Photoshop as an additional external editor.

TIFF or PSD is a better choice in this menu than JPEG, even if your goal is to prepare photographs in Photoshop for online use. That's because JPEGs behave differently than TIFFs and PSDs in the Lightroom–Photoshop workflow. For now, choose PSD as the format to pass to Photoshop in its role as additional external editor. After editing and saving in Photoshop, you'll have a PSD copy of the edited image in Lightroom. If you want a JPEG to post online, you can export a JPEG copy of the edited PSD from Lightroom, using the Export dialog covered in detail in the "Exporting from Lightroom" section in Lesson 2.

6 Choose sRGB from the Color Space menu in the Additional External Editor section.

The sRGB color space is the best color environment in which to edit a photograph you plan to upload to the web. sRGB approximates the relatively narrow color gamut of the typical online viewing environment—a PC monitor. If a photograph is bound for the web, you don't want to choose ProPhoto RGB or Adobe RGB here, because colors in a photograph edited in those color spaces look dull when viewed in a non-color-managed web browser.

7 Choose 16 bit/component from the Bit Depth menu in the Additional External Editor section.

If you start with a high-bit image, like a raw file, take advantage of all the data it contains during editing. Later, when a copy of the edited photograph is exported in JPEG format for web use, it will be reduced to 8 bits automatically.

8 Leave Resolution set to its default value in the Additional External Editor section.

When you're preparing a photograph for the web, the value in the Resolution field is irrelevant, because this number is a measure of pixels that would be assigned to each inch if and when the image is printed.

● **Note:** On Windows, the Application value will be Photoshop.exe.

The options you've chosen so far in this section affect the way a photograph will open into Photoshop when you choose Photo > Edit In and the second menu item: Edit in Photoshop.exe/Edit in Adobe Photoshop CC.app (or when you press the keyboard shortcut Ctrl-Alt-E/Command-Option-E).

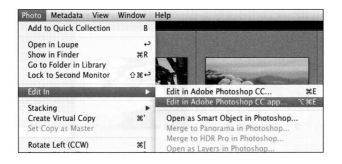

You also have the option to save these settings as an additional external editor preset, which will create yet another menu item from which you can apply these settings to photographs in the future.

9 Go to the Preset menu at the top of the Additional External Editor section, and choose Save Current Settings as New Preset.

10 In the New Preset window that opens, type a meaningful name for the set of options you just configured, like **Photoshop CC web**, and click Create.

This preset will appear as a menu item in the second section of Lightroom's Photo > Edit In menu, giving you another way to open files from Lightroom into Photoshop with the settings you just chose in the Additional External Editor preferences.

Leave the External Editing Preferences window open for the next section of the lesson.

Adobe Photoshop Elements as an external editor

Adobe Photoshop Elements can be Lightroom's primary editor, an additional external editor, or both, depending on the combination of Elements and Photoshop installed on your computer:

- If you have Elements but not Photoshop on your computer, Elements will be designated automatically as Lightroom's primary external editor. Elements is the only other application that can be the primary editor. Configure the way images open from Lightroom into Elements' Editor in the top section of Lightroom's External Editing preferences.

- If you have neither Elements nor Photoshop installed, the commands for editing in a primary external editor will not be available in Lightroom's Photo > Edit In menu. You can still designate other applications as additional external editors.

- If you have both Elements and Photoshop on your computer, you can designate Elements as an additional external editor like this:

 1 Click the Choose button in the Additional External Editor section, and navigate to the file that launches Elements' Editor (not Elements' Organizer): C:\Program Files\Adobe/Photoshop Elements 12\Photoshop Elements Editor.exe (Windows) or Applications/Adobe Photoshop Elements 12/Support Files/Adobe Photoshop Elements Editor (Mac OS). This causes Edit in Photoshop Elements 12 Editor to appear as the second menu item in Lightroom's Photo > Edit In menu.

 2 Configure how files will open from Lightroom into Elements' Editor in the Additional External Editor section of Lightroom's preferences.

 3 Optionally, use the Preset menu in the Additional External Editor section to save those settings as presets. For example, you could make one Elements preset for web use and another with different settings for print use. These will appear in the second section of Lightroom's Photo > Edit In menu.

Setting the stacking preference

Many Lightroom–Photoshop roundtrip workflows generate copies (derivative files) from the original file (the source file). These appear as separate thumbnails in the grid in Lightroom's Library module and in the Filmstrip at the bottom of various modules. Viewing derivative files right next to the corresponding source file will help you keep track of which files go together. One way to accomplish this is to enable the Stack With Original preference in Lightroom's External Editing preferences. This will create a collapsible group, called a stack, of a source file and its derivatives during a Lightroom–Photoshop work session.

● **Note:** Throughout this book, the term *source file* refers to the file that is handed off from Lightroom to Photoshop in a Lightroom–Photoshop roundtrip workflow, and the term *derivative* file means a copy of a source file that is produced during a Lightroom–Photoshop workflow.

When a stack is expanded, the source and derivative thumbnails are displayed side by side in Lightroom's grid and Filmstrip, so matching files are easy to identify. In the following image, you see an expanded stack containing a raw source file on the right and its derivative TIFF file on the left.

However, when a stack is collapsed, only one version of the file, the one on the top of the stack, appears in the grid and the Filmstrip, so you can't see all versions of the photograph when you're browsing your library. In the following image, you see the same stack collapsed, with only one of the stacked images displayed at the top of the stack.

For this reason, some photographers prefer to leave Lightroom's Stack With Original preference unchecked and rely instead on the Sort menu in the Library module to keep original files and their derivatives together. To give that a try:

1 Uncheck the Stack With Original check box in Lightroom's External Editing preferences.

Tip: If you don't see the toolbar in Lightroom's Library module, press T on your keyboard to show it.

2 Later, after you've generated some derivative files by passing photographs between Lightroom and Photoshop, click the Sort menu in the toolbar at the bottom of the Library module, and choose File Name or Capture Time. In most cases, this will place derivative files next to their source file.

Setting the file naming preference

The Template menu at the bottom of Lightroom's External Editing preferences determines the names of derivative files generated in a Lightroom–Photoshop work session. By default, derivative files are named automatically with the same filename as the source file, followed by **–Edit**.

It's fine to stick with this default file naming convention, but you do have options to choose different filename templates or create your own, using the same Filename Template Editor you used when importing photographs. In this section you'll create a filename template for derivative files from Photoshop. You could make other filename templates for files derived from other external editors and switch between filename templates as you need them.

1 If Lightroom's External Editing Preferences window is not open, choose Edit/Photoshop > Preferences and click the External Editing tab.

2 Go to the section of the Preferences window labeled Edit Externally File Naming. Choose Template > Edit.

This opens the same Filename Template Editor covered earlier in this lesson in the section on importing from a camera. Here you can build a custom file naming template using tokens and text, as you learned to do earlier.

3 In the white box near the top of the Filename Template Editor, type **-P** (for Photoshop) to the right of the default template, Filename-Edit.

4 Click the Preset menu at the top of the Filename Template Editor, and choose Save Current Settings as New Preset. In the New Preset dialog, name the preset **Filename – Edit - Photoshop**, and click Create. In the Filename Template Editor, click Done.

In the External Editing Preferences window, the new preset appears in the Template menu with an example filename above the menu. This establishes the

naming convention for all future files generated by an external editor. To apply a different naming convention at any time, return to the Template menu and choose or create another template.

Configuring Photoshop's Color Settings dialog

In this section you'll configure Photoshop's Color Settings dialog for smooth integration with Lightroom. This will help colors appear consistent as you pass photographs between Lightroom and Photoshop.

1 In Photoshop, choose Edit > Color Settings to open the Color Settings dialog.

2 In the Working Spaces section, choose ProPhoto RGB from the RGB menu.

3 In the Color Management Policies section, choose Preserve Embedded Profiles from the RGB menu.

4 In the Color Management Policies section, check the Missing Profiles: Ask When Opening check box, and leave the other check boxes unchecked.

With these settings, files will open as follows from Lightroom into Photoshop:

• Raw files will open in the color space you chose in Lightroom's External Editing preferences earlier in this lesson. Those are:

ProPhoto RGB when you use the first item in Lightroom's Photo > Edit In menu to hand off a raw file.

sRGB when you use the second item in Lightroom's Photo > Edit In menu, or when you use the additional external editor web preset you created, to hand off a raw file.

- RGB files that have an embedded color profile will open from Lightroom into Photoshop in a color space that depends on the RGB editing command you choose—Edit a Copy with Lightroom Adjustments, Edit a Copy, or Edit Original. Those commands are covered in detail in Lesson 2.

- RGB files that do not have a color profile embedded will trigger a Missing Profile warning. In the Missing Profile warning:

 If you are preparing files for the web, choose Assign profile: sRGB IEC61966-2.1. Otherwise, choose Assign working RGB: ProPhoto RGB. Then click OK to dismiss the warning and open the file into Photoshop.

5 Click OK in the Color Settings dialog to close it.

Configuring Photoshop's Maximize Compatibility preference

If you've configured Lightroom's External Editing preferences for Photoshop to save files in PSD format, and you add layers to a file in Photoshop, Lightroom may not be able to read the resulting PSD file unless you've instructed Photoshop to maximize compatibility. You can maximize compatibility on a case-by-case basis when and if you are presented with a maximize compatibility warning in Photoshop, or you can take care of it more efficiently across the board by enabling a Photoshop preference. This step is not necessary if you're saving layered TIFF files from Photoshop, because Lightroom can read layered TIFFs.

1 In Photoshop, choose Edit > Preferences > File Handling (Windows) or Photoshop > Preferences > File Handling (Mac OS).

2 In the File Handling Preferences dialog, go to the Maximize PSD and PSB File Compatibility menu and choose Always. Click OK to close the preferences dialog.

This causes Photoshop to automatically add a Lightroom-compatible composite layer to a PSD upon saving, without triggering a warning message.

Keeping Lightroom and Camera Raw in sync

Lightroom, at its heart, is a raw converter whose job is to convert the data in a raw file into an image that can be viewed and edited onscreen. Photoshop has its own raw converter, a plug-in called Camera Raw. Camera Raw and Lightroom use the same raw conversion engine, and when Adobe updates one it usually updates the other with a matching version.

Camera Raw is involved in many Lightroom–Photoshop workflows. To get the most out of using Lightroom and Photoshop together, it's a good idea to have matching versions of Lightroom and Camera Raw installed. If you have non-matching versions, you can still use Lightroom and Photoshop together, but you may run into mismatch warnings and content issues as you pass files back and forth between Lightroom and Photoshop.

To check which versions of the software you have installed:

1 In Photoshop, go to the Help menu (Windows) or the Photoshop menu (Mac OS) and choose About Photoshop. Your version of Photoshop is reported on the screen that opens. Click the screen to dismiss it.

2 In Photoshop, go to Help/Photoshop > About Plug-Ins > Camera Raw. Your version of the Camera Raw plug-in is reported on the screen that opens. Click the screen to dismiss it.

3 In Lightroom, go to the Help menu (Windows) or the Lightroom menu (Mac OS), and choose About Lightroom. A screen opens that reports your version of Lightroom. It also reports the version of Camera Raw that is fully compatible with your version of Lightroom. If you don't have that version of Camera Raw, make a note to update Camera Raw. Click the screen to dismiss it.

The best way to keep Lightroom and Camera Raw in sync is to regularly update Lightroom and Camera Raw through Adobe Creative Cloud if you're a Creative Cloud subscriber, or to choose Help > Updates in Lightroom and Photoshop (CS6 or earlier) if you own that software.

Review questions

1 Must you store your photographs on the same drive as the corresponding Lightroom catalog files?

2 What is the best import method to choose in Lightroom's Import window when you're importing photographs that are already on a computer drive?

3 What are the only two choices of import method in the Import window when you're importing photographs straight off a camera's memory card?

4 What is the purpose of the settings you choose in the top section of Lightroom's External Editing preferences?

5 Can you set up more than one configuration of Photoshop settings for opening photographs from Lightroom in Photoshop?

Review answers

1 No. Many photographers store their photographs on one or more large external drives and keep the corresponding Lightroom catalog files on their computer's primary internal drive.

2 Use the Add method of importing photographs that are on a drive. This import method leaves the photographs where they are, while creating a record of each in the Lightroom catalog.

3 Copy and Copy as DNG are the only two options when you're importing from a camera's memory card. Both download photographs from the memory card to a location of your choice and make a record of each in the Lightroom catalog.

4 The settings you choose in the top section of Lightroom's External Editing preferences determine the settings—including file format, color space, bit depth, and resolution— with which photographs will open into Photoshop from Lightroom when you choose Photo > Edit In Adobe Photoshop CC (or the latest version of Photoshop installed on your computer).

5 Yes. In addition to choosing the primary Photoshop settings in the top section of Lightroom's External Editing preferences, you can set up additional configurations of Photoshop settings in the Additional External Editor section, saving each as a preset. This will create a menu item in Lightroom's Photo > Edit In menu for each configuration.

2 LIGHTROOM–PHOTOSHOP ROUNDTRIP WORKFLOW

Lesson overview

This lesson walks you through taking a photograph from Adobe Photoshop Lightroom to Adobe Photoshop and back again for editing in both applications. It's the most important lesson to study carefully, because it covers the mechanics of working with both Lightroom and Photoshop to enhance your photographs. This lesson covers a typical roundtrip workflow, which includes:

- Handing off a raw file from Lightroom to Photoshop for pixel editing

- Saving a pixel-rendered version from Photoshop back to Lightroom

- Passing the pixel-rendered version back to Photoshop for further editing

- Exporting a copy of the final edited version from Lightroom

 You'll probably need from 1 to 2 hours to complete this lesson.

Photograph © John M. Lorenz 2013

The basic workflow for using Photoshop as Lightroom's primary external editor takes advantage of nondestructive photo processing and asset management in Lightroom, as well as pixel editing in Photoshop.

Preparing for this lesson

Do the following to prepare for this lesson:

1 Make sure you've followed the instructions in the Getting Started lesson at the beginning of this book for setting up an LPCIB folder on your computer, downloading the lesson files to that LPCIB folder, and creating an LPCIB catalog in Lightroom.

2 If the Lesson 2 files are not already on your computer, download the Lesson 2 folder from your account page at www.peachpit.com to *username*/Documents/LPCIB/Lessons.

3 Open the LPCIB catalog you created in the Getting Started lesson by doing the following: hold the Alt/Option key as you start Lightroom; then in the Select Catalog dialog, select the LPCIB Catalog.lrcat file and click the Open button.

4 Import the Lesson 2 files into the open LPCIB catalog following the bullet steps below. This is similar to the process for importing any photographs that are already on a drive (see "Importing from a drive" in Lesson 1 for more details).

- Click the Import button in the Library module.

- In the Import window's Source panel, navigate to *username*/Documents/LPCIB/Lessons and select the Lesson 2 folder. Make sure the Include Subfolders check box at the top of the Source panel and to the right of the Files label is checked

- In the Import window's workflow bar, choose Add as the import method.

- Leave all the thumbnails in the Import window checked.

- In the Import window's File Handling panel, choose Build Previews > Standard. Leave the other File Handling options unchecked.

- In the Import window's Apply During Import panel, enter **Lesson 2** in the Keywords field.

- Click the Import button in the Import window.

5 In the Library, select the Lesson 2 subfolder in the Folders panel.

Taking a raw file from Lightroom to Photoshop

Lightroom is a great place to make initial adjustments to photo quality for a number of reasons: All the adjustments you make in Lightroom are inherently nondestructive of your photographs; Lightroom's develop controls are intuitive to use; and develop adjustments are reflected automatically in Lightroom's digital asset manager, the Library. Lightroom's develop controls may be all you need to process the bulk of your photographs, but it's likely there will be photographs you'll want to enhance further with layers, compositing, retouching, or the many other pixel-level edits at which Photoshop excels. After you've taken advantage of what Photoshop has to offer, you'll want to continue to manage the edited photographs back in Lightroom's Library. The smoothest way to combine the advantages of Lightroom and Photoshop is with the roundtrip workflow detailed here.

The process of handing off files from Lightroom to Photoshop often starts with a raw file, whether that's a camera manufacturer's proprietary raw file (like .NEF from Nikon or .RAF from Panasonic) or an Adobe DNG raw file. Lightroom, at its core, is a raw converter whose primary function is to convert the data in a raw file to an image you can view and work with onscreen. You have the option to hand off RGB images (TIFFs, PSDs, and JPEGs) too, as you'll do later in this lesson.

Making initial adjustments in Lightroom

Start this Lightroom–Photoshop workflow by making adjustments to tone and color in Lightroom.

1 In Lightroom's Library module, select the Lesson 2 folder in the Folders panel. In Grid view, select the thumbnail of the raw file DSCF0431.dng (a photograph of Maroon Bells-Snowmass Wilderness, near Aspen, Colorado).

2 Click Develop in the Module Picker at the top of the screen (or press D on the keyboard) to switch to Lightroom's Develop module.

 The image is selected in the Filmstrip at the bottom of the Develop module and appears in the work area ready for adjusting.

Tip: In Lightroom, filenames are displayed above thumbnails in the Library module's Grid view and at the top of the Filmstrip. If you don't see filenames in Grid view, press J on your keyboard several times to cycle through Grid view styles.

3 In the Develop module, click the title bar of the Basic panel to open that panel.
 Use the controls in the Basic panel to adjust overall tone and color.

The specific settings you choose for this image in the Basic panel are not critical for this exercise. The point is to make some visible adjustments in Lightroom before passing this image to Photoshop. Basic panel adjustments are covered in more detail in Lesson 4.

Rendering a raw file into Photoshop

Next you'll pass the raw file from Lightroom to Photoshop for further editing, rendering the raw data into pixels that Photoshop can handle.

1 With DSCF0431.dng still open in Lightroom's Develop module, choose Photo > Edit In to open the Edit In menu, which contains all the commands for passing photographs from Lightroom to Photoshop.

▶ **Tip:** The Photo > Edit In menu is accessible from the top menu bar in the Develop, Library, and Map modules. It is also accessible from the Library module grid, where you can right-click/Control-click one or more photo thumbnails and choose Edit In from the pop-up menu.

2 Choose the first item in the Edit In menu—Edit in Adobe Photoshop CC (or the latest version of Photoshop on your computer, which appears automatically in this menu item). This is the command for passing a file to Photoshop in its role as Lightroom's primary external editor.

This launches Photoshop, if it's not already open, and hands off the raw file from Lightroom to Photoshop. You won't see Camera Raw, but Camera Raw is working behind the scenes to render the raw file so that it can be viewed and edited in Photoshop. In the process, the adjustments you made in Lightroom are embedded in the rendered image and appear in the photograph when it opens in Photoshop.

▶ **Tip:** The Filmstrip in the Develop module displays all the photographs in the folder you selected in the Library module. When you're not using the Filmstrip, you can hide it so you have more room to work. To hide or show the Filmstrip, click the triangle beneath the Filmstrip at the bottom-center of the screen (or press F6 on the keyboard).

● **Note:** Ctrl-E (Windows) or Command-E (Mac OS) is the shortcut for the first menu item in the Edit In menu. For the rest of this lesson, you'll use this shortcut to pass files from Lightroom to Photoshop as the primary external editor.

The photograph opens in Photoshop with the primary external editor properties you chose in Lightroom's External Editing preferences in Lesson 1 (Color Space: ProPhoto RGB; Bit Depth: 16 bits per channel; Resolution: 240 ppi). The image has been rendered from raw data to pixels, but its filename in the Photoshop document tab doesn't yet display an RGB suffix (.tif or .psd), because the rendered image exists only in memory until it is saved in Photoshop.

Editing in Photoshop

The image that you rendered from the Lightroom raw file DSCF0431.dng is now open in Photoshop, displaying the adjustments you made in Lightroom. In Photoshop, you'll use retouching tools to remove unwanted content, take advantage of the flexibility of layers, and add text to the image—all tasks that you can't do, or can't do as well, in Lightroom.

First, you'll remove the jet trail from the sky using some of Photoshop's effective retouching tools.

1 Choose Layer > New > Layer, and click OK in the New Layer dialog. Leave the new Layer 1 selected.

2 In Photoshop's Tools panel, select the Clone Stamp tool. In the options bar at the top of the screen, choose Current & Below or All Layers from the Sample menu, so the tool will sample source content from the layer containing the photograph. Leave the other options at their default values.

![options bar showing Clone Stamp tool settings: Mode: Normal, Opacity: 100%, Flow: 100%, Aligned, Sample: Current & Below]

3 Press the Left Bracket ([) key or Right Bracket (]) key on your keyboard to make the Clone Stamp tool brush tip slightly larger than the height of the jet trail.

 Each time you press the Left Bracket key, the size of the brush tip decreases. Each time you press the Right Bracket key, the size of the brush tip increases.

4 Hold the Alt/Option key to change the cursor to a target icon as you click a clean area of sky to load the Clone Stamp tool with pixels.

5 Release the Alt/Option key, and click the beginning of the jet trail where it touches the cloud to hide the jet trail right next to the cloud.

 The Clone Stamp tool lays down a small patch on Layer 1 without trying to blend the patch with the image. This avoids creating a visible smudge at a high-contrast edge like this, which you might get if you used Photoshop's Healing Brush tool or Spot Healing Brush tool. Those tools, unlike the Clone Stamp tool, do try to blend a patch with the surrounding area.

 You'll use Photoshop's Healing Brush tool to hide the rest of the jet trail.

6 Select the Healing Brush tool in the Tools panel. In the options bar, choose Current & Below from the Sample menu, and leave the other options at their defaults.

![options bar showing Healing Brush tool settings: Mode: Normal, Source: Sampled, Pattern:, Aligned, Sample: Current & Below]

7 Press the Left Bracket and Right Bracket keys on your keyboard to make the Healing Brush tool brush tip slightly larger than the height of the jet trail.

8 Hold the Alt/Option key, and click a clean area of sky to sample there. Then release the Alt/Option key, click just to the left of the patch you made with the Clone Stamp tool, and drag to the left over the jet trail. You can make more than one stroke and sample more than one time, as necessary.

The Healing Brush tool adds a patch over the jet trail and blends it with the surrounding sky.

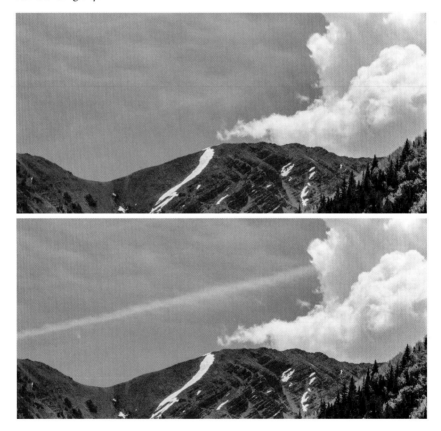

The combination of Photoshop's sophisticated retouching tools made short work of removing unwanted content in this image. Lightroom has one retouching tool—the Spot Removal tool—that offers some ability to hide content in Lightroom. However, Photoshop has multiple, feature-rich retouching tools that can be used in combination and that are the tools of choice for high-quality retouching.

Next, you'll add text to the image in Photoshop.

9 In the Tools panel, select the Horizontal Type tool. Right-click/Control-click the T icon on the left side of the options bar and choose Reset tool. In the options bar, enter **200 pt** in the Font Size field. Leave the other tool options at their default values.

10 Click in the image and type **ASPEN**.

This creates an editable Type layer in the Layers panel.

11 Select the Move tool in the Tools panel, click in the image, and drag the text into place.

Saving an RGB file from Photoshop to Lightroom

Next, apply Photoshop's Save command, causing an edited, RGB copy of the image to appear in Lightroom.

1 With the image still open in Photoshop from the preceding section, choose File > Save (or press Ctrl-S/Command-S) in Photoshop.

 Be sure to choose Save, rather than Save As, to guarantee that Lightroom recognizes the resulting RGB file as a derivative of the source file and includes it in the Lightroom catalog automatically.

 An RGB file, DSCF0431-Edit-P.tif, is saved to the same folder as its raw source file and is included automatically in the Lightroom catalog.

 Saving the file in Photoshop changed its filename to **DSCF0431-Edit-P.tif**, in accordance with the filenaming template you chose in Lightroom's External Editing preferences in Lesson 1. The **.tif** suffix confirms that this is an RGB image in the TIFF format. The **DSCF0431** prefix matches the prefix of the raw source file. **-Edit-P** is custom text you specified in the filenaming template to indicate that a file has been edited in Photoshop. The new filename now appears on the document tab in Photoshop.

2 Choose File > Close (or press Ctrl-W/Command-W) in Photoshop.

3 In Lightroom, press G to return to Grid view, and make sure the Lesson 2 folder is still selected in the Folders panel.

 Notice that there are now two versions of the image in the Lightroom catalog— the raw source file with the .dng extension, and the derivative RGB file with the .tif extension.

 The raw source file, DSCF0431.dng, displays the adjustments you made to it in Lightroom's Basic panel. Like all Lightroom adjustments, these are nondestructive edits in the form of instructions in Lightroom's catalog. So you can still change these adjustments in the raw file in Lightroom if you wish. The raw file does not contain the edits made in Photoshop.

The derivative TIFF file, DSCF0431-Edit-P.tif, displays the adjustments you made in Lightroom (the Basic panel adjustments) and the edits you made in Photoshop (removing the jet trail and adding text). The adjustments you made in Lightroom before the hand-off to Photoshop are baked into this RGB file; they can no longer be changed in Lightroom. However, the edits you made in Photoshop can be changed in Photoshop if you use the Edit Original command to re-open the TIFF into Photoshop, as you'll do later in this lesson. You can also make additional adjustments to the RGB file in Lightroom, as you'll do in the next section.

Making more adjustments in Lightroom

Once you've taken a raw file from Lightroom to Photoshop and back again, you might be finished editing and ready to export the resulting RGB image. However, you have the option to add more Lightroom adjustments to the RGB image on top of the Lightroom and Photoshop adjustments you've made so far. In this section, you'll change the color RGB image to black and white in Lightroom.

1 In Lightroom's Library module, make sure the Lesson 2 folder is still selected in the Folders panel and the RGB image DSCF0431-Edit-P.tif is selected in the grid.

2 Press V on the keyboard to convert the RGB image to black and white.

V is a shortcut for converting to black and white in Lightroom using an auto mix of tonal values. You can apply this shortcut in the Library module or Develop module.

Leave the black and white thumbnail selected in Lightroom's Library module for the next section.

Encountering a Lightroom–Camera Raw mismatch

When you open a raw file from Lightroom into Photoshop, you may encounter a mismatch warning if you don't have matching versions of Lightroom and the Camera Raw plug-in for Photoshop installed.

This version of Lightroom may require the Photoshop Camera Raw plug-in version 8.3 for full compatibility.

Please update the Camera Raw plug-in using the update tool available in the Photoshop help menu.

☐ Don't show again Cancel Render using Lightroom **Open Anyway**

When Adobe releases an update to Lightroom, it usually releases a matching update to Camera Raw with similar features, since Lightroom and Camera Raw are both raw converters that use the same conversion engine. If your versions of Lightroom and Camera Raw don't match, you may get unintended results when you pass a raw file from Lightroom to Photoshop, depending on which option you choose in the mismatch warning dialog. Knowing the consequences of each option will help you make the best choice.

- **Cancel** closes the warning dialog without passing the file to Photoshop. You can then upgrade Camera Raw, Photoshop, and/or Lightroom before trying again to pass the file to Photoshop. Upgrading the software is covered in more detail in the "Keeping Lightroom and Camera Raw in sync" section in Lesson 1.

- **Render Using Lightroom** passes the raw file to Photoshop, with Lightroom (not Camera Raw) rendering the file to pixels. Any and all adjustments you made to the raw file in Lightroom are embedded in the rendered image that opens in Photoshop. In Lightroom, an RGB image thumbnail (TIFF or PSD, depending on Lightroom's External Editing preferences) appears at this point, alongside the raw file thumbnail. After you save the rendered image in Photoshop, the RGB image in Lightroom will be updated to display your Photoshop adjustments in addition to your Lightroom adjustments. The Lightroom adjustments in the RGB image will not be editable. The advantage of Render Using Lightroom is that it ensures that all your Lightroom adjustments will be included in the rendered image. One potential downside of this option is that as soon as you click the Render Using Lightroom button in the warning dialog, an RGB copy is included in the Lightroom catalog, and it remains there even if you change your mind and decide to close the image without saving in Photoshop. In that case, you would have the extra step of deleting the RGB copy from Lightroom.

- **Open Anyway** passes the raw file to Photoshop, with Camera Raw (not Lightroom) rendering the file to pixels. This option does not guarantee that all your Lightroom adjustments will be included in the rendered image. For example, if you have a newer version of Lightroom than Camera Raw, adjustments you made with new Lightroom features may not appear in the image in Photoshop. When you save the rendered image in Photoshop, an RGB image thumbnail (TIFF or PSD) appears in Lightroom, alongside the raw file thumbnail. The Lightroom adjustments in the RGB image will not be editable. The downside of Open Anyway is that it does not ensure that all your Lightroom adjustments will be included in the rendered image. One potential upside of this option is that it does not immediately create an RGB image in the Lightroom catalog. So if you are not happy with the image that opens in Photoshop, you can close it before saving in Photoshop and there will not be an additional thumbnail to delete in Lightroom's grid.

Taking an RGB file back to Photoshop for further editing

Passing an RGB image (TIFF, PSD, or JPEG) from Lightroom to Photoshop is a different process than taking a raw file from Lightroom to Photoshop. When you hand off an RGB image, you must choose one of three options—Edit a Copy with Lightroom Adjustments, Edit a Copy, or Edit Original. In the following sections, you'll start with a TIFF or PSD in Lightroom and try each of these options to pass the file to Photoshop. Starting with a JPEG is addressed separately because JPEGs act slightly different than TIFF and PSD files.

Edit Original option

In this section, you'll start with the layered TIFF that you created in the preceding sections and pass it from Lightroom to Photoshop again to edit its type layer.

You'll use the Edit Original option, which is most useful when you're working with a TIFF or PSD that has multiple layers that you want to retain for editing in Photoshop. Another advantage of this option is that it results in one RGB file that contains all your Lightroom and Photoshop edits. The downside of this option is that your last Lightroom edits won't be visible while you're working on the image in Photoshop, as you'll see in this section.

1 In Lightroom's Library module, the Lesson 2 folder in the Folders panel should still be selected, and the black and white RGB image from the last section (DSCF0431-Edit-P.tif) should still be selected in the grid.

This layered TIFF is a derivative created from the raw file you took from Lightroom to Photoshop and back earlier in this lesson.

2 Press Ctrl-E/Command-E.

The TIFF does not open immediately in Photoshop, as a raw file would. Instead, the Edit Photo with Adobe Photoshop CC dialog (the Edit Photo dialog) appears, as it does whenever you pass an RGB image from Lightroom

to Photoshop. This dialog offers three choices, each of which produces a different result.

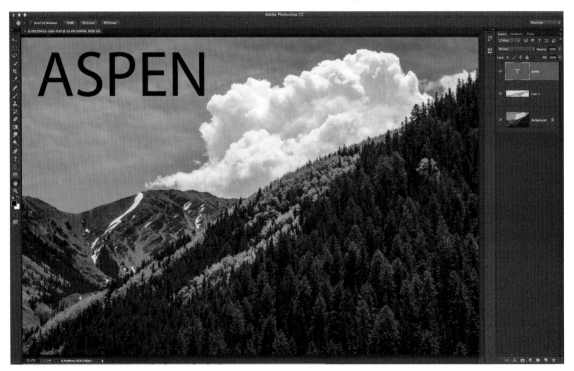

3 In the Edit Photo dialog, choose Edit Original, and click the Edit button.

When you choose Edit Original as the method for editing an RGB image:

• The RGB image opens in Photoshop with all its layers accessible in the Layers panel.

• The last round of Lightroom adjustments you made (converting the RGB image to black and white) is not visible in the image in Photoshop, so this looks like a color image in Photoshop. As you'll see in a moment, after you save in Photoshop, the Lightroom adjustment (the black and white conversion) will reappear in the image in Lightroom.

4 In Photoshop, double-click the T icon on the ASPEN type layer in the Layers panel. This selects the ASPEN type layer, selects the Horizontal Type tool, and highlights the word ASPEN in the image. In the options bar, change the font to Adobe Caslon Pro. In the image, type **Colorado** over ASPEN. Click the check mark in the options bar to commit the type edit.

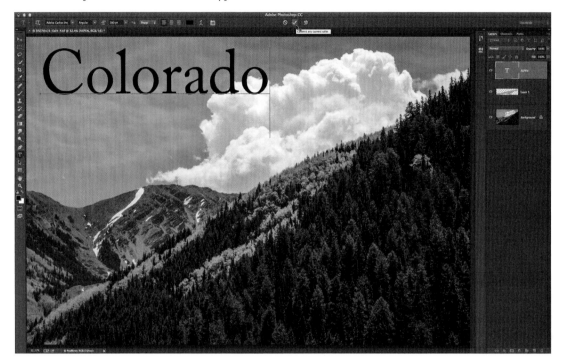

5 Press Ctrl-S/Command-S to save the edited image. Press Ctrl-W/Command-W to close the image in Photoshop.

This updates the RGB image (DSC0431-Edit-P.tif) in Lightroom with the edits you just made in Photoshop. DSC0431-Edit-P.tif is considered the "original" for this workflow.

6 Return to Lightroom.

▶ **Tip:** Whenever you save a file in Photoshop during a Lightroom–Photoshop workflow, remember to use the Save command (Ctrl-S/Command-S), not the Save As command, to ensure that the edited file will appear in Lightroom.

● **Note:** If you see an exclamation point on the image thumbnail, indicating a metadata conflict, click the exclamation point. In the dialog that appears, click the Overwrite Settings button.

In Lightroom's grid, the thumbnail of the RGB image (DSC0431-Edit-P.tif) displays the adjustments that you made earlier in Lightroom and couldn't see while working in Photoshop (the black and white conversion), as well as all your other Lightroom and Photoshop edits.

You now have two versions of the image in the Lightroom catalog:

• The RGB image (DSCF0431-Edit-P.tif) with all the adjustments you added in Lightroom and Photoshop. The last round of Lightroom adjustments (the conversion to black and white) remains editable in Lightroom.

• The raw DSCF0431.dng file with the basic adjustments you added in Lightroom at the beginning of the Lightroom–Photoshop workflow. These Lightroom adjustments remain editable on this file in Lightroom.

You'll come back to this RGB image to complete the Lightroom–Photoshop work-flow later in this lesson. But first, you'll take a look at the other two options in the Edit In dialog.

Edit a Copy with Lightroom Adjustments option

The Edit a Copy with Lightroom Adjustments option in the Edit In dialog is useful if you've made several rounds of Lightroom–Photoshop edits and you want one comprehensive RGB copy that displays all your Lightroom and Photoshop adjust-ments. However, be aware that this option flattens any existing layers in the RGB copy it creates.

1 In Lightroom's Library module, make sure the Lesson 2 folder in the Folders panel is still selected. In Grid view, select the thumbnail of the RGB image P1100132.psd (a photograph of spring tulips).

This RGB image has multiple layers: a Background layer containing the photograph and two adjustment layers that affect the colors in the image. The format of this image is PSD, its color space is sRGB, its bit depth is 16 bit, and its resolution is 72 ppi. This particular PSD is not the result of a previous Lightroom–Photoshop interaction, but the following procedure and results would be the same if it were.

2 In Lightroom, press V on the keyboard to convert the color image to black and white.

3 In Lightroom, press Ctrl-E/Command-E to pass the image to Photoshop.

4 In the Edit Photo dialog that opens, choose Edit a Copy with Lightroom Adjustments, and click Edit.

When you choose Edit a Copy with Lightroom Adjustments:

- A copy of the RGB image opens in Photoshop with the properties you set in Lightroom's External Editing preferences in Lesson 1 (Color Space: ProPhoto RGB; Bit Depth: 16 bit; Resolution: 240 ppi).

- The adjustments you made in Lightroom (the black and white conversion) are visible in the image in Photoshop.

- The multiple layers that were in the source PSD have been flattened into a single layer and applied to the image, so they are not individually accessible.

5 Add text to the image in Photoshop. In the Tools panel, select the Horizontal Type tool. In the options bar, set the Font Size field to **200 pt** and the Text Color field to white. Click in the image and type **Spring**.

6 Select the Move tool in the Tools panel, click in the image, and drag the text into place.

7 Press Ctrl-S/Command-S to save the edited image. Press Ctrl-W/Command-W to close the image in Photoshop.

This saves a copy of the image in the TIFF format (as dictated by the Lightroom External Editing preferences you chose in Lesson 1) in the same folder as the source PSD file. Saving in Photoshop also causes the TIFF copy to be imported into the Lightroom catalog.

8 Return to Lightroom.

You now have two versions of the image in the Lightroom catalog:

• The derivative TIFF image (P1100132-Edit-P.tif) with all the adjustments you added in Lightroom and Photoshop. The Lightroom adjustment in this file (the conversion to black and white) is not editable in Lightroom. The original layers that were in the RGB source image are not available in this

derivative image. If you were to open the TIFF in Photoshop using the Edit Original command, you would see only the Spring type layer you just added and the Background layer containing the photograph.

- The source PSD image (P1100132.psd) with the adjustment you added in Lightroom (the conversion to black and white), which remains editable in Lightroom in this image.

Edit a Copy option

This option is useful if you have a layered RGB image you adjusted in Lightroom and you want another copy of that RGB image with layers intact but without the Lightroom adjustments. You might use the second copy to try out a different look on the image.

1 In Lightroom's Library module, make sure the Lesson 2 folder in the Folders panel is still selected. In the grid, select the thumbnail of the RGB image P1090025.psd (a photograph of thistles).

 This RGB image has two layers: a Background layer containing the photograph and a hue-saturation adjustment layer that fine-tunes colors. The format is PSD, color space is sRGB, bit depth is 16 bit, and resolution is 72 ppi. This particular PSD is not the result of a previous Lightroom–Photoshop interaction, but the following procedure and results would be the same if it were.

2 In Lightroom, press V on the keyboard to convert the color image to black and white.

3 In Lightroom, press Ctrl-E/Command-E to pass the image to Photoshop.

4 In the Edit Photo dialog that opens, choose Edit a Copy, and click Edit.

When you choose Edit a Copy:

- A copy of the RGB image opens in Photoshop. The adjustment you made in Lightroom (the black and white conversion) is not visible in the image in Photoshop.

- The layers that were in the source PSD are visible and accessible for editing in the Layers panel.

- A copy image (P1090025-Edit-P.psd) appears in the Lightroom Library, even before you've edited or saved in Photoshop. If you change your mind about editing in Photoshop and close the image from Photoshop without saving, this copy will remain in the Lightroom catalog and you'll have the extra step of deleting it from the catalog and your computer manually.

5 Add text to the image in Photoshop. In Photoshop's Tools panel, select the Horizontal Type tool. In the options bar, set the Font Size to **200pt** and the Text Color field to white. Click in the image and type **Thistle**.

This adds a type layer in the Layers panel.

6 Select the Move tool in the Tools panel, click in the image, and drag the text into place.

7 Press Ctrl-S/Command-S to save the edited image. Press Ctrl-W/Command-W to close the image in Photoshop.

This updates the RGB copy image (P1090025-Edit-P.psd), which is already in Lightroom with the type layer you added in Photoshop.

8 Return to Lightroom.

You now have two versions of the image in the Lightroom catalog:

- The derivative RGB image (P1090025-Edit-P.psd) with all the Photoshop layers intact but without the Lightroom adjustment (the conversion to black and white). With this copy, you've started to take the image in a different visual direction than the source image.

- The source RGB image (P1090025.psd) with only the adjustment you added in Lightroom (the conversion to black and white). The Lightroom adjustment remains editable in this file.

Starting with a JPEG

When you start with a JPEG source file and use the Edit Original or Edit a Copy option to pass that file to Photoshop, you'll get different results than when you start with a PSD or TIFF file *if* you add layers to the image in Photoshop. That's because the JPEG format can't retain layers.

1 In Lightroom's Library module, select the Lesson 2 folder. In the grid, select DSCF3037.jpg (a photograph of snail shells on a roof in Provence).

Note: A develop preset is a group of saved settings that you can apply from the Quick Develop panel in the Library module or from the Presets panel in the Develop module to change the appearance of an image quickly.

2 In the Quick Develop panel on the right side of the Library module, go to the Saved Preset menu and choose Lightroom B&W Toned Presets > Sepia Tone.

This develop preset applies a sepia-toned look to the photograph.

3 With the thumbnail of the sepia-toned image still selected in Lightroom's grid, press Ctrl-E/Command-E to pass the toned image to Photoshop for further editing.

The Edit Photo dialog opens.

4 In the Edit Photo dialog, choose Edit Original, and click Edit.

The image opens in Photoshop without the Lightroom adjustment (the sepia toning) showing, just as it would if you opened a PSD or TIFF with the Edit Original option.

5 Select the Horizontal Type tool, change the Font Size field in the options bar to **500 pt**, set the Text Color field to white, and type **PROVENCE**.

This adds a type layer in the Layers panel.

6 Choose File > Save (or press Ctrl-S/Command-S).

This is where you'll see a difference when you're working with a JPEG as opposed to a TIFF or PSD. This file is not saved automatically to the same folder as the source JPEG, nor is it imported automatically to the Lightroom catalog, as it would be if you had started with a TIFF or PSD. In essence, the file you're saving is treated as a new image. Lightroom does not recognize this layered file as the original source JPEG, since a JPEG cannot have multiple layers.

Instead, the Save As dialog appears, asking where and in what format to save this file. The image is being treated as a new file that needs to be saved manually.

7 In the Save As dialog, the Save As location defaults to the same folder as the source JPEG—the Lesson 2 folder. Leave that as the location. Choose TIFF (or PSD) from the Format menu to save in a format that retains layers. Leave the Layers check box selected, and click Save. In the TIFF Options dialog, leave the options at their default values and click OK. Click OK again if you see a warning that saving with layers will increase file size.

This saves the derivative file as a TIFF, with its layers intact, but it does not automatically include that file in your Lightroom catalog.

8 Return to the grid in Lightroom to see the results:

- The source JPEG (DSCF3037.jpg) displays the Lightroom adjustment only (the sepia toning). This JPEG remains editable in Lightroom.

- The derivative TIFF file with the Photoshop type layer is not visible in Lightroom's Library.

9 To bring the derivative TIFF file into the Lightroom catalog, go to the Folders panel in the Library module, right-click/Control-click the Lesson 2 folder, and choose Synchronize Folder.

10 In the Synchronize dialog, check the Import new photos check box, leave the other options unchecked, and click Synchronize.

11 In the Folders panel in the Library module, click the Lesson 2 folder to view its contents in the grid. You now have two files in the grid:

- The derivative TIFF file (DSCF3037.tif). The TIFF contains the edit you made in Photoshop (the type layer) but not the adjustment you made to the JPEG in Lightroom (the sepia toning). The TIFF is being treated as a different image than the JPEG.

- The JPEG source file (DSCF3037.jpg). The JPEG displays the adjustment you made to it in Lightroom (the sepia toning), which remains editable in Lightroom. It does not display the type layer you added in Photoshop.

Completing the workflow in Lightroom

For this section, you'll use the derivative RGB file (DSCF0431-Edit-P.tif) as it was at the end of the earlier section "Edit Original option." This file is not included in the lesson files; it is a file you created earlier in this lesson. Let's recap the steps you followed to create this image:

- You started with a raw file (DSCF0431.dng) and adjusted it in Lightroom (making Basic panel adjustments).

- You passed the raw file to Photoshop for editing (removing the jet trail and adding the type ASPEN).

- You saved in Photoshop, generating an RGB version of the image.

- You adjusted the RGB version in Lightroom (converting it to black and white).

- You passed the RGB version to Photoshop using the Edit Original option.

- You edited the RGB version in Photoshop (changing the type ASPEN to Colorado) and saved.

Tweaking the RGB file again in Lightroom

Now make some additional adjustments to fine-tune the RGB image in Lightroom.

1 In Lightroom's Library module, make sure the Lesson 2 folder in the Folders panel is still selected. In the grid, select DSCF0431-Edit-P.tif (the black and white RGB image of a mountain overlaid with the word Colorado).

2 Press D on the keyboard to open this image in the Develop module.

3 Click the title bar of the HSL/Color/B&W panel on the right side of the Develop module to open that panel.

4 Click the Targeted Adjustment tool at the top left of the HSL/Color/B&W panel.

5 With the Targeted Adjustment tool, click in the lighter area of trees in the image and drag up to lighten the gray tones that represent colors in the original image. Repeat this in the darker area of trees.

Dragging in the image with the Targeted Adjustment tool moves corresponding color sliders in the HSL/Color/BW panel.

6 Click the title bar on the Effects panel to open that panel.

7 In the Post-Crop Vignetting section of the Effects panel, drag the Amount slider slightly to the left to darken the edges of the image.

The RGB image is complete, and you've finished the basic Lightroom–Photoshop workflow! When you are ready to make use of this image, you'll export a copy from Lightroom, as covered in the next section.

Exporting from Lightroom

There is no Save command in Lightroom. When you want a copy of an edited file for a particular use, most often you'll use Lightroom's Export command to generate a file in the format, size, color space, and other parameters that you need for that use case. Later, you can export another version of the same file with different properties.

For example, after taking an image through the Lightroom–Photoshop workflow, you might export a copy of the edited file as a small JPEG to post online—as you'll do in this section—and later as a large TIFF to send to a print shop. This is possible because your adjustments are stored as information in the Lightroom catalog and are not applied directly to a photograph until you output a copy of an image from Lightroom.

Note: This lesson has taken you through the basic Lightroom–Photoshop workflow using Photoshop as Lightroom's primary external editor. There are some other, more specialized workflows available in Lightroom's Edit In menu—Open as Smart Object in Photoshop, Merge to Panorama in Photoshop, Merge to HDR Pro in Photoshop, and Open as Layers in Photoshop—which are covered later in this book.

Note: Export is not Lightroom's only output feature. There are other ways to output—as a book, a slideshow, a print, or a web gallery. For more on those features, see the *Lightroom 5 Classroom in a Book*.

Note: The Export command is available in all of Lightroom's modules. For example, to export from the Develop module, select one or more images in the Filmstrip and choose File > Export.

Note: The Email option in the Export To menu lets you export files as direct attachments to your default email client. A simpler way to attach exported images to an email message is to export them with the Hard Drive option and then use your email client to attach them to a message.

1 In Lightroom's Library module, select the Lesson 2 folder. In the grid, select DSCF0431-Edit-P.tif (the RGB image as it looked at the end of the last section). This is the image you took through the complete Lightroom–Photoshop workflow during this lesson.

2 Choose File > Export, or click the Export button at the bottom left of the Library module.

This opens the large Export dialog. The Preset column on the left offers some combinations of Export settings that ship with Lightroom, along with any Export presets that you've created. In this section, you'll fill out the fields in the Export dialog manually and then save them all as a preset.

3 Click the Export To menu at the top of the Export dialog, and choose Hard Drive.

Tip: Another useful choice in the Export To menu is Export To Same Folder as Original. The exported copies will not write over the originals.

4 Open the Export Location section of the dialog by clicking its title bar. In the Export Location section:

 • Choose Export To > Specific Folder.

 • Click the Choose button and navigate to your desktop.

 • Check the Put in Subfolder check box, and type **Exported Photos** as the name of the subfolder.

- Leave Add to This Catalog unchecked.

 Checking the Add to This Catalog check box would automatically import the exported copy of the image to the Lightroom catalog. Oftentimes, there is no need to import this copy to the catalog, because you have the master file in the catalog from which you can always output another copy.

5 Open the File Naming section of the dialog by clicking its title bar. In the File Naming section, leave the Rename To check box unchecked to retain the filename of the original in the exported copy.

 If you want to change the name of images you're exporting, checking Rename To makes the Filename menu accessible. Here you have the same file naming template system as in Lightroom's External Editing preferences, which was covered in Lesson 1 in the "Setting the file naming preference" section.

6 Open the File Settings section of the dialog by clicking its title bar. In the File Settings section:

- Choose JPEG from the Image Format menu to export photos for web use or to send by email.

- Drag the Quality slider to 75 to set the JPEG compression quality. The higher the number, the less compressed the file will be, the better its quality will be, and the more space it will take up on disk. A setting of 75 is usually fine for web use.

- Choose sRGB from the Color Space menu, which is the best color space for a photograph destined for online use.

 Exporting with one of the other, wider color spaces can cause a photograph to look dull when viewed online.

> **Tip:** If you need to limit the file size of an image on disk, in the File Settings section, check the Limit File Size To check box and type your maximum size in kilobytes.

▶ **Tip:** If you're exporting small images and you don't want them to be enlarged past their original size, select the Don't Enlarge check box in the Image Sizing section of the Export dialog.

7 Open the Image Sizing section of the dialog by clicking its title bar. In the Image Sizing section:

- Check the Resize to Fit check box.

- Choose Long Edge from the menu to the right of the Resize to Fit check box.

- Set the measurement field to Pixels (the best choice for images bound for the web), and type **600** in that field to export an image that is 600 pixels wide on its longest edge, whether that's height or width.

- Leave the Resolution field at its default value.

 When you're exporting images for online use, it doesn't matter what number is in this Resolution field, because resolution here refers to the number of pixels per printed inch if the photograph were to be printed. If you're exporting for print, use the image resolution that is best for your printer. 300 pixels per inch (ppi) is adequate for most desktop inkjet printers.

▼ Image Sizing		
☑ Resize to Fit:	Long Edge ⬍	☐ Don't Enlarge
	600 pixels ⬍	Resolution: 72 pixels per inch ⬍

▶ **Tip:** This Output Sharpening section is for final output sharpening. It sharpens on top of any capture or creative sharpening you've already done in Lightroom's Details panel or in Photoshop. If you know you'll be exporting images from Lightroom, don't go overboard on sharpening elsewhere in Lightroom or Photoshop.

8 Open the Output Sharpening section of the dialog by clicking its title bar. In the Output Sharpening section:

- Check the Sharpen For check box, and choose Screen from the menu to the right.

 If you were exporting an image to be printed, you would choose Sharpen For > Matte Paper or choose Sharpen For > Glossy Paper, depending on the kind of paper on which you were printing.

- Choose Amount > Standard.

▼ Output Sharpening		
☑ Sharpen For:	Screen ⬍	Amount: Standard ⬍

9 Open the Metadata section of the dialog by clicking its title bar. In the Metadata section, choose Copyright & Contact Info Only from the Include menu.

 Reducing the amount of metadata keeps the file size smaller and addresses privacy concerns.

▼ Metadata	
Include:	Copyright & Contact Info Only ⬍
	☑ Remove Location Info
	☐ Write Keywords as Lightroom Hierarchy

⬤ **Note:** Copyright information is embedded in the metadata of the file you export, but it does not appear across the face of the photo. If you want to mark your photos with copyright information or your logo, go to the Watermark section of the Export dialog, where you can create and apply text and graphic watermarks.

10 Open the Post-Processing section of the dialog by clicking its title bar. In the Post-Processing section, choose After Export > Show in Explorer/Show in Finder.

This will open the location of the exported files in your operating system when the export is complete.

Tip: The After Export menu also offers options to open in Adobe Photoshop. These options are an alternative to the more integrated round-trip workflow detailed in this lesson.

11 Click Add at the bottom of the Preset column.

12 In the New Preset dialog that opens, type **Online Photos** as the Preset Name, choose User Presets from the Folder menu, and click Create.

This saves the combination of settings you just chose as a preset that you can quickly apply to any photos you're exporting in the future. When you want to apply a preset to other images, you'll click the preset name in the User Presets section of the Export dialog or choose File > Export with Preset.

13 Click Export at the bottom of the Export dialog.

A JPEG copy of the image is exported to the Exported Photos folder on your desktop with the properties you chose. An Explorer/Finder window launches automatically to show you the exported JPEG.

An alternative Lightroom–Photoshop workflow

Throughout this lesson, you used Lightroom's Edit In commands to pass photographs from Lightroom to Photoshop automatically. You have the option to avoid the Edit In commands altogether. Instead, you can share photographs between Lightroom and Photoshop the manual way:

1 Adjust one or more images in Lightroom.

2 Export them from Lightroom in a nonlossy format, such as TIFF or PSD.

3 Open the exported files in Photoshop for further editing.

4 When you save from Photoshop, the resulting edited images are not automatically imported into Lightroom. If you want to include them in your Lightroom catalog for management purposes, use Lightroom's Import or Synchronize Folder commands.

Review questions

1 What is the keyboard shortcut for Photo > Edit In > Edit in Adobe Photoshop CC (or the latest version of Photoshop installed on your computer)?

2 When you hand off a raw file from Lightroom to Photoshop by pressing Ctrl-E/Command-E, which program is rendering the photograph so you can see and work with it in Photoshop?

3 After you pass a raw file from Lightroom to Photoshop and save it in Photoshop, what format file appears in your Lightroom catalog alongside the raw file?

4 When you pass a TIFF or PSD from Lightroom to Photoshop using the Edit Original command, can you see in Photoshop the last adjustments you made to that image in Lightroom?

5 Is there a Save command in Lightroom?

Review answers

1 Ctrl-E/Command-E.

2 The Camera Raw plug-in for Photoshop does the rendering when you pass a raw file from Lightroom to Photoshop by pressing Ctrl-E/Command-E.

3 Passing a raw file from Lightroom to Photoshop and saving it in Photoshop generates a TIFF or PSD RGB file, depending on your choice in Lightroom's External Editing preferences. The TIFF or PSD appears automatically in the Lightroom catalog.

4 No. When you hand off an RGB file from Lightroom to Photoshop using the Edit Original option in the Edit Photo dialog, the last round of adjustments you made in Lightroom will not appear in the image that's open in Photoshop. However, when you save in Photoshop, the Lightroom adjustments will be visible in the resulting image in Lightroom.

5 No. There is no Save command in Lightroom. The Export command is the closest thing to Save. When you want a copy of a photograph for a particular purpose, use the Export dialog to set the format, size, filename, color space, and other properties with which you'll export a copy of the master file.

3 MANAGING PHOTOS IN LIGHTROOM'S LIBRARY MODULE

Lesson overview

A major reason to use Lightroom with Photoshop is to take advantage of the efficient photo management features in Lightroom's Library module to organize and find your photographs. This lesson covers the most important of Lightroom's photo management features. Topics in this lesson include:

- Using the Library module workspace
- Rating photographs with flags, stars, and color labels
- Organizing photographs with collections
- Keywording photos
- Moving files and folders

 You'll probably need from 1 to 2 hours to complete this lesson.

Photograph © Jan Kabili 2012

Lightroom's Library module is an efficient asset manager that offers multiple ways for you to keep track of your growing library of photographs.

Preparing for this lesson

Do the following to prepare for this lesson:

1 Make sure you've followed the instructions in the Getting Started lesson at the beginning of this book for setting up an LPCIB folder on your computer, downloading the lesson files to that LPCIB folder, and creating an LPCIB catalog in Lightroom.

2 If the Lesson 3 files are not already on your computer, download the Lesson 3 folder from your account page at www.peachpit.com to *username*/Documents/LPCIB/Lessons.

3 Open the LPCIB catalog you created in the Getting Started lesson by doing the following: Hold the Alt/Option key as you start Lightroom; then in the Select Catalog dialog, select the LPCIB Catalog.lrcat file, and click the Open button.

4 Import the Lesson 3 files into the open LPCIB catalog following the bullet steps below. This is similar to the process for importing any photographs that are already on a drive (see "Importing from a drive" in Lesson 1 for more details).

- Click the Import button in the Library module.

- In the Import window's Source panel, navigate to *username*/Documents/LPCIB/Lessons, and select the Lesson 3 folder. Make sure the Include Subfolders check box at the top of the Source panel and to the right of the Files label is checked.

- In the Import window's workflow bar, choose Add as the import method.

- Leave all the thumbnails in the Import window checked.

- In the File Handling panel on the right side of the Import window, choose Build Previews > Standard. Leave the other File Handling options unchecked.

- In the Apply During Import panel on the right side of the Import window, enter **Lesson 3** in the Keywords field.

- Click the Import button at the bottom right of the Import window.

5 In the Library module, select the Lesson 3 subfolder in the Folders panel.

The Library module workspace

The Library module has columns of panels on the left and right and a center area where image previews are displayed.

Source panels on the left

The column on the left side of the Library module contains panels in which you choose the source of the photographs that appear in the preview area. For example, in the Catalog panel, selecting All Photographs displays previews of all items in this Lightroom catalog. In the Collections panel, selecting a collection displays the items that have been included in that collection. In the Folders panel, selecting a folder displays previews of all items in that folder and its subfolders by default. The left column in the Library module also has a Navigator panel to help you zoom and pan a selected preview in the Library module.

The Folders panel

The Folders panel offers the simplest method of organization. It allows you to view previews of photographs according to the folders in which the actual photographs are stored on your drives. Selecting a folder in the Folders panel displays all imported items in that folder and its subfolders.

1 Click the header on the Folders panel to expand that panel if it is not already open.

A thick bar in the Folders panel represents a volume or drive, which contains items that have been imported into this Lightroom catalog. The green icon on a volume bar means that volume is currently online.

2 Select the Lesson 3 folder in the Folders panel, if you haven't already done so.

Selecting the Lesson 3 folder displays all photographs located in that folder and its subfolders.

3 Click the arrow to the left of the Lesson 3 folder in the Folders panel to expand the Lesson 3 folder.

This reveals a subfolder—the Cat subfolder.

4 Select the Cat subfolder in the Folders panel.

Now you see only one photograph in the center area—a photograph of a house cat. That photograph is located inside the Cat subfolder.

5 Select the Lesson 3 folder in the Folders panel to see all the photographs in that folder and its subfolder again.

▶ **Tip:** The Folders panel doesn't display all the folders on your computer. It focuses on those folders that contain items you've imported into this catalog. This keeps the Folders panel manageable. If you want to view more of the folder hierarchy, right-click/Control-click the top-level folder in your Folders panel and choose Show Parent Folder. To hide a top-level parent folder, right-click/Control-click that parent folder and choose Hide Parent Folder.

Information panels on the right

The panels in the column on the right side of the Library module are where you'll go to get information about, or to add information to, items you've imported into a Lightroom catalog.

The Histogram panel

The Histogram panel gives you information about the tonal values in your photograph, from bright tonal values on the right side of the histogram to dark tonal values on the left. The color and gray areas show you where the tonal values in each channel of the selected image fall on the histogram. Under the histogram, you can see essential exposure information at a glance—the ISO, lens length, f-stop, and shutter speed with which the photograph was captured.

▶ **Tip:** You may find it helpful to have only one panel open at a time, particularly when you're working in panels in the column on the right. To set that up, right-click/Control-click the header on any panel in the right column and choose Solo Mode.

The Histogram panel in the Library module is convenient to consult while you're reviewing photos. There's also an interactive histogram in the Develop module to guide you as you process photographs in that module.

The Quick Develop panel

Most photo processing is done in Lightroom's Develop module, but the Library module has a Quick Develop panel that comes in handy for applying quick adjustments to multiple photographs as you're reviewing photographs from a shoot.

Quick Develop adjustments are unique in that they apply relative, rather than absolute, adjustments. For example, if you select three photo thumbnails in the Library module and in the Quick Develop panel click the Exposure button with the left-facing triangle, the exposure of each photograph will decrease by 1/3 of a stop relative to the current exposure value of that photograph. So each of the photographs could end up with a different absolute exposure value. By contrast, if you were to adjust the exposure of one photograph in the Develop module and sync that change to two other photos, all the photographs would end up with the same absolute exposure value.

The Quick Develop panel also offers a Saved Presets menu from which to apply develop presets (saved combinations of develop settings) to one or more selected thumbnails. This is a quick alternative to applying develop presets from the Presets panel in the Develop module.

The Keyword panels

There are two panels related to keywords in the column on the right side of the Library module.

The Keywording panel is useful for creating and applying keywords to selected photographs all in one step. It's also useful when you want to see which keywords have been applied to selected photographs.

The Keyword List panel displays a list of all existing keywords in the catalog. It's useful for creating and organizing keywords in a catalog.

Creating, applying, and searching by keywords is covered in more depth later in this lesson, in the "Keywording" section.

The Metadata panel

The Metadata panel displays lots of information about selected photographs. Some of that information, like the camera settings with which a photograph was captured, comes from the camera. Some information, like copyright, can be added to a photograph in the Metadata panel. You also can change a photograph's metadata in the Metadata panel. For example, you can change the name of a selected photograph by entering a new name in the File Name field.

The toolbar

The toolbar at the bottom of the Library module contains tools you'll use frequently as you work with photographs in the Library module. The default tools include image preview options, a menu for sorting previews, icons for applying flags and stars, and a thumbnail size slider.

1 Select the Lesson 3 folder in the Folders panel.

2 If you don't see the toolbar at the bottom of the Library module, press T on your keyboard to display the toolbar.

It's common to inadvertently press T on the keyboard, causing your toolbar to go missing. Pressing T again will bring it back into view.

3 Drag the Thumbnails slider on the toolbar to the right to make the thumbnail previews in the Library module larger. Dragging this slider to the left makes the thumbnails smaller so you can see more image previews.

4 The Library module toolbar also contains icons for accessing different views of images in the Library module:

- Click the Loupe view icon (or press E on the keyboard) to see a large preview of a selected photograph.

> **Tip:** Don't mistake L as the shortcut for Loupe view. (The shortcut for Loupe view is E.) L cycles through Lights Out views, which allow you to view images against backgrounds of varying darkness. Press L once to dim lights, press L again to turn lights off, and press L one more time to turn lights on again.

- Click the Grid view icon (or press G on the keyboard) to view thumbnail-sized previews of images in the source in a grid arrangement.

> **Tip:** The shortcuts E for Loupe view and G for Grid view are worth committing to memory. You'll use these time-saving shortcuts often as you review photographs in the Library module.

- Click the Compare view icon (or press C on the keyboard) for a view that compares one image in the source to another.

- Click the Survey view icon (or press N on the keyboard) for a view that is useful for comparing multiple previews at once.

5 Click the triangle on the right side of the toolbar to open a menu of toolbar options to customize the toolbar. Select Color Label from that menu.

Color label icons now appear on the toolbar. You can use color labels to mark related photographs, as you'll do later in this lesson in the section "Using color labels."

The toolbar has a Sort menu you can use to change the order of preview thumbnails in the Library module. You can sort by parameters like Added Order, Capture Date, or File Name. If the source you've chosen does not contain subfolders, you can click and drag thumbnail previews in the grid to change their sort order. To do this, you must click the image, rather than the frame, in a thumbnail.

The Filmstrip

The Filmstrip, which appears at the bottom of the Library module and other modules, displays thumbnails of all the photographs in the selected source.

The bar at the top of the Filmstrip contains useful tools and information, including the name and folder/collection of a selected image, and the Go Back and Go Forward icons for moving among sources you've accessed.

The Filmstrip is useful as a place to select images in the Library module when the Library module is set to Loupe view, Compare view, or Survey view. When the Library module is set to Grid view, the Filmstrip can be redundant, so you may want to hide the Filmstrip to gain more working space. To hide the Filmstrip, click the thin black border at the bottom of the Library module. Click again to show the Filmstrip.

The Module Picker

The bar at the top of the screen contains the Module Picker. To switch between modules, click the module label in the Module Picker (or press a keyboard shortcut, like D for the Develop module or G for the Library module). You may want to hide this bar to gain more space to view image previews in the Library module. To hide the Module Picker bar, click the thin black border near the up-facing triangle at the top of the screen. To show the Module Picker bar, click there again.

Zooming and panning

Clicking an image when it is displayed in Loupe view or Compare view in the Library module toggles (by default) between Fit view, which displays the entire photograph in the preview area, and 1:1 view, which is critical for evaluating sharpness and noise. Other zoom options can be selected from the drop-down menu at the far right of the Navigator panel header.

When you are zoomed in to 1:1 view, the entire image is often too large to see in the preview area. In that case, you can pan around the image using either of two methods: drag the image in the preview area, or click the bounding box in the Navigator panel and drag.

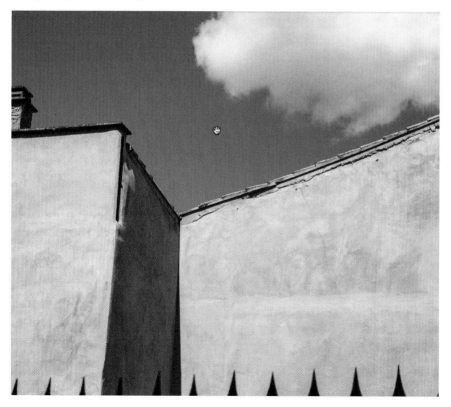

Selecting

Selecting a preview in the Library module identifies that image as one that will be affected by an action you perform. Selecting is slightly different in Lightroom than in other applications because in Lightroom, if you select multiple previews, one of those is considered "most selected." If you synchronize settings or copy and paste settings among selected images, the most selected preview will be the source of those settings.

1 With the Lesson 3 folder still selected in the Library module's Folders panel, press G for Grid view.

2 Click DSC0075.jpg (a photograph of lavender) in the grid to select that image.

3 Press V on the keyboard to convert DSC0075.jpg to black and white.

V is the shortcut for converting to black and white in the Library module and in the Develop module.

4 With DSC0075.jpg still selected, Ctrl-click/Command-click the next two previews in the grid.

The frame around the first preview you selected (DSC0075.jpg) is highlighted in the brightest tone. The frames around the other two selected photographs are highlighted in a slightly darker tone. Frames of unselected previews are not highlighted and appear darkest.

5 Press D on the keyboard to switch to the Develop module.

The most selected image (DSC0075.jpg) is the one that opens into the Develop module for editing.

6 If the Filmstrip is not open in the Develop module, click the thin black border at the bottom of the screen to show the Filmstrip.

In the Filmstrip, all three photographs you selected in the Library module are selected, and the most selected preview (DSC0075.jpg) has the brightest frame.

7 Click the Sync button at the bottom of the right panel in the Develop module.

8 In the Synchronize Settings dialog that appears, click Check None. Then check the Treatment (Black & White) check box and the Process Version check box. Click Synchronize.

These settings are synchronized from the most selected image to the other two selected images.

▶ **Tip:** There are other useful select commands in the Library module. To select a range of previews in the Library module, click the first preview and Shift-click the last preview in the range. To select all the previews, choose Edit > Select All (or press Ctrl-A/Command-A on the keyboard). To deselect all, press Edit > Select None (or press Ctrl-D/Command-D on the keyboard). To remove one preview from a selection of multiple previews, Ctrl-click/Command-click that preview.

9 Press G to return to Grid view in the Library module.

10 Press Ctrl-D/Command-D to deselect all the previews.

Selecting the thumbnail frame

It's a good idea to get in the habit of selecting a thumbnail by clicking its frame rather than clicking directly on the image in the thumbnail. That's because clicking directly on the image can have unexpected consequences:

1 In Grid view of the Library module, select the first thumbnail preview (DSC0075.jpg), which is now black and white. Ctrl-click/Command-click anywhere on the next two thumbnail previews to select them too.

2 Click directly on the image in the second selected preview.

You might expect step 2 to leave only the second preview selected, deselecting the two other previews, because that is the common behavior in other applications, like Adobe Bridge. But that is not what happened. Instead, clicking directly on the image in the second preview switched most selected status from the first to the second preview; the second preview is now highlighted in the brightest tone.

3 Press Ctrl-D/Command-D to deselect all.

4 Repeat step 1 to select three previews in Grid view again.

5 Click the frame, rather than the image, in the second preview.

The result is different than it was in step 2. Clicking the frame, rather than the image, in the second preview left only the second preview selected and deselected the other two previews.

Routinely clicking the frame rather than the image in a preview will allow you to avoid being surprised by the less common behavior you saw in step 2.

Customizing the Library module

You can customize your view of the Library module in several ways. You've already seen that you can choose between different image previews (Grid view, Loupe view, Compare view, and Survey view), and that you can darken the area around images by pressing L to cycle through Lights Out views. You can also cycle through screen views by pressing Shift-F on your keyboard. (Pressing F will take you directly to Full Screen mode.)

If you need more room to work, you can collapse the panels on the right and left sides of the Library module by pressing Tab. To collapse all the panels and bars, for maximum viewing space, press Shift-Tab. Press Shift-Tab again to bring the panels and bars back into view.

To collapse just one of the columns or bars, click the thin black border just outside that column or bar. The default behavior is to Auto Hide & Show columns and bars when you move your cursor near them. For more control, you may prefer to change that behavior to Manual. To do that, right-click/Control-click each outer border and choose Manual from the menu that appears.

Ranking photographs

Lightroom offers multiple ways to rate your photographs. You can apply flags, stars, or color labels to differentiate photos. You do not have to use all these features. Come up with a rating system that uses criteria that are meaningful to you and that is simple enough that you will apply it consistently. There are several ways to apply flags to photographs in the Library module. The fastest method is to use keyboard shortcuts: P to add a Pick flag, X to add a Reject flag, and U to unflag a flagged image.

Using flags

You can apply white Pick flags or black Reject flags to photos as you review them in the Library module. A simple way to make a first cut of your photographs after a shoot is to mark those you like best with a Pick flag, mark those that you have no use for with a black Reject flag, and leave the rest unflagged.

1 With the Lesson 3 folder selected in the Folders panel, press G for Grid view.

2 To simulate starting with a fresh batch of photographs after a shoot, remove the adjustments you added to some of the images in this folder. Select those thumbnails and choose Photo > Develop Settings > Reset.

3 Make a quick first pass through your photographs, looking for any images you have no use for. Select the thumbnails of those images and press X on the keyboard. A black flag icon appears in the upper-left corner of the thumbnails. Press Ctrl-D/ Command-D to deselect all, and the rejected thumbnails appear faded in Grid view.

If you don't see the black flag on thumbnails of rejected images in Grid view, press the J key to cycle through thumbnail views.

4 Make another pass through your photographs in Loupe view, which gives you a larger view of each image. Select the first thumbnail in Grid view and press E on the keyboard to open it in Loupe view.

5 To add a Pick flag to that image, press the P key.

Flags do not appear on previews in Loupe view, so you won't see the white Pick flag on the image here, although the white flag icon will be highlighted in the toolbar and will appear on the thumbnail when you view this image in Grid view.

6 Press the Right Arrow key on the keyboard to cycle to the next image in Loupe view. This isn't a favorite, but it isn't a reject either. Leave this image unflagged.

7 Continue in this way through all the photos in the source folder, pressing P when you come to a favorite, and pressing X when you come to a reject. If you change your mind about a flag after you've added it, press U to unflag it.

8 You can use the Library module's Attribute filters to find photographs based
 on their flagged status. Press the Backslash key (\) on the keyboard to open the
 Library Filter bar at the top of the screen.

9 In the Library Filter bar, click Attribute to access the Attribute filters. Then
 click the white flag icon in the Attribute bar to display only photographs you've
 marked with a white Pick flag.

The Attribute filters let you quickly filter photos in a selected source based on
flags, ratings, and labels. This is a quick way to find photos you've rated. If you
want to see only photos you marked as rejects, first click the white flag filter to
disable it, and then click the black flag filter in the Attribute bar. If you want to see
all photos you marked with either a white Pick flag or a black Reject flag, make
sure both the white and black flag filters are highlighted in the Attribute bar.

With the Lesson 3 folder selected in the Folders panel, the filter is considering only items in that folder. If you want to see photos you marked with a white Pick flag throughout your catalog, first select All Photographs in the Catalog panel and then click the white flag filter in the Attribute bar.

10 To turn the filters off, click the menu on the far right of the Library Filter bar and choose Filters Off.

All the photographs in the selected source reappear in the grid.

11 Press the Backslash key (\) on your keyboard to close the Library Filter bar.

Using star ratings

You also have the option to rank your photographs with star ratings. You could use all the star ratings, from 1 through 5, or just keep things simple and use a five star rating in addition to a white Pick flag to mark those photos that are your very best.

● **Note:** If you want to see star ratings on thumbnail previews in Grid view, choose View > View Options in the Library module. With the Grid View tab selected in the Library View Options dialog, go to the Expanded Cell Extras section of that dialog and check the Show Rating Footer check box. Close the dialog. In Grid view, press J on your keyboard to cycle through thumbnail views until you see star ratings under the photographs you've marked with stars.

1 In Grid view of the Library module, select two of the photographs to which you added a white Pick flag. Press 5 on your keyboard to add a five star rating to those two photographs. Press Ctrl-D/Command-D to deselect all thumbnails.

2 Reopen the Library Filter bar (press the Backslash key) and the Attribute bar (click Attribute in the Library Filter bar).

3 In the Attribute bar, click the white flag icon.

The filter again displays all photographs in the selected source that you marked with a white Pick flag.

4 Click the fifth star from the left in the Attribute bar to narrow the results further to just those photographs you marked with both a white Pick flag and five stars.

▶ **Tip:** To remove all stars from a photograph, select its thumbnail and press 0 on the keyboard.

If you don't see stars under your photographs, press the J key on the keyboard several times to cycle through thumbnail views.

You can change the number of stars on a photograph by selecting its thumbnail and pressing a different number on your keyboard, such as 1 for one star.

5 To turn off all filters so all photographs in the source folder are showing, click the menu on the far right of the Library Filter bar and choose Filters Off.

Using color labels

You can apply color labels to photo thumbnails to identify photographs that go together for any purpose you have in mind. A typical use of color labels is to mark a series of bracketed photographs you plan to blend into one HDR (high dynamic range) image, or photographs that were shot as a panorama. You might also use color labels to indicate the stage a photo has reached in your photo workflow (reviewed, adjusted, printed, and so on). Labels are also useful for identifying which photographs a client has selected, ordered, or purchased.

1 With the Lesson 3 folder selected in the Folders panel, select two photo thumbnails in the preview area.

2 Click the purple color label icon in the toolbar at the bottom of the screen to apply that color label to the selected previews.

If you don't see the toolbar, press T on the keyboard. If you don't see color label icons on the toolbar, click the triangle on the right side of the toolbar and choose Color Label.

3 Press Ctrl-D/Command-D to deselect all the thumbnails so you can better see the purple label on the thumbnail frames.

> **Tip:** To remove a color label, select a photo thumbnail and click the color label icon in the toolbar again.

4 To view only photos with a purple color label, filter on that label in the Library Filter bar.

- Press the Backslash key (\) on the keyboard to re-open the Library Filter bar.

- Click Attribute in the Library Filter bar.

- Click the purple color label icon to limit the display to just those photographs with a purple label.

5 To turn off all filters so all photographs in the source folder are showing, click the menu on the far right of the Library Filter bar and choose Filters Off. Press the Backslash key (\) to close the Library Filter bar.

Organizing with collections

Collections are a powerful, flexible way to manage photographs in your Library module. A collection is a virtual grouping of items in a Lightroom catalog. The photographs in a collection do not have to be in the same folder or even on the same drive. Including a photograph in a collection does not move it from its folder location or make an actual copy of it; it just displays a virtual preview of the photograph in the collection. So the same photograph can appear in more than one collection, and removing a photograph from a collection does not remove it from the catalog or delete it from your drive.

Rather than create lots of subject matter collections that may be redundant of the organizing you've done with other features, like keyword tags and folders, consider using collections to group items that are located in different folders but that you want to see together. These might be photographs for a particular project or portfolios of your best work.

There are two kinds of collections: manual collections, which you populate, and smart collections, which populate themselves automatically based on your rules.

Creating collections

1 With the Lesson 3 folder selected in the Folders panel, select some photographs to include in a collection of photographs for a project, such as photographs you plan to print or upload to a website. Click one thumbnail, then Ctrl-click/Command-click a few others.

2 Go to the Collections panel on the left side of the Library module, click the Plus icon (+) on the upper-right of the Collections panel, and choose Create Collection.

3 In the Create Collection dialog, enter **France photos to print** as the name of the new collection and check the Include Selected Photos check box. Click Create.

This creates a new collection in the Collections panel.

4 Click the France Photos to Print collection in the Collections panel to view its contents in the preview area of the Library module.

Note: You can add one or more photographs to an existing collection. Select one or more thumbnails in the Grid or in the Filmstrip; then click directly on the image (not the frame) of one of the selected thumbnails, and drag and drop onto the collection in the Collections panel.

5 Follow steps 1 through 3 again, this time making a collection labeled **France photos for website**. Include some but not all of the same photographs that are in your France Photos to Print collection, so you can see that the same photograph can appear in numerous collections.

Create Collection Set

Name: France projects

Location

☐ Inside a Collection Set

Cancel Create

6 Click the Plus icon (+) at the upper right of the Collections panel, and choose Create Collection Set. In the Create Collection Set dialog, name the new collection set **France projects** and click Create.

Create Collection Set

Name: France projects

Location

☐ Inside a Collection Set

Cancel Create

7 In the Collections panel, click the France Photos for Website collection and Ctrl-click/Command-click the France Photos to Print collection. Drag and drop both selected collections onto the France Projects collection set to include them in that set.

▼ Collections — +.
 ▼ 🎞 France projects
 ▷ ▭ France photos for website 2
 ▷ ▭ France photos to print 5
 ▶ 🎞 Smart Collections

8 Click the arrow to the left of the France Projects collection set to collapse that set. This keeps your Collections panel shorter and more manageable.

With the France Projects collection set selected in the Collections panel, all the photographs in both collections that are inside this set are visible in the preview area.

The purpose of collection sets is to keep the Collections panel organized. Putting these collections into this collection set did not move, copy, or otherwise affect the actual photographs referenced in these collections.

Building smart collections

Smart collections automatically populate themselves with photographs that meet particular rules. Once you've created the rules, your work is finished. Every time a new photograph meets those rules, it is added automatically to the smart collection. A common use for a smart collection is to create an automatically updating portfolio of your best work based on ratings you've given photographs.

1 Click the Plus icon (+) on the Collections panel, and choose Create Smart Collection.

2 In the Create Smart Collection dialog that opens, name the smart collection **My best photos**.

3 In the Location area of the Create Smart Collection dialog, check the Inside a Collection Set check box and choose Smart Collections from the drop-down menu.

4 From the Match menu above the rules, select All, so that this instruction reads "Match all of the following rules."

5 Create the first rule by doing this: Click the first menu and choose Rating. Click the second menu and choose Is. Click the fifth star so that five stars are bold. This rule now reads "Rating is [five stars]."

6 Click the Plus icon (+) to the right of the first rule to add a second rule.

7 Create the second rule by doing this: Click the first menu in the second rule and choose Pick Flag. Click the second menu in the second rule and choose Is. Click the third menu in the second rule and choose Flagged. This rule now reads "Pick Flag is flagged."

This smart collection is now set up to include any photograph in the catalog that has both a five star rating and a Pick flag.

8 Click Create.

9 In the Library module, make sure the new My Best Photos smart collection is selected inside the Smart Collections collection set.

The photographs that meet the rules of this smart collection (those with both a five star rating and a Pick flag) have been included automatically in this smart collection and are displayed in the preview area.

10 Select the Lesson 3 folder in the Folders panel.

11 In the preview area, add both a Pick flag and five stars to a photograph that does not have those ratings yet.

12 In the Collections panel, again select the smart collection labeled My Best Photos. The photograph to which you just added a Pick flag and five stars has been added automatically to this smart collection and is displayed in the preview area.

As you add new photos to the catalog in the future, those to which you apply a Pick flag and five stars will be automatically added to this smart collection.

Now that you know how to build a smart collection, explore each of the menus in the Create Smart Collection dialog to get a sense of the more detailed rules you could create by combining the many variables offered there.

▶ **Tip:** Open a few of the prebuilt smart collections that come with Lightroom to see how they are built and to get ideas for your own smart collections. To do that, right-click/Control-click a smart collection inside the Smart Collections collection set in the Collections panel and choose Edit Smart Collection. Click Cancel when you're ready to close the Edit Smart Collection dialog.

Keywording

Keyword tags are among the most powerful ways to keep track of photographs by subject matter in the Lightroom library. You can apply multiple keywords to the same photographs to increase your chances of locating that particular photograph among the thousands you may have in your Lightroom catalog.

Creating keywords

The secret to using keyword tags efficiently is to create keywords that are meaningful to you and that you will be likely to use as search terms when you're looking for particular photographs.

The Keyword List panel in the Library module displays all the keywords in a catalog. You'll start here by setting up some top-level keywords that act as categories and some specific keywords relevant to your photographs. You'll add more keywords and categories as your photo library grows.

1 Click the header on the Keyword List panel to open that panel.

 If you've been following along in the first three lessons, you'll see three keywords: Lesson 1, Lesson 2, and Lesson 3. You created those keywords as you imported photographs for those lessons.

2 Click the Plus icon (+) on the upper left of the Keyword List panel to open the Create Keyword Tag dialog.

3 In the Create Keyword Tag dialog, enter **PLACES** in the Keyword Name field, leave the other settings at their default values, and click Create.

Create Keyword Tag

Keyword Name: PLACES

Synonyms:

Keyword Tag Options
☑ Include on Export
☑ Export Containing Keywords
☑ Export Synonyms

Cancel Create

In the Keyword List panel there is now a new keyword, PLACES. A general, top-level keyword like this can do double duty, also serving as a category in which to nest more specific keywords.

4 Create two specific keywords the same way: **France** and **Villefranche** (which is a town in France). Then drag France on top of PLACES and Villefranche on top of France.

 You've started to build a hierarchy of keywords. Creating top-level keywords and simple keyword hierarchies (that don't grow too deep) will help you keep your keyword list organized.

5 Create some more top-level and specific keywords the same way, and drag the specific keywords into the top-level categories.

In this example, the top-level keywords are PEOPLE, PLACES, and THINGS, with specific keywords—boat, sea, and sky—inside of THINGS.

To view specific keywords in the Keyword List panel, click the triangles to the left of keywords to expand your keyword hierarchies. You can also type a keyword into the search field at the top of the Keyword List panel to reveal it in the Keyword List panel.

Tip: Of course, you don't have to use these particular keywords. Let your photographs and your point of view suggest the keywords you create. Keep in mind that the purpose of keywords is to help you find particular photographs among the many you shoot. So create keywords that reflect the way you shoot and think.

Applying keywords

Next you'll apply keyword tags to some photographs.

1 Select the Lesson 3 folder in the Folders panel.

2 Press Ctrl-A/Command-A to select all the thumbnails in the grid.

3 To apply the keyword France to all these photographs, do any of the following:

• Drag the keyword France from the Keyword List panel onto one of the selected photographs in the grid.

• Click one of the selected photographs and drag them all at once onto the keyword France in the Keyword List panel.

• Hover over the keyword France in the Keyword List panel to reveal a check box to the left of that keyword, and check that check box.

The number to the right of the keyword France in the Keyword List panel indicates the number of photographs to which that keyword has been applied.

Each of the photographs to which you've applied a keyword has a badge on its lower-right corner indicating that the photograph has a keyword.

4 Click one of the photographs that contain a boat. Ctrl-click/Command-click the other photographs that contain boats. Then use any of the methods in step 3 to apply the keyword "boat" to those photographs. Repeat to apply other keywords in this Keyword List panel to the photographs in this folder.

The numbers you see to the right of each keyword might differ from the ones in this illustration.

5 Click the header on the Keywording panel to open that panel.

6 Select the photograph of French flags in the preview area.

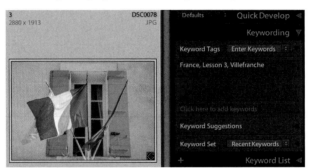

The gray field near the top of the Keywording panel lists all the keywords that have already been applied to this photograph. (Your keywords may differ from those in the illustration.)

Another way to apply a keyword to one or more selected photographs is to type it into the Keywording panel. This method creates and applies keywords in one step.

7 Click in the field labeled "Click here to add keywords."

8 Type a new keyword—**flags**.

9 Type a comma.

A keyword can consist of more than one word, like the keyword Lesson 3 in the illustration. Commas are used to separate keywords in this panel.

10 Type another new keyword—**window**.

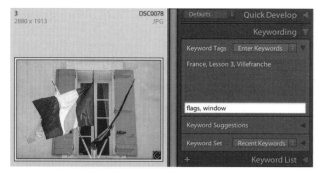

11 Press Enter/Return on the keyboard

The keywords "flag" and "window" both have been applied to the selected photographs and added to the Keyword List panel.

If you change your mind about a keyword, you can delete it.

12 Right-click/Control-click the keyword "window" in the Keyword List panel (not the Keywording panel).

13 In the menu that appears, choose Delete.

This menu offers lots of options for managing this keyword. You can edit it, remove it from the selected photo, or delete it altogether.

14 At the warning, click Delete again.

The keyword "window" is removed from the keyword list and from any photographs to which it has been applied.

Searching by keyword

The purpose of creating and applying keywords is to make it easier to find photographs. There are several ways to search by keyword.

1 In the Keyword List panel, hover over the keyword "boat." This reveals a right-facing arrow to the right of the keyword. Click that right-facing arrow.

This returns all the photographs in this catalog that contain the keyword "boat." (Your results may be different from the illustration, depending on the keywords you applied during this lesson.)

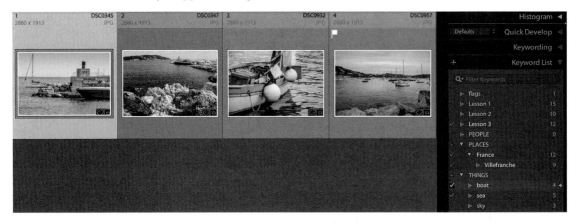

2 Clear the search so you can see all the previews in the selected source: First click the thin black border at the bottom of the screen to display the Filmstrip.

Then click the menu at the far right of the bar at the top of the Filmstrip, and choose Filters Off.

The method above is useful for searching by a single keyword.

To search by multiple keywords, you can use a text search or a Metadata filter. Let's look at a text search first.

3 In the Library module, select the Lesson 3 folder in the Folders panel.

4 Press the Backslash key (\) on the keyboard to display the Library Filter bar.

5 In the Library Filter bar, click Text to use the Text filter.

6 In the Text filter, choose Keywords from the first menu.

This limits the text that is searched to keywords.

7 Choose Contain All from the second menu.

8 In the search field, enter **sky**, followed by a comma (to indicate a separate keyword), followed by **sea**.

This returns all photographs in the selected source that contain both the keyword "sea" and the keyword "sky." (Your results may be different from the illustration, depending on the keywords you applied during this lesson.)

Library Filter: Text Attribute Metadata None Custom Filter

Text : Keywords ▾ | Contain All ▾ | Q▾ sky, sea ⊗

1
2880 x 1913 DSC0957
 JPG

9 To clear the search so you can see all previews in the selected source again, click the X icon on the far right of the search field.

Now let's look at the Metadata filter. It offers the most powerful way to search. Here you can combine a keyword search with other search variables.

10 In the Library Filter bar, click Metadata to choose the Metadata filter.

Library Filter: Text Attribute Metadata None No Filter ▾

Date		Camera		Lens		Label	
All (6 Dates)	12	All (1 Camera)	12	All (1 Lens)	12	All (2 Labels)	12
▸ 2012	12	NIKON D90	12	18.0-105.0 mm f/3.5-5.6	12	Purple	2
						No Label	10

11 In the drop-down Metadata filter, click the label at the top of the first column (Date, in the illustration) and choose Keyword.

12 In the Keyword column, click the arrow to the left of the keyword THINGS and select the keyword "boat."

13 In the Label column on the right, select Purple.

Library Filter: Text Attribute Metadata None Custom Filter ▾

Keyword		Camera		Lens		Label	
All (5 Keywords)	12	All (1 Camera)	4	All (1 Lens)	4	All (2 Labels)	4
flags	1	NIKON D90	4	18.0-105.0 mm f/3.5-5.6	4	Purple	2
Lesson 3	12					No Label	2
▸ PLACES							
▾ THINGS							
boat	4						
sea	5						

1
2880 x 1913 DSC0345 2 DSC0347
 JPG 2880 x 1913 JPG

This returns all photographs in the selected source that have both the keyword "boat" and a purple color label. (Your results may be different from the illustration, depending on the keywords and color labels you applied during this lesson.)

14 To clear the search so you can see all previews in the selected source again, click the Custom Filter menu at the far right of the Library Filter bar and choose Filters Off.

15 Press the Backslash key on the keyboard to close the Library Filter bar.

There are numerous ways to create, apply, and search by keywords in Lightroom. For more details on keywording, see Lesson 5, "Organizing and Selecting," in *Adobe Lightroom 5 Classroom in a Book.*

Moving files and folders

Once you've imported photographs into Lightroom, you have to be careful about moving them so that you don't break the link between the photographs and the Lightroom catalog, in which case Lightroom will consider your files or folders to be missing.

There are two recommended methods for moving files between folders. The first method—dragging and dropping files between folders inside Lightroom's Library module—is useful if you are moving one file or just a few files. The second method—moving a folder full of files outside Lightroom and then relinking the relocated folder to the Lightroom catalog—is useful when you're moving many files at once.

Moving files inside the Library module

Lightroom will lose track of files in a catalog if you move them from outside Lightroom—for example, if you move files around in your operating system or in another program, like Adobe Bridge. If that happens, an exclamation point will appear in the upper-right corner of the thumbnail of each missing file in the Library module, and you will not be able to work with those photographs elsewhere in Lightroom, including in the Develop module. To avoid files going missing, use this drag-and-drop method to move files between folders.

1 If your Lesson 3 folder is not expanded in the Folders panel, click the arrow to the left of the Lesson 3 folder.

2 Select the Cat subfolder inside the Lesson 3 folder in the Library module's Folders panel.

3 Drag the photo thumbnail of a house cat DSC0204.jpg from the grid onto the Lesson 3 folder in the Folders panel.

You must click directly on the photo thumbnail, not on the frame around the thumbnail, to drag the photo.

4 In the warning that appears, click Move.

Don't be put off by the strong wording of this warning. You can always move a file back to its original location the same way you are moving it now.

This moves the actual photograph (DSC0204.jpg) from the Cat folder to the Lesson 3 folder on your drive. The photograph also appears inside the Lesson 3 folder in Lightroom's Library module.

Moving a folder and files outside Lightroom

If you are moving many files at once, there is an alternative method you may be more comfortable with, which is to copy a folder of files in your operating system, paste that folder to a new location outside Lightroom, and then redirect Lightroom to the new location of that folder. This is the method to use if you are moving many photographs to a new drive, for example.

1 In your operating system, copy the top-level folder that contains the files you want to move.

2 In your operating system, go to the new destination to which you want to move that folder, and paste.

3 In your operating system, delete the top-level folder from its original location. Don't do this until you are sure that the copy and paste operation was successful and that there is a full copy of all the files in their new location.

4 Return to Lightroom's Library module. In the Folders panel, you will see a question mark on the top-level folder you deleted from its original location, and the files in that folder will display an exclamation point, indicating that they are missing from the Lightroom catalog.

5 To re-link the missing folder and all the files it contains in one step, right-click/ Control-click the question mark on the missing folder in the Folders panel and choose Find Missing Folder.

6 In the Locate window that opens, navigate to the new destination of the copied folder, select the folder there, and click Choose.

In the Library module, the question mark disappears from the folder and the exclamation points disappear from the files, since Lightroom now recognizes the new location of the folder full of files.

Re-linking missing files

You can re-link photographs that go missing from your Lightroom catalog if you know where those files are currently located or if you can find them by searching in your operating system.

First, to simulate a file going missing, you'll move a photograph in your operating system:

1 In your operating system, go to *username*/Documents/LPCIB/Lessons/Lesson 3. Or right-click/Control-click the Lesson 3 folder in the Library module Folders panel and choose Show in Explorer/Finder.

 You moved the photograph of the house cat to this Lesson 3 folder in the last section, "Moving files inside the Library module."

2 In your operating system, drag the photograph of the house cat (DSC0204.jpg) out of the Lesson 3 folder and into the Cat folder one level down. Close your Explorer/Finder window.

3 Return to Lightroom's Library module and select the Lesson 3 folder.

In the Library module, you'll see a small exclamation point in the upper-right corner of the thumbnail preview of DSC0204.jpg, which indicates that this photograph is missing from the Lightroom catalog. If you don't see the exclamation point at first, drag the Thumbnails slider in the toolbar to the right. The exclamation point means that Lightroom does not know the current location of this photograph, because you moved it from outside of Lightroom.

Now re-link the missing file to the Lightroom catalog using the following steps.

4 In the Library module, click the exclamation point on the upper-right corner of the DSC0204.jpg photo thumbnail. A warning dialog opens.

5 If you do not know the current location of the missing file, take note of its name in the warning dialog and search for the file by name using the search features in your operating system, outside of Lightroom. Leave the warning dialog open as you do this.

6 When you find the location of the missing file, click the Locate button in the warning dialog.

7 In the Locate window that opens, navigate through the file system on your drive to the missing file (DSC0204.jpg) in its current location (inside the Cat folder) and click Select.

This relinks the file to the Lightroom catalog in its current location (inside the Cat folder). The exclamation point disappears from the thumbnail preview of this photograph in the Library module.

Review questions

1 When you select a folder in the Folders panel, which previews will you see in the grid in the center of the Library module?

2 If you don't see the toolbar near the bottom of the Library module, how can you bring it into view?

3 You'll often use the keyboard shortcuts for Grid view and Loupe view in the Library module. What are those shortcuts?

4 How do you collapse all the panels and bars in the Library module for maximum viewing space?

5 What is a smart collection?

Review answers

1 When you select a folder in the Folders panel, by default you'll see previews of all items in that folder and in any subfolders it contains.

2 Pressing the T key on the keyboard shows and hides the toolbar.

3 Press G on the keyboard to switch to Grid view of thumbnail-sized previews in the Library module. Press E on the keyboard to switch to the larger Loupe view of a photograph in the Library module.

4 Press Shift-Tab to collapse all the panels and bars in the Library module.

5 A smart collection is a virtual grouping of photographs that populates automatically according to rules you create.

4 PROCESSING PHOTOS IN LIGHTROOM'S DEVELOP MODULE

Lesson overview

The Develop module offers controls you can use to correct and enhance your photographs. This lesson covers the most essential adjustments in Lightroom's Develop module. Topics in this lesson include:

- Global editing in the Basic panel
- Working with local adjustment tools
- Using the Tone Curve panel to fine-tune contrast
- Using the HSL panel to fine-tune color
- Making lens corrections
- Reducing noise
- Sharpening

 You'll probably need from 2 to 2 1/2 hours to complete this lesson.

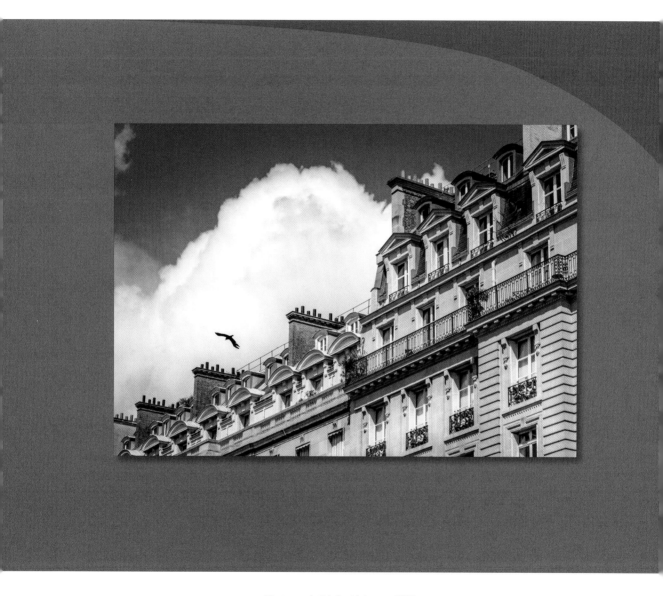

Photograph © John M. Lorenz 2012

Use the intuitive controls in Lightroom's Develop
module to adjust color, tone, and composition
without changing the pixels in your photographs.

Preparing for this lesson

Do the following to prepare for this lesson:

1 Make sure you've followed the instructions in the Getting Started lesson at the beginning of this book for setting up an LPCIB folder on your computer, downloading the lesson files to that LPCIB folder, and creating an LPCIB catalog in Lightroom.

2 If the Lesson 4 files are not already on your computer, download the Lesson 4 folder from your account page at www.peachpit.com to *username*/Documents/LPCIB/Lessons.

3 Open the LPCIB catalog you created in the Getting Started lesson by doing the following: Hold the Alt/Option key as you start Lightroom; then in the Select Catalog dialog, select the LPCIB Catalog.lrcat file and click the Open button.

4 Import the Lesson 4 files into the open LPCIB catalog following the bullet steps below. This is similar to the process for importing any photographs that are already on a drive (see "Importing from a drive" in Lesson 1 for more details):

 • Click the Import button in the Library module.

 • In the Import window's Source panel, navigate to *username*/Documents/LPCIB/Lessons, and select the Lesson 4 folder. Make sure the Include Subfolders check box at the top of the Source panel and to the right of the Files label is checked.

 • In the Import window's workflow bar, choose Add as the import method.

 • Leave all the thumbnails in the Import window checked.

 • In the File Handling panel on the right side of the Import window, choose Build Previews > Standard. Leave the other File Handling options unchecked.

 • In the Apply During Import panel on the right side of the Import window, enter **Lesson 4** in the Keywords field.

 • Click the Import button at the bottom right of the Import window.

5 In the Library module, select the Lesson 4 subfolder in the Folders panel.

Photo editing in Lightroom

Understanding how Lightroom's editor works and planning your Lightroom–Photoshop editing workflow will help you make the best use of Lightroom's Develop module.

How Lightroom's editor works

Lightroom uses a parametric editing system, which means that when you adjust a photograph in Lightroom you simply are creating a set of parameters or instructions for how to interpret the image data. You are not changing image pixels, as you do in a pixel editor like Photoshop. This makes Lightroom a truly nondestructive editor and one that is flexible to use.

How does this parametric editing system work? When you make adjustments in the Develop module, the adjustments are recorded as instructions in the Lightroom catalog. These instructions control the appearance of the image previews you see and work with in Lightroom. To help other programs see your Lightroom adjustments, you can choose to save the instructions back to the photographs too, without altering the actual image data in the photographs, as explained later in this lesson in "Saving metadata to files." If you output photographs from Lightroom, the instructions will be applied to the derivative copies that are generated, but your originals will remain unchanged.

The important point is that none of the adjustments you make in Lightroom will alter the image data in your original photographs.

This system makes editing in Lightroom not only nondestructive, but very flexible too. For example, a Develop adjustment made to a raw file in Lightroom can be changed or deleted at any time, since all you're doing is tweaking an instruction. Batch processing in Lightroom is as simple as copying and pasting instructions among multiple photographs. You can even experiment with different sets of instructions on a single photograph without making actual copies of that photograph, using a feature called virtual copies, as you'll do later in this lesson in "Working with virtual copies."

Photo editing workflow

If you shoot raw files, a recommended workflow is to do the bulk of your photo editing in Lightroom's Develop module first—correcting tone and color, removing spots, reducing noise, performing initial sharpening, fixing perspective and other lens-related issues, and sometimes making local adjustments. It's best to perform these fundamental corrections on photographs in their raw state (DNGs or proprietary raw files), because raw files offer the most editing latitude.

Then, if particular photographs call for specific edits that are best done in Photoshop (like detailed retouching, compositing, or the other Photoshop techniques covered in this book), pass those photographs from Lightroom to Photoshop, which creates RGB derivatives of the original raw files, as covered in more detail in Lesson 2.

Although Lightroom's Develop controls are tailor-made for raw files, you can use them to adjust JPEGs, TIFFs, PSDs, and PNGs too. However, you may experience less editing flexibility than with raw files, and some of the Develop features will behave differently on RGB images than on raw files, as you'll see in the section "White balancing" in this lesson.

The Develop module workspace

This section introduces the Develop module workspace and offers some tips for working efficiently in this module. The Develop module looks and behaves a lot like the Library module. Some of the Develop module features mentioned here are covered in more depth in the context of the Library module in the Lesson 3 section "The Library module workspace."

Interface overview

The Develop module interface is similar to the Library module interface. The main elements of the Develop module interface are:

A The center work area with a live preview of the photograph you're adjusting.

B A column of adjustment panels and tools on the right side of the module.

 You'll spend a lot of time working in the right panel column. This column contains a live histogram that updates as you adjust a photograph, a tool strip of local adjustment tools, the important Basic panel, and other panels with adjustment controls for correcting and enhancing photographs.

C A column of panels on the left side of the module.

 The left panel column contains the Navigator panel for zooming and panning, the Presets panel for applying pre-built sets of adjustments, the Snapshots panel for saving adjustments at a particular point in time, the History panel for stepping forward and backward through adjustments over time, and the Collections panel for accessing photographs in collections without jumping back to the Library module.

D The Filmstrip at the bottom of the module, which displays thumbnails of photographs in the current source.

The Filmstrip plays an important role in the Develop module. It allows you to select a different image to work on from the current source without jumping back to the Library module.

E The bar at the top of the Filmstrip, which offers access to filename and folder information, other image sources, and some filters, so you don't have to switch to the Library module for those items.

▶ **Tip:** To access sources of other photographs without switching to the Library module, click the down-facing arrow on the bar at the top of the Filmstrip. From the pop-up menu, choose Recent Sources, All Photographs, Quick Collection, Previous Import, or sources you've marked as favorites.

F The toolbar above the Filmstrip, in which the features change depending on whether you're making global adjustments or working with particular local adjustment tools.

G The menu bar at the top of the screen.

H The Module Picker bar at the top of the module (which is closed in the following illustration).

▶ **Tip:** If the toolbar goes missing from the Develop module, press T to bring it back into view.

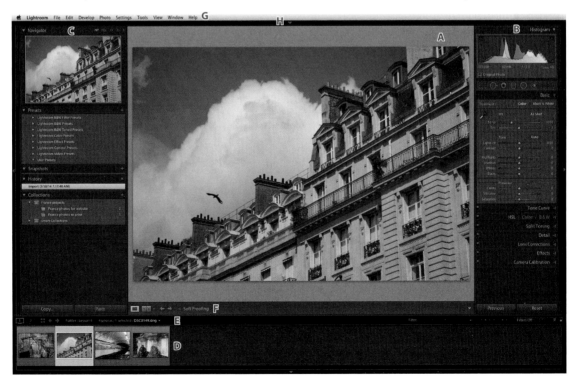

Customizing the Develop module

You can customize the layout and panel behavior of the Develop module to your taste. Try these tips to make your workspace more user-friendly.

1 In the Library module, with the Lesson 4 subfolder selected in the Folders panel, select DSC0149.dng (a photograph of rooftops in Paris).

2 In the Library module, press D on the keyboard (or click Develop in the Module Picker) to switch to the Develop module.

The Develop module opens with the selected image in the center work area.

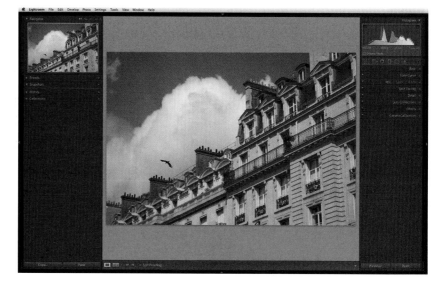

3 If the left panel column, the Filmstrip, or the Module Picker bar is open, click the thin black border outside each of those open items.

This is a useful setup for working in the Develop module. If you need to access the left column, click its outer border again to bring it back into view. If you need to access the Filmstrip, click its outer border again (or press F6 or fn-F6).

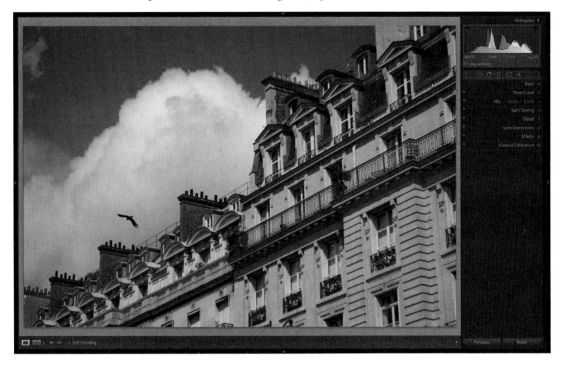

4 Right-click/Control-click the header of any panel in the column on the right, and choose Solo Mode from the panel list pop-up menu. (Or Alt/Option-click the header of any panel in that column.)

This puts all the panels in the column in Solo mode, which means that only one panel will stay open at a time. This reduces the amount of scrolling you'll do to access the many panels and controls in this column, particularly if you're working on a small screen.

▶ **Tip:** If a panel that you expect to see in a Develop module column is missing, right-click/Control-click the header of any panel in that column to open the panel list pop-up menu. Select the missing panel name in that menu.

Develop module shortcuts

In the Develop module, you can hide and show interface elements and change views by using some of the same shortcuts as in the Library module. The following shortcuts are among those you'll use most as you work in the Develop module. To view an overlay of module-specific shortcuts in the Develop module, choose Help > Develop Module Shortcuts. Click the overlay to close it.

- To hide or show all the columns and bars (the Filmstrip on the bottom, the Module Picker bar on the top, and the columns of panels on the left and right), press Shift-Tab on the keyboard.

- To hide or show the left and right panel columns together, press Tab on the keyboard.

- To hide or show a bar or column individually, press F5 or fn-F5 for the Module Picker bar, press F6 (or fn-F6) for the Filmstrip, or click the thin black border outside any bar or column.

 If a bar or column is set to Auto Hide & Show, causing it to pop in and out of view, you may prefer changing its hide and show behavior to Manual, as described in the Lesson 3 section "Customizing the Library module."

- To cycle through screen modes, press Shift-F on the keyboard.

- To toggle Full Screen mode on and off, press F on the keyboard.

- To cycle through useful displays of image information on the photograph, press I on the keyboard.

- To hide or show the toolbar, press T on the keyboard.

Zooming and panning in the Develop module

Zooming and panning in the Develop module is similar to zooming and panning in the Library module.

1 With DSC0149.dng still open in the Develop module, click the thin black border on the far left to open the left panel column, and click the Navigator header at the top of that column to open the Navigator panel.

 Zoom-level options are listed along the top of the Navigator panel and in a pop-up menu at the top right of that panel.

2 Make sure the zoom level in the Navigator panel is set to its default option, Fit.

 The Fit zoom level automatically zooms to a ratio that displays the entire photograph in the center work area.

3 Click the photograph in the center work area (or press the spacebar). This magnifies the photograph to the 1:1 zoom level by default.

The 1:1 zoom level displays one image pixel in one screen pixel, which is critical for evaluating sharpness and noise.

When the photograph is zoomed in so close that you can't see all of it in the work area, the cursor automatically changes to the Hand tool.

4 With the Hand tool, drag the photograph around in the center work area so you can view different parts of it. This is known as *panning*.

Another way to pan the photograph in the center work area is to drag the edge of the frame overlay inside the Navigator panel.

Each time you click the photograph (or press the spacebar) the zoom level will toggle between Fit and 1:1 until you change one or both of these zoom levels.

5 Click the triangle icons at the top right of the Navigator panel to open a menu of additional zoom levels. Choose 3:1 from that menu. The photograph zooms in to a 3:1 ratio of screen pixels to image pixels.

6 Click the photograph again, and it zooms out to Fit view. Now each time you click the photograph (or press the spacebar) the zoom level will toggle between Fit and 3:1.

7 To reinstate the default behavior (toggling between the Fit and 1:1 zoom levels), click the 1:1 icon at the top of the Navigator panel. Switch to Fit view for the next section.

Undoing adjustments

As you adjust a photograph in the Develop module, you'll often want to undo an adjustment or reinstate a previously made adjustment. The Develop module is very flexible in this regard. It offers the History panel, the Snapshots panel, and multiple ways to undo and reset.

1 With DSC0149.dng still open in the Develop module, in the panel column on the left, click the header of the Presets panel to open that panel.

The Presets panel contains Develop presets, which are groups of saved settings. Presets are a quick way to apply adjustments, so you'll use them to set up these exercises about undoing adjustments.

2 In the Presets panel, click the triangle to the left of the Lightroom B&W Filter Presets folder to expand that folder. Click the Yellow Filter preset. This black and white Develop preset is applied to the photograph.

3 Choose Edit > Undo (or press Ctrl-Z/Command-Z) to remove the Yellow Filter
 preset from the photograph.

 The Undo command undoes your last action. Each time you apply the Undo
 command it moves back one more step. Undo is most useful when you want to
 roll back no more than a few steps.

4 Choose Edit > Redo (Shift-Ctrl-Z/Shift-Command-Z). The black and white
 Yellow Filter preset is re-applied.

 The Redo command reinstates steps you've undone, one step at a time.

5 In the Presets panel, click the triangle to the left of the Lightroom B&W Toned Presets folder to expand that folder. Click the Sepia Tone preset. That preset is applied to the photograph.

6 Click the Reset button at the bottom right of the Develop module. This takes the photograph all the way back to its default settings, removing all the Develop adjustments you've applied.

The Reset command is useful for those times when you want to start over from the beginning.

7 In the Presets folder, click the triangle to the left of the Lightroom Color Presets folder to expand that folder. Click the Aged Photo preset.

8 In the Presets folder, click the triangle to the left of the Lightroom Effect Presets folder to expand that folder. Click the Grain–Heavy preset. Click the header of the Presets panel to close the Presets panel.

The Grain–Heavy preset and the Aged Photo preset display cumulative effects on the photograph. They do not cancel each other out, like multiple presets sometimes do, because they are composed of different adjustments.

9 Go to the Snapshots panel in the left panel column. Click the Create Snapshot (+) button on the right side of the Snapshots panel to capture a snapshot of the current edited state of the photograph.

10 In the New Snapshot dialog, you can accept the default name (the date and time of the snapshot) or type over it with a more meaningful name, like **Aged Photo + Grain Heavy**.

11 Click Create in the New Snapshot dialog. The snapshot appears by name in the Snapshots panel.

▶ **Tip:** A snapshot is useful if you want to hold onto an edit that you like but experiment with other adjustments too. You can quickly reapply a state you captured in a snapshot by opening the same photograph in the Develop module at any time and clicking the snapshot name in the Snapshots panel. All the snapshots you retain in the Snapshots panel will be available in the future, even after you close and reopen Lightroom.

▶ **Tip:** If you no longer need a snapshot, select it in the Snapshots panel and click the Minus icon at the top right of the Snapshots panel to delete it from the panel.

12 Click the triangle to the left of the History panel in the left panel column to open that panel.

The History panel keeps track of all Develop adjustments you make to a photograph—including individual settings—as chronological states in editing history. You can go backward or forward in the editing history of a photograph, re-applying any of its history states.

⬤ **Note:** The History panel in Lightroom, unlike the History panel in Photoshop, is persistent. All existing history states for this photograph will be available in the History panel whenever this photograph is open in the Develop module— even after you close and reopen Lightroom.

13 In the History panel, click the history state labeled Preset: Sepia Tone. This applies that history state to the photograph in the work area.

In the History panel, there are more states above the one that is currently selected. If you make any other adjustment at this point, those states will disappear from the History panel, which keeps track only of linear history. To retain all the history to date, click the topmost history state before continuing to develop a photograph. Or to retain a particular state, take a snapshot of it.

If you ever want to remove all history states from the History panel, click the Clear All (x) icon at the top right of the History panel.

▶ **Tip:** Hover over history states one by one in the History panel to see them previewed on the photograph in the Navigator panel.

Comparing Before and After views

The best way to evaluate adjustments you've made to a photograph is often to compare the adjusted photograph to the photograph you started with. There are several ways to do that in the Develop module.

1 With DSC0149.dng still open in the Develop module, click the Reset button at the bottom right of the Develop module to reset the photograph to its default appearance before you applied any adjustments.

2 In the Presets panel in the left panel column, click the arrow to the left of the Lightroom Color Presets folder to open that folder. Click the Old Polar preset to apply it to the photograph.

3 Press the Backslash key (\) on your keyboard to switch to Before view—a view of the photograph as it looked just after importing, before develop adjustments were applied.

The Backslash key is a shortcut for View > Before/After > Before Only.

4 Press the Backslash key (\) again to return to After view—a view with the current adjustments (the Old Polar preset) applied.

Toggling between Before and After views can help you evaluate adjustments you've made. Another way to compare Before and After views is to see them together on the screen, as you'll do in the next steps.

5 If your toolbar isn't showing at the bottom of the module, press T on the keyboard.

6 The default view in the Develop module is Loupe view, a single After view that updates as you apply adjustments. To switch from Loupe view to Before and After views of the open photograph, click the Before and After Views button (the button with the YY icon) in the toolbar (or press Y on the keyboard).

When a Before and After view is active, the toolbar displays additional Before & After buttons for copying and swapping settings between Before and After versions.

7 There are four Before and After views to choose from: Left/Right, Left/Right Split, Top/Bottom, and Top/Bottom Split. Click the Before and After Views button in the toolbar several times to cycle through the Before and After views. Or click the triangle to the right of the Before and After Views button and choose a view option from the pop-up menu.

- Before/After Left/Right

- Before/After Top/Bottom

- Before/After Left/Right Split

- Before/After Top/Bottom Split

8 To return to Loupe view from any of the Before and After views, click the Loupe view button in the toolbar (or press D on the keyboard).

You can also access Before and After views of all the adjustments made in a panel, all the adjustments made in a panel section, and individual adjustments, as covered in "Working with the sliders" in this lesson.

Developing photographs

Lightroom, as a raw converter, does its best to interpret the raw data captured by your camera to render an image that you can view and work with onscreen. However, that rendering is only an initial interpretation of the raw data. The controls in the Develop module give you the opportunity to fine-tune that interpretation. If you're not satisfied with the initial appearance of a raw image in Lightroom, don't be too quick to reject the photograph. You'll be surprised at the latitude you have to correct color, recover highlight detail, and otherwise enhance the appearance of images rendered from raw files.

In this section, you'll apply Develop module controls to raw photographs. You can work with RGB images in the Develop module too.

Note: As you work through this lesson and the book, you do not have to use the exact value for each adjustment that you see in the illustrations. Choose values that look good to you on your monitor. The values in the illustrations indicate the general direction of adjustments and approximate values only.

Adjusting color and tone in the Basic panel

The Develop module's Basic panel contains controls for making fundamental global corrections to color and tone. Global corrections are those that affect the entire photograph, as opposed to local corrections, which affect just part of an image. You'll apply Basic panel adjustments to most photographs you process in the Develop module, so it's important to have a thorough understanding of the Basic panel controls.

Working with the sliders

The Basic panel contains sliders divided into three main sections:

- The WB (White Balance) section controls color balance.

- The Tone section controls exposure, contrast, and specific tonal values.

- The Presence section controls intensity of tone and color.

There's also a narrow Treatment section at the top of the Basic panel where you can click between Color and Black & White labels (or press V on the keyboard) to quickly see how a color photograph will look converted to black and white.

Before digging in to apply Basic panel sliders, here are some tips that will help you use the sliders efficiently.

1 With DSC0419.dng still open in the Develop module, click the header of the Basic panel in the right panel column to open the Basic panel.

2 Drag the Exposure slider in the Basic panel to the right to lighten the photograph. (The value you choose doesn't matter for this step.) Then double-click the slider control (or double-click the slider label) to return the slider to its default value of 0.

To return any slider in the Basic panel to its default value, double-click the slider control or the slider label.

The Exposure slider and the other sliders in the Tone and Presence sections of the Basic panel default to 0, in the middle of each slider. The sliders in the White Balance section default to the white balance settings captured by the camera.

▶ Tip: To compare Before and After views of a single slider adjustment, double-click the slider control (or the slider label) to return the slider to its default value (the Before view); then press Ctrl-Z/Command-Z to undo, which returns the slider to its last adjusted value (the After view).

3 An alternative to dragging a slider is to move it in increments for more control. Click the Exposure slider's label to activate that slider; then use the Plus (+) and Minus (−) keys on the keyboard to move the slider by preset increments. Double-click the slider control or label to reset the slider.

Holding the Shift key during this process moves a slider in larger increments. Holding the Alt/Option key moves it in smaller increments.

Another way to move a slider in increments is to hover over the slider and press the Up Arrow or Down Arrow key on your keyboard to move that slider in increments. The same modifier keys apply to this method: Shift for larger increments, and Alt/Option for smaller increments.

▶ **Tip:** To set a slider to a particular value, click in the field to the right of the slider, type a value, and press Enter/ Return. For example, if you know you want to increase exposure the equivalent of one stop, type 1 in the Exposure field to change the Exposure value to +1.00.

4 Adjust a few sliders in the Tone section of the Basic panel. (The values you choose don't matter for this step.) To return all the sliders in this section to their default values of 0, double-click (or Alt-click/Option-click) the Tone label at the top of the section.

To return all sliders in the Presence section to their defaults, double-click (or Alt-click/Option-click) the Presence label at the top of that section. To return all sliders in the White Balance section of the Basic panel to their defaults, double-click the WB label in that section.

● **Note:** To compare Before and After views of all adjustments made in the Basic panel, in the History panel click the state just beneath the first Basic panel adjustment (the Before view). Then press Ctrl-Z/Command-Z (the After view). Each of the other panels in the right panel column has a panel switch ■ in its header for toggling Before and After views of all adjustments made in that panel. The Basic panel has no such panel switch.

5 If the Histogram panel at the top of the Develop module's right panel column is not open, click its header to open it.

6 Hover over the Highlights slider in the Basic panel and notice the light gray overlay that appears in the histogram. Repeat this with each of the other sliders in the Tone section.

The overlay in the histogram indicates the part of the tonal range that will be most affected by adjusting a particular slider. Each slider in the Tone section has its primary effect on a different area of the histogram (although other areas are tangentially affected too).

The significance of process version

The instructions in this book, particularly instructions that concern the Basic panel, are for the current Lightroom process version—PV 2012, which was introduced in Lightroom 4. Process version means Lightroom's underlying image processing technology, which changed significantly with PV 2012. Some of the Basic panel sliders look and behave differently in PV 2012 than they do in previous process versions.

How does the current process version affect photographs that you adjusted in a previous process version? If you like the way a photograph looks with its older processing, it's fine to leave that photograph as is. If you want to re-adjust the photograph to take advantage of improvements in PV 2012, open it in the Develop module. At first, the Basic panel sliders will look different than the current PV 2012 sliders. Click the lightning icon at the bottom right of the Histogram panel [⚡]. Then click Update in the Update Process Version dialog. This replaces the older Basic panel controls with the PV 2012 sliders, and you can use them to re-adjust the photograph.

> ### Update Process Version
>
> **Lr** New processing technology is available for this image. If you choose to update, please note that moderate to significant visual changes may occur. It is recommended that you update only one image at a time until you are familiar with the new processing technology. You may elect to preserve the original settings by selecting Cancel.
>
> ☐ Review Changes via Before/After
> ☐ Don't show again
>
> [Update All Filmstrip Photos] [Cancel] [Update]

Updating a photograph you adjusted in an earlier process version can affect the appearance of the photograph, as the dialog warns. So although this dialog gives you the option to Update All Filmstrip Photos, it's usually preferable to update one photograph at a time.

Evaluating the photograph

Take the time to evaluate a photograph before making adjustments. Ask yourself whether the photograph is too bright or dark. Is it overly contrasty or flat? Is there detail missing from highlight or shadow areas? Is the color off?

The Histogram panel in the Develop module can help with this evaluation. The histogram displays the location of a photograph's tones across a range, from black on the far left to white on the far right. For example, with DSC0149.dng open in the Develop module, the histogram looks like the following illustration. The lack of bars on the right and left sides of the histogram indicates that there are no completely white tones and very few rich black tones in this photograph. This suggests that the photograph could be improved by setting a white point with the Whites slider and a black point with the Blacks slider.

Leave the Histogram panel open. As you make adjustments to the photograph, check this live histogram to confirm the effects that your adjustments are having on tonal values.

Order of adjustments

There is no hard and fast technical requirement to make develop adjustments in a particular order. A common approach is to begin with the Basic panel, work your way down through the panels in the right panel column, and make most global adjustments before local adjustments.

There are a few workflow exceptions to this approach. If you decide to jump to the Camera Calibration panel to change the camera profile that Lightroom uses to render raw files, it's logical to do that at the beginning of your Develop workflow, even though the Camera Calibration panel is at the bottom of the right panel column. And although most local adjustments are made after global adjustments, try to do local retouching with the Spot Removal tool before Lens Correction panel adjustments to enhance accuracy and rendering performance.

When you're working in the Basic panel, a top-down approach is common; but don't be afraid to stray from that order as necessary. For example, if a photograph is so dark that you can't evaluate its color balance, increase the Exposure slider before tackling the White Balance controls at the top of the Basic panel. Or if you need to re-adjust a Basic slider that you've already set, feel free to go back and do that.

White balancing

The overall color of a photograph reflects the color of the light illuminating the scene, which is measured as color temperature. Strictly speaking, the purpose of Lightroom's white balance controls is to neutralize the color of light in order to remove unwanted color casts. However, there is no requirement to remove a color cast. In your subjective judgment you might elect to retain or even emphasize a color cast, like the warm gold in a sunset scene. In that sense, Lightroom's white balance controls are color correction tools that you can use to convey a mood that meets your subjective photographic vision.

There are three kinds of controls in the WB (White Balance) section of the Basic panel:

- The Temperature and Tint sliders give you control over two axes of color. The Temperature slider ranges from cool blue to warm gold; the Tint slider ranges from green to magenta. You can use the sliders on their own or to fine-tune results from the other white balance controls.

- The white balance presets menu offers preset combinations of Temperature and Tint slider values.

- The White Balance Selector tool is useful for neutralizing color.

You'll apply all three white balance controls in this exercise.

Tip: Another
way to set both the
Temperature and Tint
sliders to their Auto
values is to Shift-
double-click the WB
label in the White
Balance section. If you
want to set just the
Temperature slider
or just the Tint slider
to its default value,
Shift-double-click the
control or label on
that slider. To undo an
auto adjustment, press
Ctrl-Z/Command-Z.

1 With DSC0149.dng (the photograph of the Paris rooftops) still open in the
 Develop module, click the Reset button at the bottom right of the module to
 reset any adjustments you've made so far.

2 In the Basic panel, click the drop-down menu
 of white balance presets on the right side of
 the White Balance section and choose
 Daylight. This option shifts the Temperature
 slider to the right toward gold and the Tint
 slider to the right toward magenta on this
 photograph, warming the overall color.

The options in this drop-down menu are preset values for the Temperature
and Tint sliders. The As Shot option reflects the white balance captured by
the camera. (As Shot may not be available, depending on the camera settings.)
The Auto option is Lightroom's best guess from the image data about how to
set the Temperature and Tint sliders. Each of the other presets is a different
combination of these sliders.

3 Use the Temperature and Tint sliders to tweak the preset color balance to your
 taste. In the following illustration, the Tint slider was decreased slightly.

4 Press the Y key on the keyboard to compare Before and After views.

The After view, on the right side of this illustration, is warmer in color than the
Before version, on the left.

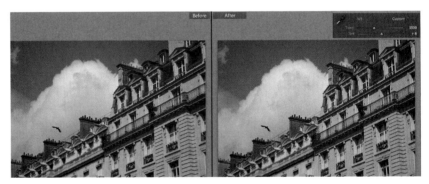

5 Press the Y key again (or the D key) to toggle back to Loupe view.

6 Click the Plus icon (+) on the right side of the Snapshots panel. In the New
 Snapshot dialog, name this snapshot **White Balance**, and click Create.

You'll come back to this photograph in this state to make further adjustments
later in this lesson. In the meantime, you'll switch files for the next example, in
which you'll neutralize color using the White Balance Selector tool.

7 Open the Filmstrip by pressing F6 (or fn-F6) on the keyboard. In the Filmstrip, select 7073846.dng (a photograph of a Paris subway station), which has a strong, warm color cast.

8 Click the White Balance Selector tool (the eyedropper icon) in the White Balance section of the Basic panel.

This tool is most useful when there is an area in the photograph that you think should be neutral in color—like the tiles on the right side of the subway platform floor, which were light gray in the actual scene.

9 If the toolbar isn't showing, press the T key on your keyboard. The toolbar now displays options specific to the White Balance Selector tool. In the toolbar, make sure the Auto Dismiss check box is unchecked and the Show Loupe check box is checked.

Unchecking Auto Dismiss will allow you to apply the White Balance Selector tool multiple times to get the result you want, without having to reselect the tool in the Basic panel each time. Checking Show Loupe will display a magnified view of the area under your cursor to help you pick a color to neutralize.

10 Hover the White Balance Selector tool over something that should be neutral in this photograph, like the floor tiles on the right side of the subway platform.

The Loupe confirms that the color under the cursor is not neutral. If it were, the three RGB values at the bottom of the Loupe would be more similar.

The Navigation panel on the left offers a live preview of the effect of the White Balance Selector tool. As you move the cursor in the image, you can see how the color would change if you were to click that spot with the White Balance Selector tool.

11 Click the floor tiles on the subway platform with the White Balance Selector tool to shift them from gold to neutral gray.

The rest of the colors in the image shift relative to that neutralized color, significantly reducing the warm color cast in this photograph.

If you don't like the result, you can continue to click with the White Balance Selector tool on other objects that were gray or white in the actual scene. Depending on where you click, you'll get very different results, potentially introducing another unwanted color cast elsewhere in the image. This makes

the White Balance Selector tool relatively unpredictable as compared to the other white balance controls.

12 To deactivate the White Balance Selector tool, click the empty circle on the left side of the White Balance section of the Basic Panel.

White balancing JPEGs

If you shoot JPEGs, you have less flexibility to set white balance in Lightroom than you do with raw files. That's because white balance is already baked into JPEGs by your camera at the time of capture, which is not the case with raw files.

Lightroom's white balance controls are different for JPEGs than for raw files. When you're working with a JPEG, you'll see different values on the Temperature and Tint sliders and fewer options in the white balance presets menu.

Trying out Auto adjust

The six sliders in the Tone section of the Basic panel control the tonal values in a photograph. The default for all these sliders is 0. The Auto button at the top right of the Tone section sets all the sliders in the Tone section to automatically calculated values. Some photographers shy away from the Auto button, but you might give it a try if you're short on time or want a quick read of how a photograph will look with tone adjustments. To return all the sliders in the Tone section back to their defaults, double-click the Tone label at the top left of the Tone section.

▶ **Tip:** To set an individual tone slider to its Auto value, Shift-double-click the control or label on that slider. Double-click the control or label on that slider again to return it to its default value.

Adjusting exposure and contrast

The first sliders at the top of the Tone section in the Basic panel are Exposure and Contrast. The Exposure slider controls the overall brightness of a photograph. The Contrast slider affects the overall contrast.

1 If the Filmstrip is not open at the bottom of the Develop module, press F6 (or fn-F6) on the keyboard. In the Filmstrip, select DSC0149.dng (the photograph of the Paris rooftops you last worked with in the section "White balancing").

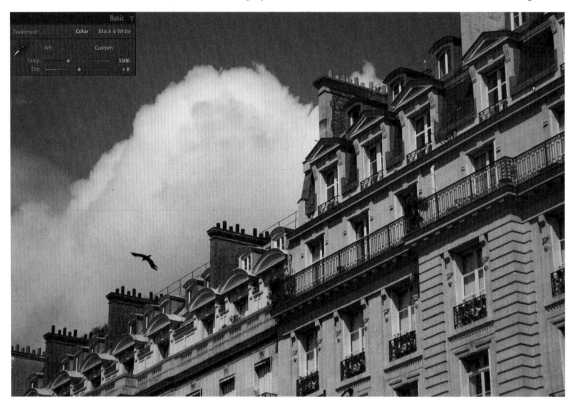

2 Make sure the white balance controls are as you set them for this photograph in the "White balancing" section. If you created a snapshot to record your white balance settings, as suggested in that section, click that snapshot in your Snapshots panel now.

3 Hover over the Exposure slider in the Basic panel.

A light gray overlay appears in the center of the histogram in the Histogram panel. This represents the tonal range on which the Exposure slider has its primary effect— the midtones.

4 Drag the Exposure slider to the right from its default of 0.

Dragging the Exposure slider to the right increases the overall brightness of a photograph. The tones—particularly the midtones—move to the right on the histogram. Dragging the Exposure slider to the left would decrease overall brightness.

5 Click the label on the Contrast slider to activate that slider. Then press the Plus (+) key on your keyboard to increase contrast in this photograph slightly.

When you're making small moves to a slider, this and the other incremental methods of setting a slider, covered earlier in "Working with the sliders," offer finer control than dragging.

Contrast refers to the range of tones in an image. When you increase the Contrast slider, tones are pushed apart across the tonal range, with light tones getting lighter and dark tones darker except at the extreme light and dark ends of the tonal range. This is similar to the effect of an s-shaped tone curve, which has a steep slope in the middle, where contrast is high, and a relatively flat top and bottom, where contrast is lower.

You don't have to apply the Contrast slider to every image, but increasing contrast with this slider can benefit photographs that are lacking in contrast to varying degrees. On the other hand, if a photograph is too contrasty, moving the Contrast slider to the left will compress tones along the tonal range and reduce contrast.

Note: The Exposure, Highlights, Shadows, Whites, and Blacks sliders in the Basic panel each have a primary effect on a different area of the tonal range, with secondary effects on other parts of the tonal range.

Note: Exposure slider values simulate stops on a camera. Setting Exposure to +1.00 is like exposing one stop over the metered exposure in camera.

Note: Increasing contrast may also increase color saturation. In that case, you can use global or local saturation controls, addressed later in this lesson, to tame the increased saturation.

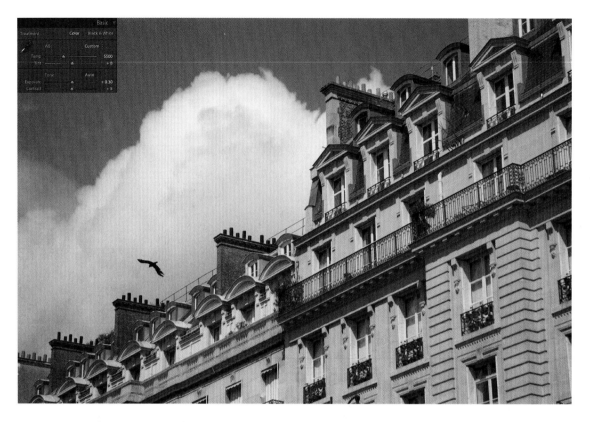

6 Toggle the Backslash key (\) on the keyboard to compare Before and After views of your adjustments to this point.

7 Leave the photograph open for the next section.

Adjusting highlights and shadows

The Highlights and Shadows sliders fine-tune contrast in light and dark areas of a photograph, respectively. The Highlights slider is very useful for recovering highlight detail. The Shadows slider is useful for revealing detail in dark areas.

1 With DSC0149.dng (the photograph of the Paris rooftops) still open in the Develop module, hover over the Highlights slider in the Basic panel. A light gray overlay appears over the 1/4-tone highlights in the Histogram panel, representing the tonal range on which the Highlights slider has its primary effect. Notice that this is not the brightest area of the histogram, which is on the far right.

2 Drag the Highlights slider to the left of its
 default of 0.

Dragging the Highlights slider to the left
darkens and separates the lighter tones in a
photograph, with minimal impact on darker tones. The effect is to emphasize
detail and edge definition in highlight areas, like the clouds in this photograph.
The Highlights slider is most often used for this purpose, although it can also be
dragged to the right to brighten highlights without clipping them.

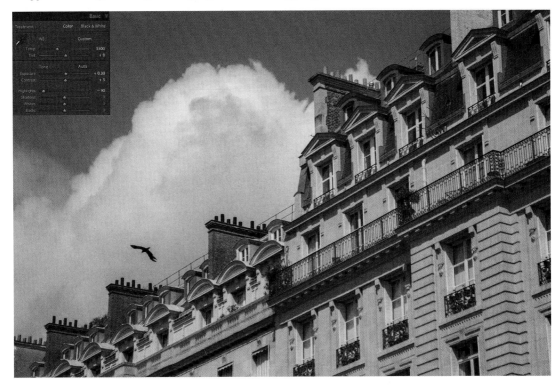

3 Hover over the Shadows slider in the Basic
 panel. A light gray overlay appears over the
 3/4-tone shadows in the Histogram panel,
 representing the tonal range on which the
 Shadows slider has its primary effect. These
 tones are dark, but they are not the very
 darkest part of the tonal range.

4 Drag the Shadows slider to the right of its default of 0.

Dragging the Shadows slider to the right lightens and separates relatively dark tones in the photograph. The effect is to reveal detail in darker areas, like the shadows under the balconies in this photograph. The Shadows slider is most often used for this purpose, although it can also be dragged to the left to darken shadows without clipping them.

Dragging the Shadows slider to the right flattens contrast. To compensate, when you drag the Shadows slider to the right it's often a good idea to drag the Blacks slider to the left, as you'll do in the next section. This re-introduces contrast in dark areas.

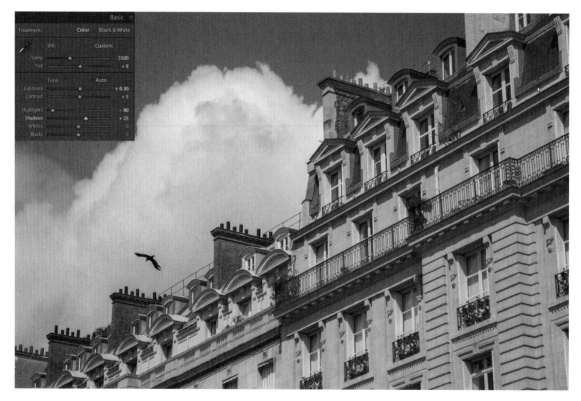

5 Leave the photograph open for the next section.

Setting white and black points

The Whites and Blacks sliders set the white and black points, respectively, at each end of the tonal range. Setting these points appropriately maximizes contrast while avoiding excessive clipping of image detail, which is particularly important in the highlights.

1 With DSC0149.dng (the photograph of the Paris rooftops) still open in the Develop module, hover over the Whites slider in the Basic panel. In the Histogram panel, a light gray overlay appears on the far right of the histogram, representing the tonal range on which the Whites slider has its primary effect.

2 Click the highlight clipping indicator (the triangle at the top right of the Histogram panel) to activate it.

This indicator will add a red overlay to the image to show you the highlights that will be clipped as you drag the Whites slider to the right.

Highlight clipping turns the brightest parts of a photograph to pure white with no image detail. Highlight clipping is usually best to avoid, except in specular highlights (like highlights in shiny chrome).

3 Drag the Whites slider to the right until there is a red overlay over the brightest areas of the photograph.

The red overlay is the highlight clipping indicator's way of telling you which highlights will be clipped.

Note: Another way to see which highlights will be clipped is to hold the Alt/Option key as you drag the Whites slider to the right. Areas clipped in all channels are white, areas clipped in one or two channels are in color, and unclipped areas are black.

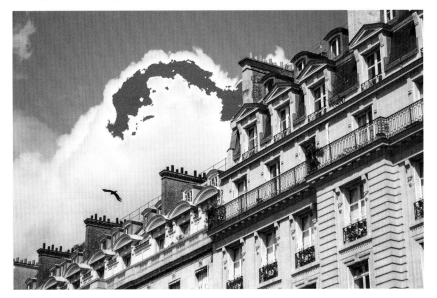

4 Drag the Whites slider back to the left until there are just a few specks of red overlay in the photograph.

The red overlay indicates where highlight clipping will occur. The brightest tones in the image are clipped by pushing them off the right side of the histogram.

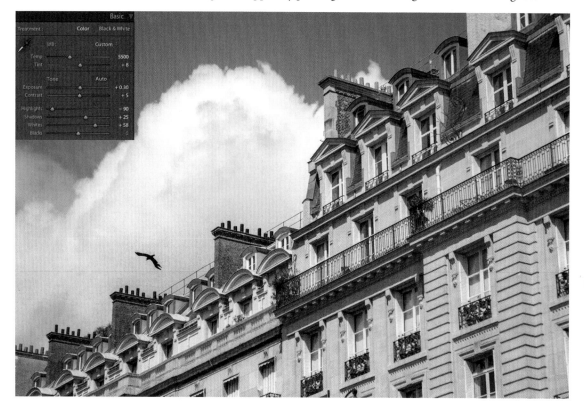

5 Click the highlight clipping indicator in the Histogram panel again to deactivate it.

6 Hover over the Blacks slider in the Basic panel. In the Histogram panel, a light gray overlay appears on the far left side of the histogram, representing the tonal range on which the Blacks slider has its primary effect.

7 Click the shadow clipping indicator (the triangle at the top left of the Histogram panel) to activate it.

This indicator will add a blue overlay to the image to show you the shadows that will be clipped as you drag the Blacks slider to the left.

8 Drag the Blacks slider to the left until there is a blue overlay over the darkest parts of the photograph in which you don't mind losing detail.

The blue overlay indicates where shadow clipping will occur.

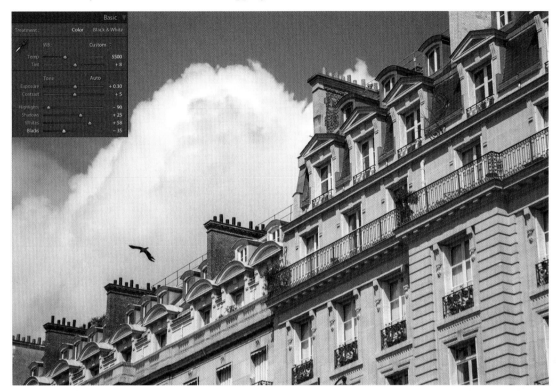

Shadow clipping pushes the darkest tones off the left side of the histogram, introducing rich blacks into the image. Some shadow clipping is often desirable, particularly after you've dragged the Shadows slider to the right to open up 3/4-tone shadow areas. You usually don't have to be as careful about clipping blacks as you do about clipping whites, because in many photographs dark areas do not contain important details.

9 Click the shadow clipping indicator in the Histogram panel again to deactivate it.

10 Toggle the Backslash key (\) on the keyboard to compare Before and After views of your adjustments to this point.

11 Leave the photograph open for the next section.

Note: Another way to see which dark areas will be clipped is to hold the Alt/Option key as you drag the Blacks slider to the left. Areas that are clipped in all channels are black, areas clipped in one or two channels are in color, and unclipped areas are white.

Adding positive or negative clarity

The Clarity slider in the Presence section of the Basic panel can have a big impact on a photograph. Dragging Clarity to the right adds punch to a photograph. Dragging Clarity to the left adds a soft glow.

1 Drag the Clarity slider to the left of its default of 0 to add negative clarity.

Negative Clarity adds a diffused glow that is a great way to soften a portrait or give a scene a dreamlike quality.

2 Drag the Clarity slider to the right of 0 to add positive clarity.

Positive clarity adds a special combination of midtone contrast and edge definition that brings out detail and adds punch to an image. In this photograph, for example, it emphasizes detail in the buildings and the edges of the clouds. To avoid the risk of visible halos at image edges, don't be too aggressive with positive clarity.

3 Leave the photograph open for the next section.

Controlling color saturation

The last two sliders in the Basic panel—Vibrance and Saturation—control color intensity. These sliders work in slightly different ways, so try them both on a photograph before deciding which to apply.

1 Drag the Vibrance slider to the right of its default of 0 to increase the intensity of colors.

Dragging the Vibrance slider to the right increases color saturation in an intelligent way, by adding the most saturation to colors that need it most. Dragging this slider to the left would decrease saturation.

The Vibrance slider is almost always a good choice for adding saturation to photographs of people, because it protects skin tone colors (including yellow and orange) from oversaturation. But in this case, dragging the Vibrance slider far enough to the right to saturate the yellows and oranges in the buildings causes the blue sky to become oversaturated.

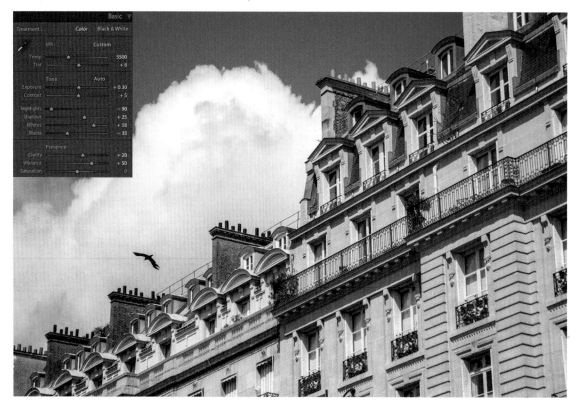

2 Double-click the label or control on the Vibrance slider to return it to its default of 0.

3 Drag the Saturation slider to the right of its default of 0.

Increasing the Saturation slider saturates all colors in a photograph equally. This sometimes causes too strong an effect, but in this case increasing the Saturation slider adds intensity to the warm colors of the buildings without making the sky exceedingly oversaturated. You'll use controls in the HSL panel to fine-tune the color of the sky in the section "Fine-tuning color in the HSL panel."

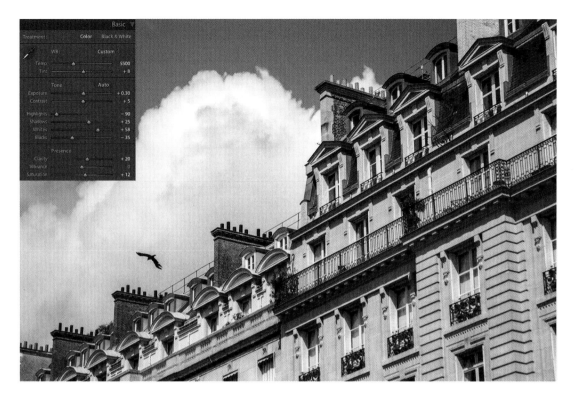

4 Press the Y key on the keyboard to compare the Before view on the left,
 which has no adjustments, with the After view on the right, which has all the
 adjustments you added in the Basic panel.

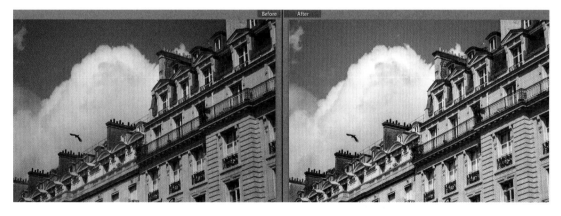

5 Press Y again to return to Loupe view.

6 Click the Plus icon (+) on the right side of the Snapshots panel to capture a
 snapshot of the photograph with all the Basic panel adjustments you made.
 Name the snapshot **Basics** and click Create.

7 Leave the photograph open for the next section.

Fine-tuning contrast in the Tone Curve panel

After you've made global adjustments in the Basic panel, if you need to make more targeted adjustments to contrast and brightness, you can do so in the Tone Curve panel.

1 DSC0149.dng (the photograph of the rooftops in Paris) should be open in the Develop module with all the Basic panel adjustments you added to it in preceding sections. If you made a snapshot you named Basics, as suggested at the end of the last section, click that snapshot in the Snapshots panel.

2 Click the header on the Tone Curve panel to open that panel to its default parametric tone curve view.

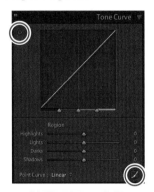

The parametric Tone Curve panel offers four sliders that you can use to adjust the four regions of the curve: Highlights, Lights, Darks, and Shadows. If your Tone Curve panel doesn't look like this, click the Point Curve icon ![icon] at the bottom right of the Tone Curve panel.

3 Click the Targeted Adjustment tool (the TAT) ![icon] at the top left of the tone curve panel to activate the TAT ![icon] .

The TAT allows you to make adjustments to targeted tones by dragging directly on the photograph.

4 With the TAT activated, go to the photograph in the work area and drag a dark part of the building down slightly.

Dragging down with the TAT moves the corresponding part of the curve down, darkening those tones throughout the image.

The light gray overlay on either side of the curve indicates the tonal region that is most affected by this move.

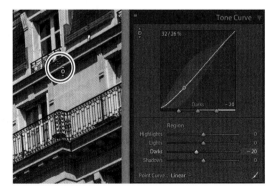

5 With the TAT, drag a bright part of the building up slightly.

Dragging up with the TAT moves the corresponding region of the curve up, lightening those tones throughout the image.

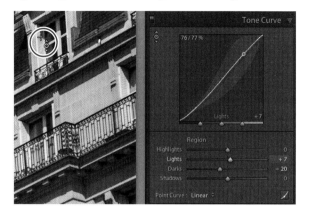

6 Double-click the Region label above the sliders to return all the sliders in the parametric Tone Curve panel to their defaults of 0.

To return an individual region slider to its default, double-click the label or control on that slider.

7 Drag the Shadows slider in the Tone Curve panel to the left to make the darkest tones in the photograph darker. The effect is similar to that of dragging the Blacks slider in the Basic panel to the left.

Dragging any of the four region sliders is another way to make a targeted adjustment in the parametric Tone Curve panel.

Hovering over a slider displays a gray overlay on the curve that tells you which part of the curve is most affected by that slider.

8 Click the Point Curve icon at the bottom right of the parametric Tone Curve panel to switch to another view of this panel—the point curve view.

In point curve view, you can zero in more closely on particular tones by clicking directly on the curve to add and drag points. This makes point curve view more focused, but also more complex to use.

● **Note:** All the curves you create in either view of the Tone Curve panel are cumulative.

9 Click the Channel menu beneath the point curve and choose Blue to access the Blue channel.

10 In the Blue channel, click the center of the curve and drag up to make the photograph more blue overall, or drag down to make the photograph more gold.

One advantage of point curve view is that it gives you access to curves for individual Red, Green, and Blue color channels. You can use these color curves as color correction tools, as you did here. The color channels are also handy for making custom split-tones, by dragging the shadow area of a color curve in one direction and the highlight area in the opposite direction.

11 Choose RGB in the Channel menu to return that menu to its default.

12 Double-click the Point Curve label at the bottom left of the panel to return all curves you made in point curve view to their defaults.

13 Click the Point Curve icon at the bottom right of the panel to return the Tone Curve panel to parametric view.

14 Toggle the panel switch ■ on the left side of the Tone Curve panel header to compare the Before view (with no Tone Curve panel adjustments) with the After view (with your current Tone Curve panel adjustment).

If there were multiple parametric curves and point curves still in effect, the panel switch would toggle all of them together.

15 Click the Plus icon (+) on the right side of the Snapshots panel to capture a snapshot of the photograph with your Basic panel adjustments and your tone curve adjustment. Name the snapshot **Tone Curve** and click Create.

16 Leave the photograph open for the next section.

Fine-tuning color in the HSL panel

The Develop module panel labeled HSL/Color/B&W (the HSL panel) offers controls for adjusting ranges of colors wherever those colors occur in an image. You can use these controls to adjust the hue, saturation, and lightness of particular color ranges.

1 DSC0149.dng (the photograph of the rooftops in Paris) should be open with all the adjustments you've made to it to this point. If you made a snapshot you named Tone Curve, as suggested at the end of the last section, click that snapshot in the Snapshots panel now.

2 Click the HSL label (not the Color or B&W label) on the header of the HSL panel. Then click the Saturation tab at the top of the panel.

3 Click the Targeted Adjustment tool (the TAT) ▣ at the top left of the HSL panel to activate the tool ▣.

 The TAT allows you to make adjustments to targeted colors by dragging directly on the image.

4 With the TAT, drag down in a saturated blue area of the sky in the photograph.

 Dragging down with the TAT decreases saturation in the range of colors that corresponds to the color under your cursor. Dragging up would increase saturation in those colors.

 The Blue slider in the Saturation tab of the HSL panel moves to the left and the blues across the photograph become less saturated.

● **Note:** The HSL panel is useful for converting photographs from color to black and white too. Click the B&W label in the panel header. Then use the color range sliders to fine-tune the conversion of individual colors to black and white brightness values.

5 Click the Luminance tab, which offers the same color range sliders as the Saturation tab, except that these sliders affect the brightness of colors.

6 With the TAT still active, drag down slightly in the blue sky in the photograph to darken the blues.

 Dragging up would lighten the blues.

7 Drag down in a light orange area of the buildings in the photograph to darken the corresponding colors across the photograph.

Notice that the Orange and Yellow sliders moved to the left in the illustration. That indicates that there was more than one color under the TAT cursor when this move was made. One advantage of using the TAT to make adjustments directly on the image, rather than dragging sliders in the HSL panel, is that the TAT knows exactly which color ranges are involved and can drag more than one slider to correspond to the colors under your cursor.

▶ **Tip:** Using the TAT and dragging sliders are not the only ways to set controls in the HSL panel. You can type a value into the field to the right of a slider. Or you can click a slider label and use the Plus (+) and Minus (–) keys on your keyboard (along with modifier keys described earlier in "Working with the sliders") to change a slider value in increments.

8 Click the Hue tab in the HSL panel, which you can use to change the hue of colors in a photograph.

9 Drag the Orange slider to the left, toward red. This makes orange hues across the photograph (including those in the buildings, the chimneys, and the smokestacks) more red-orange as opposed to yellow-orange.

The Hue tab of the HSL panel has a TAT too. You might use this TAT to make a blue sky more purple or aqua in hue.

10 Toggle the panel switch on the left side of the HSL/Color/B&W panel header to compare the Before view (without HSL adjustments) with the After view (with all the current HSL adjustments).

11 To compare the photograph with all adjustments you've made to this point to the original uncorrected photograph, press the Backslash (\) key on your keyboard, or toggle the Y key to see Before and After views. Some of the adjustments applied so far have been subtle, but their cumulative effect is significant.

12 Click the Plus icon (+) on the right side of the Snapshots panel to capture a snapshot of the photograph with your Basic, Tone Curve, and HSL panel adjustments. Name the snapshot **HSL** and click Create.

You'll come back to this photograph in this state to make further adjustments later in this lesson. In the meantime, you'll switch files for the next example, in which you'll reduce digital noise and perform initial sharpening on a photograph.

Reducing noise in the Detail panel

The Develop module has powerful controls for reducing the noise that is inherent in a digital capture. Digital noise is most apparent in photographs shot with a high ISO and in shadow areas of a photograph.

1 If the Filmstrip is not open in the Develop module, press F6 (or fn-F6) on the keyboard. In the Filmstrip, select P1050905.dng (a photograph of garden rakes), which was shot at ISO 400.

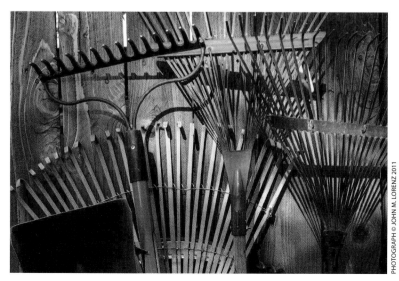

PHOTOGRAPH © JOHN M. LORENZ 2011

● **Note:** If you do not zoom to 1:1 view before opening the Detail panel, when you do open that panel, it will display a warning icon (!) to the left of the Sharpening label cautioning you to zoom to 100% or larger. Clicking that warning icon will zoom the photograph to 1:1 view.

2 Click the photograph to zoom in to 1:1 view. Then drag to pan to an area of the photograph that displays some grainy digital noise.

The 1:1 view is the only zoom level at which you can accurately evaluate digital noise and sharpening. However, some of the illustrations in this lesson are zoomed to 2:1 view to ensure that the effects of noise and sharpening are visible in this book.

3 Click the header of the Detail panel in the Develop module to open that panel.

4 If your Detail panel does not display a preview area, click the triangle to the right of the Sharpening label at the top of the Detail panel to reveal a small 1:1 preview.

5 In the Detail panel's 1:1 preview, drag to an area of the photograph that displays some grainy noise.

Alternatively, click the square icon to the left of the 1:1 preview in the Detail panel; then click a grainy area in the photograph to direct the 1:1 preview to that spot.

6 In the Noise Reduction section of the Detail panel, drag the Color slider to the left to 0.

This disables color noise reduction, revealing a significant amount of color noise in the photograph.

7 Double-click the Color label to return the Color slider to its default of 25.

This hides the color noise in the image, although there is still some grayscale luminance noise.

Three of the sliders in the Noise Reduction section address color noise. Dragging the Color slider to the right increases the amount of color noise reduction, but also can cause a loss of edge detail. In some images, dragging the color Detail slider to the right preserves some of that detail, but the effect of this slider may not be noticeable unless there is a lot of color noise in the photograph. If you have larger areas of mottled color too, dragging the Smoothness slider to the right sometimes reduces those artifacts. For this exercise, leave the color Detail and Smoothness sliders at their default values of 50.

8 In the Noise Reduction section, drag the Luminance slider to the right to reduce luminance noise, the grainy grayscale noise that is visible in shadow areas of this photograph.

Increasing the Luminance slider reduces noise by blurring the image slightly. Too much luminance noise reduction can give a photograph an artificially smooth look. Your goal when setting the Luminance slider is to reduce noise to an acceptable level without blurring the image so much that it looks artificial.

The purpose of the Detail and Contrast sliders under the Luminance slider is to compensate for the softening effects of reducing luminance noise. The luminance Detail slider acts as a threshold. The lower the value for this slider, the more details are softened. In some images, increasing the Detail slider can bring back some detail, and increasing the Contrast slider can bring back some edge contrast lost by reducing luminance noise. Leave these sliders at their defaults of 50 and 0, respectively, for this exercise.

9 Still at 1:1 view, toggle the panel switch on the left side of the Detail panel header to compare the Before view (with default noise reduction) with the After view (with your noise reduction adjustments).

10 Leave the photograph open for the next section.

Capture sharpening in the Detail panel

The purpose of sharpening in the Develop module's Detail panel is to compensate for the softness that is inherent in digital capture. This initial sharpening is sometimes called capture sharpening. You'll probably sharpen again to prepare a photograph for output—either in Lightroom's Export dialog, Lightroom's output modules, or Photoshop. And you may do some creative sharpening along the way too. So be careful not to oversharpen now in the Detail panel.

1 P1050905.dng (the photograph of garden rakes) should still be open with the noise reduction adjustments you applied in the previous section, and the image should still be zoomed to 1:1 view, which is critical when sharpening.

2 Pan to an area of the image that displays detail.

3 Drag the Amount slider to the right of its default of 25 to increase the amount of sharpening.

The Amount slider determines the strength of the sharpening effect. Sharpening is accomplished by increasing contrast at image edges. The higher the amount, the more edge contrast is introduced.

Tip: The Amount and Radius sliders affect one another. So it's common to move back and forth between these sliders as you set their values, evaluating the results in the 1:1 previews in the work area and in the Detail panel.

4 Drag the Radius slider to the left of its default of 1.0 to decrease the size of the sharpening halos.

Radius determines the width of the sharpening effect at image edges (the halos). If a photograph has lots of detail, the ideal setting for the Radius slider is usually lower than it would be for a portrait or other photograph that has less detail you want to sharpen.

5 Leave the Detail slider at its default of 25 to control detail sharpening.

Alt/Option-click the control on the Detail slider to display a grayscale version of the image that shows you which image edges are being sharpened (the light gray edges). Dragging the Detail slider further to the right would sharpen digital noise in this image, which is usually something to avoid.

6 Hold the Alt/Option key as you drag the Masking slider to the right to protect parts of the photograph from sharpening.

This displays a mask in which the areas protected from sharpening appear in black as you drag the Masking slider. The Masking function is useful to protect non-edges from sharpening—like a model's skin in a portrait, a clear sky in a landscape, or digital noise.

7 For Before and After views of your sharpening settings, double-click the Sharpening label in the Detail panel to see the Before view, with default sharpening settings; then press Ctrl-Z/Command-Z to undo and see the After view, with the sharpening settings you chose.

This comparison leaves your noise reduction settings in place in both the before and after states.

Next, you'll apply what you've learned about noise reduction and sharpening to the photograph of the Paris rooftops you last worked with in the section "Fine-tuning color in the HSL panel."

8 If the Filmstrip is not open at the bottom of the Develop module, press F6 (or fn-F6) on the keyboard. In the Filmstrip, select DSC0149.dng (the photograph of the Paris rooftops).

9 Make sure the adjustments for DSC0149.dng are as they were at the end of the section "Fine-tuning color in the HSL panel." If you created an HSL snapshot to record your last adjustments to this image, as suggested at the end of that HSL section, click that snapshot in your Snapshots panel now.

10 Try setting the controls in the Detail panel on your own for this photograph, using what you learned in this lesson about sharpening and noise reduction. The following illustration suggests some sharpening and noise reduction settings to try.

▶ **Tip:** Lightroom comes with some sharpening presets that you can use as a starting place for capture sharpening. When you're sharpening an image that has lots of detail, in the Presets panel choose Lightroom General Presets > Sharpen – Scenic. When you're sharpening a portrait or some other low-frequency image, choose Lightroom General Presets > Sharpen – Faces. Then fine-tune the resulting sharpening values in the Detail panel.

11 Click the Plus icon (+) on the right side of the Snapshots panel to capture a snapshot of DSC0149.dng with your Basic, Tone Curve, HSL, and Detail panel adjustments. Name the snapshot **Detail** and click Create.

12 Leave this photograph open for the next section.

Retouching with the Spot Removal tool

The Spot Removal tool is useful for hiding circular spots, like dust spots or blemishes, and also for removing some non-circular content from a scene.

1 DSC0149.dng (the photograph of the rooftops in Paris) should be open with all the adjustments you've made to it to this point. In the Snapshots panel, click the Detail snapshot you made at the end of the previous section.

2 Select the Spot Removal tool in the tool strip, which is beneath the Histogram panel in the column on the right side of the Develop module.

A panel of Spot Removal controls (the Spot Removal tool panel) drops down beneath the tool strip.

3 If the Develop module toolbar isn't showing at the bottom of your screen, press T on your keyboard.

Tool Overlay : Auto ÷ Visualize Spots

4 In the toolbar at the bottom of the Develop module, check the Visualize Spots check box. This displays a mask on the photograph in which spots appear as white or gray dots.

The Visualize Spots feature is useful for revealing spots caused by dust on a lens, sensor, or scanner that you might not have noticed in the photograph.

You can control the sensitivity of the Visualize Spots feature by dragging the Visualize Spots slider in the toolbar to the right or left.

5 To zoom in to the photograph, hold the spacebar on the keyboard and click the photograph. Release the spacebar and drag to move to a spot you want to remove.

● **Note:** Zooming in or out when you're working with a local adjustment tool requires that you hold the spacebar as you click the photograph. When a local adjustment tool is not selected, simply clicking the photograph zooms in and out.

Tip: If you have lots of spots to remove that are close together, you may find it more efficient to accomplish that in Photoshop, using Photoshop's Spot Healing Brush tool or Healing Brush tool.

Tip: To page through a photograph to inspect it for spots, press the Home key on your keyboard to start at the upper-left corner of the photograph. Press the Page Down button on the keyboard to page through the photograph from top to bottom in a column-like pattern.

6 Move the cursor over a dust spot in the photograph. Size the cursor so that it is slightly bigger than the dust spot by pressing the Left Bracket key ([) to decrease cursor size or the Right Bracket key (]) to increase cursor size.

7 Click the dust spot to remove it from view.

The Spot Removal tool samples content from a nearby source area in the photograph to create a patch to hide the dust spot. Two circles appear in the image. The circle with the Plus icon (the destination circle) represents the patch that is hiding the spot; the empty circle (the source circle) represents the area from which the patch was sampled.

8 Uncheck the Visualize Spots check box in the toolbar to return to regular view, where you'll no longer see this dust spot.

You can remove spots in either the regular view or the Visualize Spots view. One approach is to switch back and forth between views as you work, by checking and unchecking the Visualize Spots check box.

In either view, when you move your cursor off the photograph in the center work area, the circles disappear from view, because by default the Tool Overlay menu in the toolbar is set to Auto. You can change that behavior to Always, Never, or Selected (to view just a selected patch).

9 If you don't like the appearance of a patch, click its destination circle to select that patch. Then try one or more of these options:

- To sample from a different location, hover over the source circle to change the cursor to a Hand tool, and drag the source circle to a different location.

- To resize the patch, hover over either circle to change the cursor to a double-pointed arrow, and drag out to increase or drag in to decrease the size of the circles. Or drag the Size slider in the Spot Removal panel.

- To blend the patch with the surroundings, make sure the Heal option, rather than the Clone option, is selected in the Spot Removal tool panel.

- To soften the edge of the patch, drag the Feather slider in the Spot Removal tool panel to the right. You can reset this slider and any of the sliders in the Spot Removal tool panel to its default value by double-clicking the slider label or control.

- To make the patch less opaque, drag the Opacity slider in the Spot Removal tool panel to the left.

- To remove the selected patch, press the Delete/Backspace key on the keyboard. (If you want to remove all Spot Removal tool patches, click the Reset label at the bottom right of the Spot Removal tool panel.)

Syncing spot removal

If a spot of dust on your camera lens or sensor appears in multiple photographs, you can quickly remove it from multiple photographs at once using Lightroom's Sync feature.

1 Use the Spot Removal tool to hide the dust spot on one photograph.

2 With that photograph selected, in the Develop module Filmstrip Ctrl-click/ Command-click thumbnails of other photographs with the same dust spot. Make sure that the photograph you corrected is the most selected thumbnail (the one with the lightest thumbnail frame in the Filmstrip).

3 Click the Sync button at the bottom of the right panel column in the Develop module. If that button reads AutoSync, click the panel switch just to the left of the button to change it to read Sync.

4 In the Synchronize Settings dialog, click Uncheck All. Then check the Spot Removal and Process Version check boxes. Click Synchronize to automatically hide the spot on all selected photographs.

5 If the result needs fine-tuning on any of the affected photographs, open that photograph in the Develop module for further editing.

10 Lightroom's Spot Removal tool can also hide non-circular content. Zoom and pan to locate content you want to hide—like one of the railings at the top right of this photograph.

11 Size the cursor so it is just a bit larger than the height of the railing, select the Clone option in the Spot Removal panel (to avoid the risk that the blending behavior of the Heal option will smudge the ends of the patch), and drag across the railing in the photograph.

> **Tip:** If you have more complex content to remove, remember that you can hand off a photograph from Lightroom to Photoshop to take advantage of Photoshop's full-featured retouching tools.

12 Toggle the panel switch for the Spot Removal tool, which is at the bottom left of the Spot Removal panel.

Toggling the panel switch gives you Before and After views of all the circular and non-circular corrections you made with the Spot Removal tool.

13 To close the Spot Removal panel, click the Close label at the bottom right of that panel.

14 Click the Plus icon (+) on the right side of the Snapshots panel to capture a snapshot of DSC0149.dng with all your global adjustments and your Spot Removal corrections. Name the snapshot **Spot Removal** and click Create.

15 Leave this photograph open for the next section.

Making lens corrections

In the Develop module's Lens Corrections panel you can adjust for a variety of issues related to your camera lens, including lens distortion, lens vignetting, chromatic aberration, and perspective problems.

Applying a lens profile

Lightroom uses profiles of camera lenses to correct for lens-related geometric distortions and vignetting.

1 DSC0149.dng (the photograph of the rooftops in Paris) should be open with all the adjustments you've made to it to this point. In the Snapshots panel, click the Spot Removal snapshot you made at the end of the previous section.

2 Click the header on the Lens Corrections panel to open that panel, and click the Basic tab in the Lens Corrections panel, if that tab is not already open.

3 Check the Enable Profile Corrections check box. In many cases, this automatically applies a lens profile for the lens with which the photograph was shot and automatically corrects geometric distortion (pincushioning or barrel distortion) and vignetting (dark corners) in the photograph.

If checking Enable Profile Corrections does not alter the photograph, it could be that Lightroom did not find the lens profile automatically. In that case, click the Profile tab in the Lens Corrections panel and use the Lens Profile menus there to choose the make, model, and profile manually for the lens with which the photograph was captured.

Adobe has created lens profiles for many popular lenses, but if you have a new or unusual lens it's possible Adobe has not yet profiled that lens. In that case, you could look into making a lens profile yourself, but the simpler approach is to use the sliders in the Manual tab of the Lens Corrections panel to fix geometric distortion and vignetting manually.

If you shoot with a mirrorless camera (sometimes called a Micro Four Thirds camera), the camera may have compensated for lens issues by embedding lens correction instructions into the metadata of your raw files. Those corrections may be applied when Lightroom initially converts the raw files, rather than through a lens profile invoked in the Lens Corrections panel.

4 Leave this photograph open for the next section.

Removing chromatic aberration

Chromatic aberration is a lens-related anomaly that can cause unwanted color to appear along image edges. Lightroom can remove some chromatic aberration automatically.

1 With DSC0149.dng open, zoom to 1:1 view and pan to an edge with visible color fringing. Notice the magenta color along the edge of the chimney and the green color along the shadows on the window structure.

2 Click the Basic tab in the Lens Corrections panel if the Basic tab is not already open.

3 In the Basic tab, check the Remove Chromatic Aberration check box.

> **Note:** If you see purple or green fringing at high-contrast edges after checking the Remove Chromatic Aberration check box, try using the Defringe controls in the Color tab of the Lens Corrections panel to remove the fringing.

The magenta and green lines in the preceding illustration are now barely visible in the photograph.

4 Leave this photograph open for the next section.

Correcting perspective with Upright

The Upright feature in the Lens Corrections panel offers automatic corrections for some perspective problems related to the angle at which a photograph was shot, including leveling a crooked image and reducing keystoning (vertical distortion) in shots of buildings. The Upright feature was introduced in Lightroom 5.

1 With DSC0149.dng open, click the Basic tab in the Lens Corrections panel if it is not already open.

2 With the Enable Profile Corrections check box checked in the Basic tab, click each of the four Upright buttons—Level, Vertical, Full, and Auto—in turn to try them out on the photograph. This is usually the best way to approach applying Upright, because results can vary from image to image.

• The Level option tries to straighten or level a photograph that is crooked on the horizontal or vertical axis.

- The Vertical option not only levels a photograph but also tries to correct for converging vertical lines—like those that make buildings shot from street level appear to be leaning back (keystoning).

In this case, the Vertical option makes such an extreme correction that white areas of the canvas are left showing on two sides of the adjusted image.

When an Upright correction reveals canvas around an image, you have several options: You can try checking the Constrain Crop check box in the Basic tab, although this option may eliminate more content than you would like in some photographs. If applying the Upright correction pushed some of the photograph off the canvas, you can use the Scale slider in the Manual tab of the Lens Corrections panel to reduce scale until all the photograph is back in view; then crop the image manually using Lightroom's Crop Overlay tool with the lock icon unlocked for maximum flexibility. Or hand the image off to Photoshop, where you can crop the image with Photoshop's Crop tool or try to fill the white edges using Photoshop's Content-Aware Fill feature.

- The Full option tries to fix leveling, vertical perspective, and horizontal perspective. This option often delivers the most extreme results, as is the case with this photograph.

- The Auto option is often the best choice, as it is in this case. This option attempts to level an image and fix perspective problems, while maintaining a natural look. Leave this photograph with the Auto option applied.

3 Toggle the panel switch on the left side of the Lens Corrections panel header to compare the Before view (with no lens correction adjustments) with the After view (with the current lens correction adjustments).

4 Click the Plus icon (+) on the right side of the Snapshots panel to capture a snapshot of DSC0149.dng with all your global adjustments, your Spot Removal corrections, and your lens corrections. Name the snapshot **Lens** and click Create.

5 Leave this photograph open for the next section.

▶ **Tip:** After you make an Upright correction, you can fine-tune the results using the sliders in the Manual tab of the Lens Corrections panel.

Making local adjustments

Most of the adjustments you've made so far are global adjustments—adjustments that affect the entire photograph. Often you'll want to make local adjustments too—adjustments that affect just part of a photograph. Photoshop has lots of features for making local adjustments, like dodge and burn tools, selections, and masks. Lightroom has only a few local adjustment tools, but they are often quite useful. Before you hand a file off to Photoshop for local adjustments, consider what

you can accomplish in Lightroom with the Graduated Filter tool, the Radial Filter tool, and the Adjustment Brush tool.

These three Lightroom local adjustment tools have a lot in common. They all work by creating a mask that limits the area affected by adjustments. They all offer the same list of adjustments, which you can apply individually or in combination. That list of adjustments includes adjustments that are also in the Basic panel—Temperature, Tint, Exposure, Contrast, Highlights, Shadows, Clarity, Saturation—plus Sharpness, Noise, Moire, Defringe, and Color tint.

Working with the Graduated Filter tool

With the Graduated Filter tool you can apply adjustments to part of a photograph in a gradient pattern. In this exercise you'll apply two gradient filters with different combinations of adjustments to get different effects on the sky and the buildings.

1 With DSC0149.dng still open in the Develop module, select the Graduated Filter tool in the tool strip beneath the Histogram panel.

 The Graduated Filter panel drops down from the tool strip.

2 In the Graduated Filter panel, double-click the Effect label at the top left of the sliders to set all the sliders to their defaults of 0.

 The sliders for all the local adjustment tools are sticky, so it's important to reset them. Doing that all at once is most efficient. To reset an individual slider to its default, double-click the slider label or control.

3 Drag the Exposure slider all the way to the left.

 Setting one or more sliders before you create a graduated filter loads the Graduated Filter tool with those settings so that they will be applied as you create the next graduated filter. This negative exposure setting is just a way to help you see the gradient you'll create in the next step.

4 Click the upper-left corner of the photograph and drag toward the lower-right corner, stopping near center of the photograph so that this graduated filter covers just the sky.

 This creates a mask in a gradient pattern over the sky. The gradient mask defines where the Exposure value and any additional parameters you set in the future will be applied.

You can create multiple graduated filters. Each filter will be represented by a separate pin in the photograph. To select a graduated filter, click its pin. When a particular graduated filter is selected, its pin turns black. All the pins will disappear from view when you move your cursor off the photograph in the center work area, because by default the Show Edit Pins menu in the toolbar is set to Auto.

5 To reposition this graduated filter, drag its black pin. To rotate the graduated filter, drag its center line clockwise or counterclockwise slightly.

The three white lines on a graduated filter represent the strength of the parameters it applies: 100%, fading through 50%, and then down to 0%. You can contract or extend the filter's gradient by dragging either of the outside white lines toward or away from the center line.

6 With the filter's pin selected in the photograph, change the settings for this filter in the Graduated Filter panel. Drag the Exposure slider so it is slightly to the left of its default of 0, drag the Temperature slider to the left of its default of 0, and drag the Saturation slider slightly to the left of its default of 0.

These changes are applied to the selected graduated filter, making the sky slightly darker and more blue.

▶ **Tip:** You can save this combination of local adjustment settings as a preset to apply to other photographs. Click the Effect menu at the top of the drop-down panel, and choose Save Current Settings as New Preset. Name the preset and click Create. When you want to access these settings for future use with the Graduated Filter tool, the Radial Filter tool, or the Adjustment Brush tool, select this preset from the Effect menu in the drop-down panel for that tool.

7 To add another graduated filter, click the New label at the top right of the Graduated Filter panel.

This deselects the first pin, which changes to white.

8 Double-click the Effect label in the panel to reset all the sliders in the Graduated Filter panel to their defaults of 0.

9 Drag a new graduated filter from the lower-right corner up toward the upper-left corner, stopping near the top of the buildings, so that this filter covers most of the buildings. The two graduated filters can overlap.

This time the graduated filter was not preloaded with settings, to demonstrate that you have the option to wait to set parameters until after you create a graduated filter. The same is true of the other local adjustment tools—the Radial Filter tool and the Adjustment Brush tool.

10 With the pin for the second graduated filter selected in the photograph, go to the Graduated Filter panel and drag the Temperature slider to the right to warm up the color of the building, drag the Shadows slider to the right to open up shadow areas in the building, and drag the Clarity slider to the right to emphasize the details on the building facade.

11 Toggle the panel switch for the Graduated Filter tool, which is at the bottom left of the Graduated Filter panel.

Toggling the panel switch gives you Before and After views of all the graduated filters you added. To see Before and After views of just one graduated filter, select its pin in the photograph and double-click the Effect label in the Graduated Filter panel (the Before view). Then press Ctrl-Z/Command-Z to undo (the After view).

12 To close the Graduated Filter panel, click the Close label at the bottom right of the Graduated Filter panel or click the Graduated Filter icon in the tool strip.

13 Click the Plus icon (+) on the right side of the Snapshots panel to capture a snapshot of DSC0149.dng with all your global adjustments, your Spot Removal corrections, your lens corrections, and your graduated filters. Name the snapshot **Graduated** and click Create.

14 Leave this photograph open for the next section.

▶ **Tip:** To remove an individual graduated filter, select its pin and press the Delete/ Backspace key on the keyboard. To remove all graduated filters, click the Reset label at the bottom of the Graduated Filter panel.

Using the Adjustment Brush tool

The Adjustment Brush tool works much like the Graduated Filter tool. The two tools apply the same adjustments, individually or in combination, to local areas of a photograph that are defined by masks behind the scene. The difference is that with the Adjustment Brush tool you paint the adjustments where you want them. Many of the mechanics of working with the Graduated Filter tool apply to the Adjustment Brush tool also, so refer to the preceding section "Working with the Graduated Filter tool" for more details.

1 With DSC0149.dng (the photograph of Paris rooftops) still open in the Develop module, select the Adjustment Brush tool in the tool strip beneath the Histogram panel.

The Adjustment Brush panel drops down from the tool strip. The Effect section of the panel offers the same adjustments as the Graduated Filter panel. The Brush section contains brush options for the Adjustment Brush tool.

2 Double-click the Effect label near the top left of the Adjustment Brush panel to reset all the Effect sliders to their defaults of 0.

3 Choose brush options in the Brush section of the Adjustment Brush panel:

 • Use the Size slider to set the size of the brush.

 Alternatively, after you've created an adjustment brush, size the selected brush by pressing the Right Bracket (]) and Left Bracket ([) keys on the keyboard.

 • Use the Feather slider to set the softness of the brush.

 Alternatively, after you've created an adjustment brush, set the feather value of the selected brush by pressing the Shift-Left Bracket ([) to decrease feathering or Shift-Right Bracket (]) to increase feathering.

 The default value of the Feather slider is 100 (maximum softness). To reset this slider to its default, double-click the slider label or control.

 • Use the Flow slider to set the rate at which adjustments are applied.

 When the Flow slider is decreased, the brush acts like an airbrush, building up the opacity of adjustments over multiple strokes.

- Use the Density slider to set the maximum opacity of adjustments.

 If you're not getting the full effect you expect from a brush stroke, it may be because the value of the Density slider, the Flow slider, or both is less than 100. To reset each of those sliders to its default of 100, double-click the slider label or control.

- If you want to adjust a defined area (like an object against a solid background), check the Auto Mask check box. With this box checked, Lightroom will do its best to confine the adjustment brush mask to areas that match the tone and color under your cursor. It does this by continuously sampling as you paint with the adjustment brush.

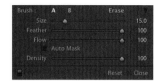

4 If the toolbar is not showing at the bottom of the screen, press T on your keyboard. In the toolbar, check the Show Selected Mask Overlay check box.

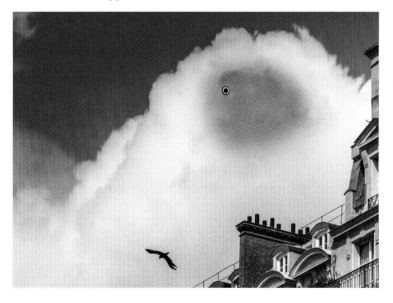

5 Paint over part of the cloud in the photograph.

 The red overlay is the mask that defines where the adjustments associated with this brush will be applied.

If you paint too far and want to erase part of the mask, hold the Alt/Option key as you paint.

6 Uncheck the Selected Mask Overlay check box in the toolbar to turn off the red overlay in the image.

▶ **Tip:** There are many practical uses for local adjustment brush corrections, like burning and dodging (selective darkening and lightening), creative sharpening, removing noise from shadows, balancing color, and removing color fringe.

7 With the pin that represents this adjustment brush selected in the image, go to the Adjustment Brush panel to set the values of the adjustments for this brush. Drag the Clarity slider to the right of its default of 0 and the Highlights slider to the left of its default of 0 until you like the result in the image.

These adjustments are applied to the area affected by this adjustment brush, emphasizing cloud detail.

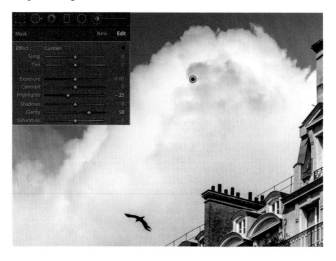

8 To extend the area affected by these adjustments, with the pin for this adjustment brush selected, paint over another part of the clouds.

To see where you've painted, check and then uncheck the Show Selected Mask Overlay check box in the toolbar.

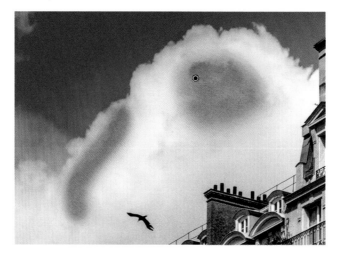

9 To make a change to the adjustments applied by this brush, with the pin for this brush selected, go to the Adjustment Brush panel and drag the Exposure slider slightly to the left.

You can change or add a setting to an adjustment brush at any time by selecting its pin in the image and setting controls in the Adjustment Brush panel.

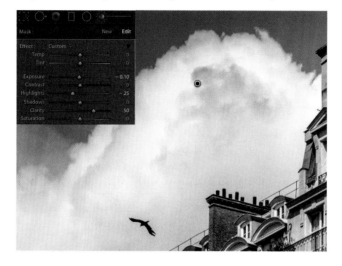

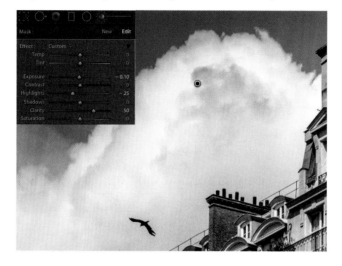

> **Note:** You can add multiple adjustment brushes to an image, each with its own settings and pin. To add a new brush, click the New label at the top of the Adjustment Brush panel and click the image.

10 Toggle the panel switch for the Adjustment Brush tool, which is at the bottom left of the Adjustment Brush panel.

If you've created multiple adjustment brushes, this gives you Before and After views of all of them. To see Before and After views of just one adjustment brush, select its pin in the photograph and double-click the Effect label in the Adjustment Brush panel (the Before view). Then press Ctrl-Z/Command-Z to undo (the After view).

11 To close the Adjustment Brush panel, click the Close label at the bottom right of the Adjustment Brush panel or click the Adjustment Brush icon in the tool strip.

12 Click the Plus icon (+) on the right side of the Snapshots panel to capture a snapshot of DSC0149.dng with all your adjustments to this point, including adjustment brushes. Name the snapshot **Brush** and click Create.

13 Leave this photograph open for the next section.

Applying the Radial Filter tool

The Radial Filter tool applies the same adjustments as the Gradient Filter tool and Adjustment Brush tool, but in a circular pattern. The Radial Filter tool is useful for spotlighting elements in a photograph and for vignetting to draw attention to an off-center element.

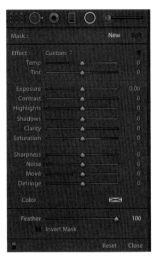

1 With DSC0149.dng still open, select the Radial Filter tool in the tool strip beneath the Histogram panel.

 The Radial Filter panel drops down from the tool strip.

2 Double-click the Effect label near the top left of the Radial Filter panel to reset all the Effect sliders to their defaults of 0.

3 Drag the Feather slider in the Radial filter panel to 100, if it is not already there.

 This ensures a gradual, soft transition at the outside edge of a radial filter. After you create a radial filter with a particular Feather value, you can still adjust the amount of feather on that filter using the Feather slider.

4 Make sure the Invert Mask check box is not checked, which is the default.

 This ensures that adjustments assigned to a radial filter affect the area outside, not inside, the radial filter.

5 Drag the Exposure slider to the left in the Radial Filter panel.

▶ **Tip:** To add a radial filter that fills the image and is centered, Ctrl-Alt-double-click/ Command-Option- double-click in the photograph.

6 In the photograph, position your cursor slightly off-center (over the clouds) and drag to the right to create a large radial filter.

 The decrease in exposure affects the area outside the radial filter by default, creating a subtle vignette effect.

 The purpose of a vignette is to direct the viewer's attention away from the edges of the photograph and toward important content. The advantages of creating a vignette with the Radial Filter tool are that a radial filter vignette can be off-center and it can incorporate any of the adjustments in the Radial Filter panel. For example, you could adjust the color temperature or the saturation of the vignette instead of just the exposure. (The Post-Crop Vignette feature in the Develop module's Effects panel doesn't offer these advantages.)

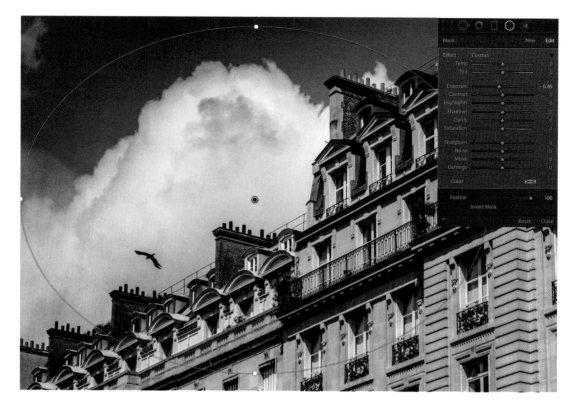

7 With the pin that represents this radial filter selected in the photograph, go to the Radial Filter panel and tweak the value of the Exposure slider to your taste, making the vignetted corners darker or lighter than they were initially.

8 Reposition and resize the filter to your liking using these techniques:

* Drag from inside the radial filter to move it to a different location on the image.

* Hover over a square anchor point on the border of the radial filter. When the cursor changes to a double-pointed arrow, drag toward or away from the center of the filter to resize the filter.

* Hover outside the border of the radial filter. When the cursor changes to a curved arrow, drag to rotate the filter.

9 Click the New button at the top right of the Radial Filter panel to start creating another radial filter.

10 Position your cursor over the bird in the photograph and drag outward to create another, smaller radial filter around the bird. Reposition and resize this filter to your liking.

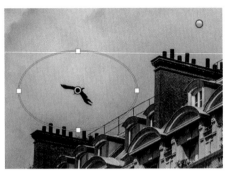

11 With the pin that represents the radial filter around the bird selected in the photograph, check the Invert Mask check box near the bottom of the Radial Filter panel.

This ensures that the adjustments you assign to this radial filter will affect that area inside the filter rather than outside the filter. This allows you to use the Radial Filter tool as a spotlighting tool, rather than just another vignetting tool.

12 In the Radial Filter panel, drag the Exposure and Contrast sliders to the right of their defaults of 0.

This increases exposure and contrast inside this radial filter to draw attention to the bird.

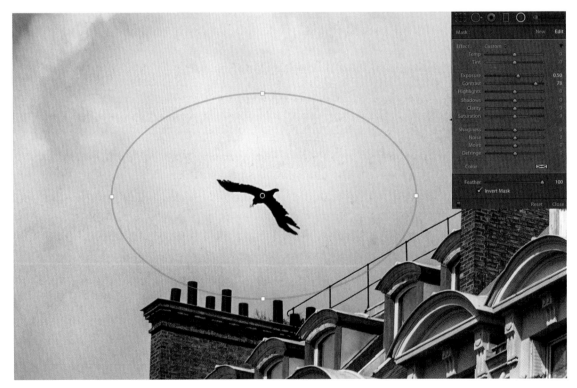

13 Create one more radial filter using the same techniques. With Invert Mask still checked, create another radial filter over a part of the building to which you'd like to add some light. For this radial filter, move the Temperature and Tint sliders to the right to warm up the color, set Exposure to the right of its default of 0 for brightness, and set Highlights to the left of its default of 0 to retain detail in the highlights.

This filter gives the impression of sunlight shining like a subtle spotlight on part of the building.

14 Right-click/Control-click the pin of the sunlight radial filter and choose Duplicate from the pop-up menu.

The duplicate filter is directly on top of the original filter, so at first the adjustments appear at double strength.

15 Drag the selected pin (which is the pin for the duplicate filter) to another part of the building to add a spot of sunlight there.

16 Reshape the duplicate filter in its new location to fit the content there, using the techniques covered earlier in this section. With the duplicate filter selected, you can also tweak its settings in the Radial Filter panel separately from the original filter.

17 Toggle the panel switch for the Radial Filter tool, which is at the bottom left of the Radial Filter panel.

If you've created multiple radial filters, this gives you Before and After views of all of them. To see Before and After views of just one radial filter, select its pin in the photograph and double-click the Effect label in the Radial Filter panel (the Before view). Then press Ctrl-Z/Command-Z to undo (the After view).

18 To close the Radial Filter panel, click the Close label at the bottom right of the Radial Filter panel or click the Radial Filter icon in the tool strip.

19 Toggle the Backslash key (\) to compare the current version of the photograph (with all the global and local adjustments you made in Lightroom's Develop module) to the original (with no adjustments).

20 Click the Plus icon (+) on the right side of the Snapshots panel to capture a snapshot of DSC0149.dng with all your global and local adjustments, including radial filters. Name the snapshot **Radial** and click Create.

21 Leave this photograph open for the next section.

Saving metadata to files

One way to save metadata to files is to do so manually.

- With DSC0149.dng still open in the Develop module with all the adjustments you added to it during this lesson, choose Photo > Save Metadata to File (or press Ctrl-S/Command-S).

Why save metadata to the file?

Develop adjustments and other metadata changes are recorded in the Lightroom catalog by default. Saving metadata to the file saves your changes back to the photograph too. This ensures that other applications, like Adobe Bridge and Camera Raw, will be able to view the changes you've made to the photograph. Saving metadata to a file also acts as an insurance policy. It protects you from losing your changes if a photograph and its metadata are inadvertently removed from the Lightroom catalog.

When you save metadata to a DNG file, the metadata is stored in a special area inside the DNG without affecting the image pixels. The same is true when you save metadata to a JPEG, TIFF, PSD, or PNG. However, when you save metadata to a camera manufacturer's proprietary raw file, the metadata is stored in a separate XMP sidecar file that you must keep with the corresponding raw file.

When you're working with a DNG file you have an alternative to the Save Metadata to File command. You can choose to select the file in the Library module and choose Metadata > Update DNG Previews & Metadata. This saves the metadata to the file just like the Save Metadata to File command and also ensures that the JPEG preview in the DNG file is updated so other applications can see your changes.

Another way to save metadata to files is to do so automatically to all your photographs.

- To enable the automatic option, choose Lightroom/Edit > Catalog Settings, click the Metadata tab, and check the Automatically Write Changes into XMP check box. Close the Catalog Settings dialog.

 The upside of the automatic option is that whenever you make an adjustment it is saved automatically to the photograph, without you having to do anything else to make that happen. The major downside is that continuous, automatic saving could possibly interfere with Lightroom's performance.

Working with virtual copies

When you want to experiment with different adjustments, or when you need different versions of a photograph (like a color version and a black and white), virtual copies come in handy.

1 If the Filmstrip is not showing in the Develop module, press F6 (or fn-F6) on your keyboard. Select DSC0149.dng in the Filmstrip if it is not already selected there.

▶ **Tip:** You can also make virtual copies of one or more photographs in the Library module.

2 Choose Photo > Create Virtual Copy, or press the keyboard shortcut Ctrl-' (apostrophe)/Command-' (apostrophe).

This creates a virtual copy of the photograph that appears in the Filmstrip along with the original. The virtual copy is identified by the turned-up page icon at its bottom left corner.

A virtual copy is not an actual pixel-based copy that takes up valuable space on your computer drive. It is just an alternative set of processing instructions stored in the Lightroom catalog. This means you can create and experiment with multiple virtual copies of a photograph, each with different adjustments, without a lot of overhead.

3 In the Filmstrip, select the virtual copy you just made.

4 Press V on the keyboard to quickly convert the virtual copy to black and white.

Notice that this adjustment does not affect the original of the photograph. You are free to make additional virtual copies and try out different adjustments on each of them without affecting the original or filling up your drive.

Review questions

1 When you adjust a photograph in Lightroom's Develop module, do your adjustments change image pixels in the photograph?

2 If you close Lightroom after making adjustments to a photograph and reopen Lightroom a week later, when you open that photograph in the Develop module will your previous adjustments be listed in the History panel?

3 Lightroom has many controls for making global adjustments to a photograph. When you want to make targeted, local adjustments, do you always have to pass a photograph off to Photoshop for that purpose?

4 What does the Exposure slider do in the current Lightroom process version?

5 Is there one right way to white balance a photograph?

Review answers

1 No. Adjustments you make to a photograph in Lightroom do not change image pixels. Adjustments are recorded as instructions in the Lightroom catalog.

2 Yes. The History panel keeps track of all the adjustments you make to a photograph forever, unless you delete history states.

3 No. You can make some local adjustments in Lightroom, using tools like the Graduated Filter tool, the Radial Filter tool, and the Adjustment Brush tool. If you need to make a more complex local correction, such as one that requires a precise selection, then pass the file off to Photoshop, usually after making fundamental global corrections in Lightroom.

4 Increasing or decreasing the Exposure slider affects the overall brightness of a photograph. The Exposure slider has its primary effect on the midtones in a photograph.

5 No. White balancing is subjective. Lightroom's White Balance controls can neutralize a color cast in a photograph, but there are times when a color cast is desirable as a way to communicate the mood and message that you, as the photographer, choose to convey.

5 LIGHTROOM TO PHOTOSHOP FOR COMBINING PHOTOS

Lesson overview

You've mastered the essentials of the Lightroom–Photoshop roundtrip workflow, Lightroom's Library module, and Lightroom's Develop module. Now you'll put all that knowledge to practical use. This lesson and those that follow step through common creative scenarios in which you'll use Lightroom and Photoshop together.

This lesson covers using Lightroom and Photoshop together to combine photographs, whether you're making a layered design, a composite of flexible smart objects, an HDR merge, or a panorama. This lesson walks you through each of those round-trip projects. Along the way, you'll learn useful design techniques, such as how to use Photoshop blend modes to add texture to a photograph and how to use layer masks to combine images.

Topics in this lesson include:

- Using Lightroom's Open as Layers in Photoshop command for a composite
- Working with embedded Smart Objects in Photoshop and Lightroom
- Working with linked Smart Objects in Photoshop and Lightroom
- Using Lightroom's Merge to HDR in Photoshop command
- Using Lightroom's Merge to Panorama in Photoshop command

 You'll probably need from 2 to 2 1/2 hours to complete this lesson.

Photographs in composite © armina—Fotolia,
© Ruth Black—Fotolia, © Photofollies—Fotolia,
© anple—Fotolia

Photoshop is the place to go to combine
photographs. You can pass multiple photographs
from Lightroom to Photoshop to merge them into
composites, HDR images, and panoramas.

Preparing for this lesson

Do the following to prepare for this lesson:

1 Make sure you've followed the instructions in the Getting Started lesson at the beginning of this book for setting up an LPCIB folder on your computer, downloading the lesson files to that LPCIB folder, and creating an LPCIB catalog in Lightroom.

2 If the Lesson 5 files are not already on your computer, download the Lesson 5 folder from your account page at www.peachpit.com to *username*/Documents/LPCIB/Lessons.

3 Open the LPCIB catalog you created in the Getting Started lesson by doing the following: Hold the Alt/Option key as you start Lightroom; then in the Select Catalog dialog, select the LPCIB Catalog.lrcat file and click the Open button.

4 Import the Lesson 5 files into the open LPCIB catalog following the bullet steps below. This is similar to the process for importing any photographs that are already on a drive (see "Importing from a drive" in Lesson 1 for more details):

 • Click the Import button in the Library module.

 • In the Import window's Source panel, navigate to *username*/Documents/LPCIB/Lessons, and select the Lesson 5 folder. Make sure the Include Subfolders check box at the top of the Source panel and to the right of the Files label is checked.

 • In the Import window's workflow bar, choose Add as the import method.

 • Leave all the thumbnails in the Import window checked.

 • In the File Handling panel on the right side of the Import window, choose Build Previews > Standard. Leave the other File Handling options unchecked.

 • In the Apply During Import panel on the right side of the Import window, enter **Lesson 5** in the Keywords field.

 • Click the Import button at the bottom right of the Import window.

5 In the Library module, select the Lesson 5 subfolder in the Folders panel.

Creating a layered composite

In this section you'll use Lightroom's Open as Layers in Photoshop command to pass photographs from Lightroom to Photoshop to create a layered composite.

Making initial adjustments in Lightroom

You'll start by making a few representative adjustments in Lightroom to photographs that are destined for this composite. When you're preparing your own photographs for a composite, make as many global adjustments in Lightroom as necessary to optimize overall tone and color in the component images. Use Lightroom's local adjustment tools to make some selective adjustments, holding off on any corrections that are better accomplished in Photoshop (like precise retouching).

1 In Lightroom's Library module, select the Lesson 5 folder in the Folders panel.

2 If the toolbar at the bottom of the Library module is not showing, press T on the keyboard. In the toolbar, choose Sort > File Name, if that option is not already selected.

3 In the Library module grid, select c-shoes.dng (the photograph of bridal shoes).

4 Press D on the keyboard to switch to the Develop module.

 The Develop module opens with the selected image in the center work area.

5 In the Develop module, press F6 (or fn-F6) on the keyboard to open the Filmstrip, if it is not already open.

6 In the Basic panel on the right side of the Develop module, drag the Temp slider slightly to the right toward gold.

Note: As you work through this lesson and the other lessons in the book, you do not have to use the same values for Lightroom and Photoshop adjustments that you see in the illustrations. Instead, choose values that look good to you on your monitor.

Your goal is to create a subtle warm color cast in the photograph of shoes that brings it into line with the warmth of two other photographs visible in the Filmstrip: c-cupcakes.dng (the photograph of wedding cupcakes) and c-rings.dng (the photograph of wedding rings).

As you make adjustments to photographs you plan to composite, try to achieve uniformity of tone, color, and texture so that the photographs will look like they belong together in the composite.

7 With c-shoes.dng still selected, in the Filmstrip Ctrl-click/Command-click the frames of the thumbnails c-cupcakes.dng and c-rings.dng.

In the Filmstrip, the frame around the thumbnail of the shoes is highlighted in a brighter shade than the frames around the other two thumbnails, which means the shoes will be the source of synced settings.

Auto Sync

▶ **Tip:** Lightroom has a number of features that make quick work of sharing adjustments across photographs (Auto Sync, Sync, Previous, and copy and paste options). Recording actions and setting up batch processing in Photoshop requires more time and effort. So do as much synchronizing of component images as you can in Lightroom.

8 Make sure the Auto Sync button is showing at the bottom of the column on the right side of the Develop module. If the Sync button is showing instead, click the panel switch just to the left of the Sync button to change the button to Auto Sync.

9 In the Basic panel, drag the Clarity slider slightly to the left to give all three photographs a diffused glow.

This change will be auto-synced from the photograph of the shoes to the photographs of the cupcakes and the rings.

10 Click the panel switch to the left of the Auto Sync button to change the button back to Sync.

11 Press Ctrl-D/Command-D to deselect all the thumbnails in the Filmstrip. Then select only c-cupcakes.dng in the Filmstrip.

The photograph of the cupcakes fills the center work area.

12 Select the Adjustment Brush tool in the tool strip under the histogram on the right side of the Develop module.

13 In the drop-down Adjustment Brush panel, double-click the Effect label to reset all the effects sliders to their defaults. Drag the Highlights slider to the left.

14 Paint with this brush on the white icing on the bride cupcake to recover highlight detail there.

15 Adjust the Highlights slider in the Adjustment Brush panel to your taste. Then click the Close button at the bottom right of the Adjustment Brush panel.

Using Lightroom's Open as Layers in Photoshop command

When you pass multiple images from Lightroom to Photoshop to use in a layered design, apply Lightroom's Open as Layers in Photoshop command to put all the images automatically into a single layered Photoshop document. This saves the time and energy of combining images in Photoshop manually.

1 Select c-bride.dng (a bride in a field of lavender) in the Filmstrip in Lightroom's Develop module or in the grid in Lightroom's Library module. Then Ctrl-click/Command-click three more images: c-shoes.dng, c-cupcakes.dng, and c-rings.dng.

2 Choose Photo > Edit In > Open as Layers in Photoshop.

All four images open into a single document in Photoshop, each on a separate layer.

3 Leave this layered document open in Photoshop for the next section.

Building out the layered composite in Photoshop

Now that you've got a good starting point with multiple images in a single document, build out your layered design in Photoshop.

1 In the Layers panel, drag the layer c-bride.dng to the bottom of the layer stack, if it is not already there, and release the mouse button when the bottom edge of the current bottom layer changes to a double line.

 If the other layers are not in the order you see them in the illustration, drag them in the Layers panel to match the illustration.

2 In the Layers panel, right-click/Control-click the c-cupcakes.dng layer (not the layer thumbnail) and choose Convert to Smart Object. Repeat this separately on the c-rings.dng layer and the c-shoes.dng layer.

This converts each layer to a separate embedded Smart Object layer, as indicated by the icon on the thumbnail for each layer.

You'll learn more about embedded Smart Object layers in the next section. For now, the reason to convert each layer in a composite to a Smart Object is so that you can scale and otherwise transform it multiple times without degrading image quality.

You could have combined the multiple selected layers into a single Smart Object, but in this case it's advantageous to be able to quickly access each Smart Object layer individually.

3 In the Layers panel, select the layer at the top of the layer stack. Then Shift-click the third layer from the top, so that three layers are selected: c-cupcakes.dng, c-rings.dng, and c-shoes.dng. The layer c-bride.dng is not selected.

4 Choose Edit > Free Transform (or press Ctrl-T/Command-T on the keyboard).

5 If you do not see anchor points at the corners of a transform box in the document window, press Ctrl-0/Command-0 (zero) on the keyboard.

This keyboard shortcut zooms the image out far enough to reveal the transform box and its anchor points. This is necessary when an image is larger than the available editing space.

6 Hold the Shift key to constrain proportions and the Option key to scale from the center as you drag a corner anchor point on the transform box toward the center of the box.

The images on all three of the selected layers shrink in size. These layers are stacked on top of one another, so they are not all visible in the image.

The exact size to which you scale the images doesn't matter. You can scale each of them over and over without degrading image quality, because you converted these layers to Smart Objects, as long as you don't increase their sizes much larger than 100% of the original sizes. When you are transforming a Smart Object layer, keep your eye on the W and H fields in the options bar to make sure you don't increase those percentage values much beyond 100%.

7 Drag from inside the resized transform box to the upper left of the document to reposition the three selected, scaled-down layers.

8 Click the check mark in the options bar (or press Enter/Return on the keyboard) to complete the transform.

9 In the Layers panel, click the c-cupcakes.dng layer. This deselects the other two layers, so the c-cupcakes.dng layer is the only layer selected.

10 With the Move tool selected in the Tools panel, drag the cupcake image to the lower left of the image.

11 In the Layers panel, select the c-rings.dng layer and with the Move tool drag it to the center left of the image.

Don't worry about the exact alignment and distribution of the images on the left side of the composite now. Just make sure the distance between the top and bottom images on the left side of the composite (the shoes and the cupcakes) is to your liking.

12 In the Layers panel, again select all three layers—c-cupcakes.dng, c-rings.dng, and c-shoes.dng. With the Move tool selected, in the options bar, click the Align Left Edges button.

The three images—the cupcakes, rings, and shoes—are now aligned by their left edges.

13 Choose View > Rulers. Drag a guide from the ruler on the left of the document window to the right edge of the shoes image. Drag another guide to the left edge of the shoes image.

You'll use the guide on the right to resize the cupcakes and rings images to match the width of the shoes image. You'll use the guide on the left to make sure the left edges of the three images remain aligned as you do this.

14 In the Layers panel, select the c-cupcakes.dng layer. It should be the only layer selected at this point.

15 Choose Edit > Free Transform (or press Ctrl-T/Command-T on the keyboard). Shift-drag the bottom right anchor point on the box around the cupcake image toward the guide on the right, stopping when the guide turns red. Click the check mark in the options bar (or press Enter/ Return on the keyboard) to complete the transform.

16 Select the c-rings.dng layer, and repeat step 15 on this layer.

The three images—the cupcakes, rings, and shoes—are now the same width.

17 Select the c-cupcakes.dng layer, the c-rings.dng layer, and the c-shoes.dng layer in the Layers panel. Select the Move tool, and in the options bar click the Distribute Vertical Centers icon to evenly distribute the three images vertically.

18 Choose View > Clear Guides to dismiss the guides.

19 With the three layers selected, fine-tune your design. Drag the three images into final position with the Move tool. If you want to tweak the size of all three images, check the Show Transform Controls option in the Move tool options bar, drag a corner anchor point, and press Enter/Return on the keyboard.

There are many other creative directions in which you could take this basic design. For example, you could add a drop shadow layer style to one of the Smart Object layers and copy it to the other Smart Object layers. Or create a layer group and add a drop shadow or other layer style to the group. Or you could add a layer mask to a Smart Object layer or to a group of Smart Object layers and then add a black-to-white gradient to the mask to fade images into view in the composite. You'll learn more about layer masks later in this lesson.

Saving the composite back to Lightroom

Now you'll save the composite in Photoshop in a way that ensures it appears in Lightroom.

Choose File > Save (or press Ctrl-S/Command-S). Then choose File > Close (or press Ctrl-W/Command-W).

This saves the final composite back to the Lesson 5 folder as a TIFF with -Edit-P added to the filename (c-bride-Edit-P.tif), in accordance with the Lightroom External Editing preferences you chose back in Lesson 1. The composite is an RGB format file, even though its components are DNG files, because Photoshop can save only RGB format images.

Be sure to choose File > Save, rather than File > Save As. This ensures that the location, name, and format of the saved file are unchanged, so that Lightroom knows that this is a derivative of the most selected image you opened from Lightroom into Photoshop at the beginning of this exercise—c-bride.dng.

Back in Lightroom, the composite c-bride-Edit-P.tif appears in the grid alongside the images you included in the composite.

Working with embedded Smart Objects

In this section, you'll open multiple files from Lightroom into Photoshop as embedded Smart Objects in a Photoshop composite.

An embedded Smart Object is a separate image that is contained within a Photoshop document. If you pass a raw file from Lightroom to Photoshop and embed the raw file as a Smart Object in a Photoshop document, a copy of the raw data is preserved in the Smart Object. You then can edit that raw data using Photoshop's Camera Raw plug-in, which is similar to Lightroom's Develop module. While you're in Photoshop you can apply other useful Photoshop features to a Smart Object too, like layer masks and layer effects. Smart Objects also offer other advantages, like the ability to scale and otherwise transform an image many times without losing pixels or degrading image quality.

Until recently, all Photoshop Smart Objects were embedded. Adobe introduced another kind of Smart Object, the *linked* Smart Object, in an early 2014 update to Photoshop CC. Using linked Smart Objects with Lightroom is covered in the next section. This section focuses on using embedded Smart Objects with Lightroom.

1 In Lightroom's Library module, select so.psd. Choose Photo > Edit In > Edit in Adobe Photoshop CC (or press Ctrl-E/Command-E). In the dialog that opens, choose Edit a Copy with Lightroom Adjustments, and click Edit.

When you place Smart Objects, you must have a document open in Photoshop to place them into. That document could be blank, like this one, or it could be another photograph.

If you are on a Mac, the drag-and-drop method described in steps 2 through 9 is an efficient way to composite multiple photographs as embedded Smart Objects. Unfortunately this drag-and-drop method is not available on Windows, so if you are a Windows user, skip to step 10.

2 Arrange the programs on your monitor[s] so you can see both Photoshop and Lightroom. Choose Window > Screen Mode > Normal so you can resize Lightroom. Hover over a corner of Lightroom's interface until your cursor changes to a double-headed arrow; then drag toward the center of the interface so Lightroom takes up less room on your screen. Position Lightroom so that you can see both it and part of the document that is open in Photoshop.

3 In Lightroom's Library module grid, click to select gordes.dng (a raw photograph of the hill town Gordes, France).

PHOTOGRAPH © JAN KABILI 2013

4 Drag the thumbnail of gordes.dng in Lightroom to the document that is open in Photoshop, so-composite.psd.

5 The photograph of the hill town, which is a DNG raw file, automatically opens
 in the Camera Raw dialog.

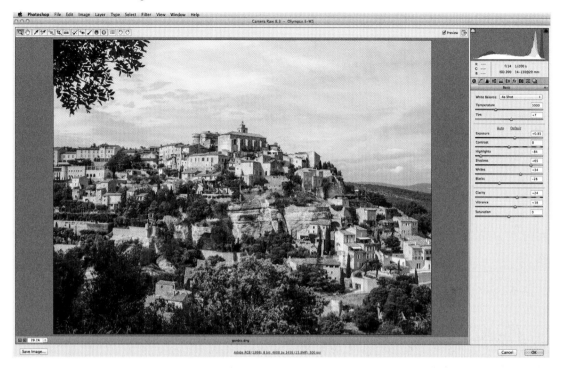

This raw file already has some basic adjustments, which were made to the lesson
file in Lightroom. Those adjustments are reflected in the controls in Camera
Raw too.

6 Click OK to close the Camera Raw dialog without making any additional adjustments in Camera Raw.

The photograph of the hill town now appears in a box in the center of the document that's open in Photoshop: so.psd. In the Layers panel, there is a separate layer for this photograph.

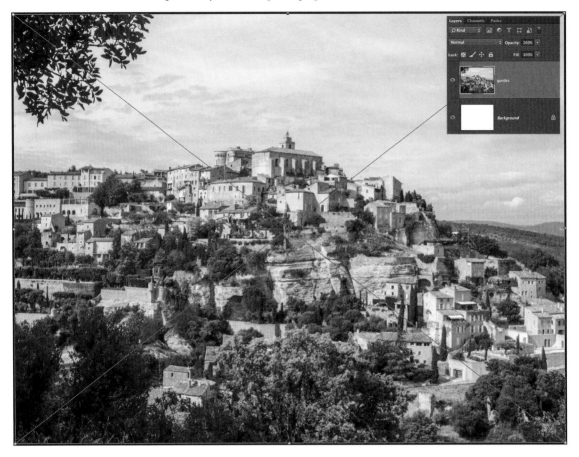

7 In Photoshop, click the check mark in the options bar (or press Return on the keyboard) to finish placing the photograph of the dock as an embedded Smart Object in so.psd. The icon on the gordes layer thumbnail indicates that this is an embedded Smart Object.

8 Return to Lightroom's Library module grid and select texture.jpg (a JPEG of textured paper).

9 Drag the thumbnail of texture.jpg from Lightroom to the image open in Photoshop, so.psd.

The photograph of the texture that you selected in Lightroom now appears in a bounding box in the center of so-composite.psd. There is a separate layer in the Layers panel for this image.

Mac users, skip to step 14.

Windows users, use the method in steps 10 through 13—rather than steps 2 through 9 above—to place the photograph of the hill town and the texture image in so.psd.

10 With so.psd open in Photoshop, choose File > Place Embedded, and navigate to *username*/Documents/LPCIB/Lessons/Lesson 5/gordes.dng. Click Place.

If you are not using an early 2014 or later version of Photoshop CC, you won't see a File > Place Embedded command. Choose File > Place instead.

11 In the Camera Raw dialog that opens, click OK without making any adjustments.

12 In Photoshop, click the check mark in the options bar (or press Enter/Return on the keyboard) to finish placing the photograph of the hill town as an embedded Smart Object in so.psd.

13 Choose File > Place Embedded again, and navigate to *username*/Documents/ LPCIB/Lessons/Lesson 5/texture.jpg. Click Place. Continue to step 14 before you press Enter or click the check mark in the options bar to complete the Place command.

Again, if you are not using an updated version of Photoshop CC, choose File > Place.

Both Mac and Windows users continue with the next step.

14 Hover over the right edge of the box on the texture image to change the cursor to a double-pointed arrow. Hold the Alt/Option key and drag the edge outward to expand the texture image to cover the photograph of the hill town. Then click the check mark in Photoshop's options bar (or press Enter/Return on the keyboard). The icon on the texture layer thumbnail indicates that this is an embedded Smart Object.

Expanding an image beyond its original size can degrade the quality of that image, but because you'll be blending this layer and using it only for texture, it is acceptable in this case. Alternatively, you could scale down the other layers in the file to match the width of the texture layer, but you would have to crop away some of the height of the texture layer, because its square proportion doesn't match the rectangular proportions of the images on the other layers.

15 With the texture layer selected in the Layers panel, click the blend mode menu at the top of the Layers panel, and choose Multiply to blend the image on the texture layer with the photograph on the gordes layer beneath it.

▶ **Tip:** Cycling through blend modes is a good way to test each one quickly on an image. Select the Move tool in the Tools panel, and hold the Shift key as you press the Plus (+) or Minus (–) key on the keyboard.

16 With the texture layer selected, scrub the Opacity control at the top of the Layers panel to the left to make the texture more transparent so that it is less visible on the photograph.

17 In the Layers panel, right-click/Control-click the gordes layer (not the layer thumbnail) and choose New Smart Object via Copy.

This creates another Smart Object layer, named gordes copy, which is located above the gordes layer in the Layers panel. The New Smart Object via Copy command unlinks the copy of the Smart Object from the original Smart Object. (If you were to choose the Duplicate Layer command instead, edits you make to the duplicate Smart Object would also affect the original Smart Object.)

18 Double-click the Smart Object thumbnail on the gordes copy layer.

This opens the corresponding Smart Object—a copy of the gordes.dng raw file—into Camera Raw. The raw data for this photograph has been preserved inside the Smart Object that is embedded in the Photoshop composite so.psd. In the Camera Raw dialog, you can access that raw data and make adjustments using controls similar to those in Lightroom's Develop module.

19 In the Basic tab of the Camera Raw dialog, make some adjustments to bring out more detail in the sky. Don't worry about the effect on the foreground as you do this. Try reducing Exposure slightly, increasing Contrast, decreasing Highlights, and increasing Clarity. Then click OK to close the Camera Raw dialog.

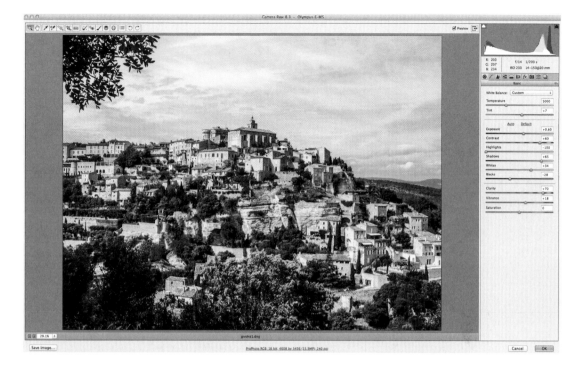

In Photoshop, the image displays the adjustments you made to the Smart Object on the gordes copy layer in Camera Raw. In the next steps you'll combine part of the gordes copy layer with part of the gordes layer beneath it using a selection and a layer mask.

20 Select the Quick Selection tool in the Tools panel and press the Left Bracket key ([) on the keyboard to make the brush tip small.

21 With the gordes copy layer selected in the Layers panel, drag the Quick Selection tool over the top of the photograph until the sky (including the branches at the top left) is selected.

The animated dashes, called marching ants, indicate the edge of the selection.

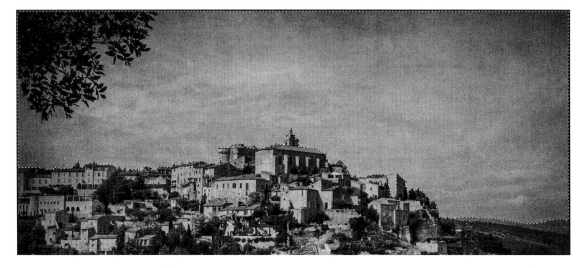

22 If you inadvertently select some of the foreground too, in the options bar select the Subtract from Selection option for the Quick Selection tool, and drag over the area you want to remove from your selection.

23 With the gordes copy layer still selected, click the Add Layer Mask icon at the bottom of the Layers panel.

This adds a layer mask to the gordes copy layer. The mask is white inside the selection you made and black outside the selection.

Where the layer mask is white (the sky area), the changes you made to the gordes copy layer in Camera Raw are visible. Where the layer mask is black (the foreground area), the changes you made to the gordes copy layer in Camera Raw are hidden from view and the layer below it—the gordes layer—shows through.

24 Double-click the Smart Object thumbnail on the gordes layer to open the separate Smart Object on this layer in Camera Raw.

Layer mask primer

A layer mask is useful for hiding part of the content on a layer, whether that content is a Smart Object, pixels, or an adjustment.

A layer mask is a grayscale element, so the only colors it can contain are white, black, and shades of gray. Each has a different effect:

- Where a layer mask is white, it reveals the content of the layer to which the mask is attached. When you first add a default mask to a layer, it is white, so it appears to have no effect.

- Where a layer mask is black, it conceals content on the layer to which it is attached. So you can see through the corresponding part of that layer to the layers below.

- Where a layer mask is gray, it partially conceals content on the layer to which it is attached.

A mnemonic that may help you remember how a layer mask works is "Black conceals; white reveals."

A useful metaphor for a layer mask is a stencil. The solid part of a stencil acts like the black part of a layer mask, concealing content. The empty part of a stencil acts like the white part of a layer mask, revealing content.

To add black, white, or gray to a layer mask, you can use the Brush tool to paint on the mask, the Gradient tool to create a black-to-white gradient on the mask, or a selection.

If a selection is active when you create a layer mask, the selected area will be white on the mask, the non-selected area will be black, and transition areas will be gray. Otherwise, use the Edit > Fill command to fill a selection on an existing layer mask with black, white, or gray.

25 In Camera Raw, use the sliders in the Basic tab to adjust the foreground, without regard to the effect of your adjustments on the sky. Try dragging the Shadows slider to the right to open up shadow areas in the foreground and dragging the Blacks slider slightly to the left to make the darkest blacks richer. Click OK.

In Photoshop, the black part of the layer mask on the gordes copy layer lets you see down to the changes you just made to the Smart Object on the gordes layer.

The final composite is a combination of two different versions of the same raw photograph, each with different Camera Raw adjustments: the sky from the Smart Object on the gordes copy layer, and the foreground from the Smart Object on the gordes layer.

26 Choose File > Save (or press Ctrl-S/Command-S). Then choose File > Close (or press Ctrl-W/Command-W).

It's important that you save without changing the location, name, or format of the saved file so that Lightroom knows that this is a derivative of so.psd, which you opened from Lightroom at the beginning of this section.

This saves the final composite back to the Lesson 5 folder as a TIFF with -Edit-P added to the filename (so-Edit-P.tif), in accordance with the External Editing preferences you chose in Lightroom back in Lesson 1.

In Lightroom's Library module, with the Lesson 5 folder selected, so-Edit-P.tif appears in the grid.

Lightroom's Open as Smart Object command

Another way to open photographs from Lightroom into Photoshop as Smart Objects is to select one or more thumbnails in Lightroom's Library module and choose Photo > Edit In > Open as Smart Object in Photoshop. Each of the photographs opens directly into Photoshop as a separate document with an embedded Smart Object on a single layer. You can edit any of these Smart Objects in Camera Raw by double-clicking the Smart Object thumbnail on its layer.

If you want to make a composite of multiple images you've opened this way, you'll have the additional step of combining them into a single document in Photoshop. One way to accomplish that is to do the following:

1 Choose Window > Arrange > Tile so that you can see all the images at once, each in a separate document.

2 With the Move tool, drag an image from one document to another.

3 Choose Window > Arrange > Consolidate All to Tabs to see a single document with multiple embedded Smart Objects, each on its own layer.

Working with linked Smart Objects

Linked Smart Objects in Photoshop CC allow you to update a Smart Object in one image and have that change ripple through other images that reference the same Smart Object. A linked Smart Object is an external file, rather than an embedded element like the Smart Objects covered in the preceding section. Linked Smart Objects are useful for logos, web design elements, template items, or any image you include in multiple documents in Photoshop. For this section, you must be using an early 2014 or later version of Photoshop CC.

On a Mac (but not on Windows), you can create a linked Smart Object directly from Lightroom by dragging and dropping from Lightroom to Photoshop. On Windows, you use the Place Linked command for that purpose.

1 In Lightroom, make sure you are in the Library module. With the Lesson 5 folder selected, select aqua.tif, gold.tif, and purple.tif (three background images) in the grid.

2 Choose Photo > Edit In > Edit in Adobe Photoshop CC (or press Ctrl-E/Command-E). In the Edit Photo with Adobe Photoshop CC dialog, choose Edit a Copy with Lightroom Adjustments, and click Edit.

Three background images open in Photoshop, each in a separate tab.

3 In Photoshop, click the tab for gold.tif to open that image in the document window.

4 If you are on a Mac, follow these steps:

- Make sure you still can see both Photoshop and Lightroom on your monitor[s]. If you can't, follow the instructions in step 2 of the preceding section "Working with embedded Smart Objects" to arrange the programs.

- If the Filmstrip isn't open in Lightroom's Library module, press F6 (or fn-F6). Drag logo.psd from the Filmstrip onto the open document in Photoshop. After you start dragging, press the Option key and hold it until you release your mouse button.

 Without the Option key, the logo will come into the open document as an embedded Smart Object rather than as a linked Smart Object.

5 If you are on Windows, Choose File > Place Linked and navigate to *username*/Documents/LPCIB/Lessons/Lesson 5/logo.psd. Click Place.

6 The logo appears in the center of the gold background image. In Photoshop's Layers panel, there is a new layer for the logo. Drag inside the logo's bounding box to position the logo where you want it.

7 Shift-drag a corner anchor point toward the center of the bounding box to reduce the size of the logo.

● **Note:** The gray checkerboard pattern on the logo layer thumbnail means that the logo is surrounded by transparent pixels. Lightroom can't display this transparency, so in Lightroom the transparent pixels in logo.psd appear white.

8 When you're satisfied with the position and size of the logo, click the check mark in the options bar (or press Enter/Return on the keyboard).

You can make the logo larger again without losing quality, because this is a Smart Object. Use the Free Transform command (Ctrl-T/Command-T) to resize or reposition the logo further.

The thumbnail on the logo layer has a link icon, indicating that this is a linked Smart Object. This icon differs from the one for an embedded Smart Object, covered in the preceding section "Working with embedded Smart Objects."

9 Choose File > Save (or press Ctrl-S/Command-S) to save the document with these changes. Leave this document open.

The filename changes to gold-Edit-P.tif. It is saved automatically as a TIFF and with -Edit-P appended to the filename, in accordance with the way Lightroom's External Editing preferences were configured back in Lesson 1. If you did not follow along with Lesson 1, you may get a different filename and format when you save the file.

10 Click the document tab labeled aqua.tif. Repeat steps 4 and 6 through 9 (Mac) or 5 through 9 (Windows) to place the same logo.psd file in this document too.

When you save this document with these changes, its filename changes to aqua-Edit-P.tif. Leave this document open.

11 Click the document tab labeled purple.tif. Repeat steps 4 and 6 through 9 (Mac) or 5 through 9 (Windows) to place logo.psd in this document too. When you save this document with these changes, its filename changes to purple-Edit-P.tif.

12 Choose File > Save (or press Ctrl-S/Command-S). Then choose File > Close (Ctrl-W/Command-W) to close purple-Edit-P.tif.

The documents gold-Edit-P.tif and aqua-Edit-P.tif are the only documents now open in Photoshop.

13 Click the document tab labeled gold-Edit-P.tif. In the Layers panel for gold-Edit-P.tif, double-click the thumbnail on the logo layer. Click OK at the prompt about saving.

This opens the Smart Object as a separate document—logo.psd— in Photoshop.

14 In the Smart Object document logo.psd, choose Select All (or press Ctrl-A/Command-A).

15 Choose Edit > Stroke.

16 In the Stroke dialog, enter **20 px** in the Width field.

17 Click the Color field in the Stroke dialog to open the Color Picker. Click the aqua color in the logo to set the Color field in the dialog to aqua. Click OK in the Color Picker to close the Color Picker.

18 In the Location section of the Stroke dialog, choose Inside, and click OK to close the Stroke dialog and apply the stroke.

19 Choose Select > Deselect (or press Ctrl-D/Command-D).

The linked Smart Object in logo.psd has been modified to include an aqua border.

20 Choose File > Save (Ctrl-S/Command-S). Then choose File > Close (or press Ctrl-W/Command-W).

It's important to use the Save command, rather than Save As, so that the Smart Object is saved without changing its name, location, or format.

This updates the Smart Object in gold-Edit-P.tif to display an aqua stroke around the logo.

21 Click the document tab of the other document that is still open in Photoshop, aqua-Edit-P.tif. Notice that the logo in this document has also been updated with an aqua stroke around the logo. This happened automatically because these two open documents share a linked Smart Object.

The important point is that changing a linked Smart Object in one document automatically updates that same linked Smart Object in any other document that is currently open in Photoshop. However, that is not the case for documents that contain the linked Smart Object but are not open, as you'll see next.

22 In Photoshop, choose File > Save (or press Ctrl-S/Command-S); then choose File > Close (or press Ctrl-W/Command-W) to close aqua-Edit-P.tif. Repeat this step on gold-Edit-P.tif to save and close that document too.

Again, it is important to use the Save command, so that the filename, location, and format remain unchanged.

23 Return to the Lightroom's Library module to see how Lightroom has kept track of the changes to the linked Smart Object in the three files that you worked on in Photoshop.

Two of the files display the change to the linked Smart Object: the gold version, in which you made that change, and the aqua version, which was open in Photoshop at the time you made the change in the gold version. The purple version, which also contains the linked Smart Object but was not open when the Smart Object was changed in the gold version, does not display the update.

● **Note:** Edit Original is the best choice when you want to access individual layers in Photoshop when handing off a layered RGB file from Lightroom to Photoshop.

24 Select purple-Edit-P.tif in the Library module and press Ctrl-E/Command-E. In the Edit Photo with Adobe Photoshop CC dialog, choose Edit Original.

The file opens into Photoshop with both of its layers displayed in the Layers panel.

The thumbnail on the logo layer in purple-Edit-P.tif displays a yellow warning, which means that the linked Smart Object has changed externally but has not yet been updated in this file.

25 Right-click/Control-click the logo layer (not the layer thumbnail) and choose Update Modified Content from the menu.

Convert to Smart Object
New Smart Object via Copy
Reveal in Finder
Update Modified Content

Alternatively, choose Window > Properties to open the Properties panel, if it's not already open. In the Properties panel, click the yellow triangle, and from the menu that appears, choose Update Modified Content.

This updates the linked Smart Object in purple-Edit-P.tif, adding an aqua stroke around the logo in this document too.

The point to remember is that if you update a linked Smart Object that is contained in documents that are currently closed, you must open those documents one by one and choose whether to update the linked Smart Object in each document. Photoshop does not assume that when you update a linked Smart Object in one document you want to update it in every closed document in which it appears.

26 Choose File > Save (or press Ctrl-S/Command-S). Then choose File > Close (or press Ctrl-W/ Command-W) to close purple-Edit-P.tif.

Back in Lightroom, purple-Edit-P.tif now displays the modified linked Smart Object.

Creating a 32-bit merged HDR

Your camera cannot capture the full dynamic range that your eye can see in a high-contrast situation. A solution is to shoot multiple bracketed exposures and merge them into a high dynamic range (HDR) composite. Using Lightroom and Photoshop together to do this is a great way to achieve a natural-looking HDR image with detail in highlights, midtones, and shadows.

You'll use Photoshop to merge the original photographs into a 32-bit file packed with image data, and then you'll apply Lightroom's familiar Develop controls to tone map the HDR image. This technique requires Lightroom 4.1 or later.

Tip: When you shoot multiple exposures for HDR, bracket by varying the shutter speed, not the aperture, in your camera. A tripod is helpful but not always necessary. The optimal number of shots and amount to bracket varies with the brightness and contrast in the scene and the capabilities of your camera. These three exposures were shot handheld, 2/3 of a stop apart, in bright daylight.

1 With the Lesson 5 folder selected in Lightroom's Library module, select 4458.dng in the grid. Take a look at the information under the histogram in the Library module's Histogram panel. Then do the same for 4459.dng and 4460.dng.

 Notice that the shutter speed changed between these three shots of the same scene, producing three different exposures: one overexposed to bring out shadow detail, one underexposed to retain highlight detail, and one in between. You'll merge these three exposures into a single HDR image.

2 Press D on the keyboard to switch to the Develop module.

3 Press F6 (or fn-F6) to open the Filmstrip if it is not already open. In the Filmstrip, select 4460.dng; then Ctrl-click/Command-click the other two shots of the scene (4458.dng and 4459.dng) to select them too.

4 If the Auto Sync button is not showing at the bottom left of the column on the right side of the Develop module, click the panel switch to the left of the Sync button to switch it to Auto Sync.

5 In the Lens Corrections panel, check the Remove Chromatic Aberration check box. This correction is applied automatically to the other two selected shots too.

Lens Corrections panel adjustments and Detail panel adjustments are among the adjustments you might make in Lightroom before merging to HDR. Don't bother making tonal adjustments at this stage; you'll be tone mapping the merged image later in this exercise.

6 Click the photograph to zoom in to 1:1 view, and pan to an area of blue sky to view the luminance noise there. In the Noise section of the Detail panel, drag the Luminance slider slightly to the right to reduce noise. This adjustment is applied automatically to the other two selected shots too.

7 Toggle the panel switch to the left of the Auto Sync button so the button reads Sync.

8 With all three shots of the scene still selected in the Filmstrip, choose Photo > Edit In > Merge to HDR Pro in Photoshop.

Tip: If you want to fine-tune an adjustment, such as noise reduction, on an individual shot, make sure Auto Sync is turned off, select only that thumbnail in the Filmstrip, and make the adjustment.

This passes the three shots from Lightroom to Photoshop, where they are aligned and merged into a single image that is displayed in Photoshop's Merge to HDR Pro dialog. This may take a minute to complete.

9 In the Merge to HDR Pro dialog, make sure Mode is set to 32 Bit.

The other options in the Mode menu produce files with much less image data and offer their own controls for tone mapping. The advantages of the 32 Bit option are that it creates a file with maximum image data, and you can use the familiar adjustment controls in Lightroom's Develop module to tone map the file that Photoshop produces.

10 In the Merge to HDR Pro dialog, check the Remove Ghosts check box.

In the merged image, this reduces blur resulting from movement in the scene between component shots. There may have been trees blowing in the wind, clouds moving in the sky, or in this case, water rippling in the pond (which you can barely see if you zoom in using the zoom control at the bottom left of the Merge to HDR Pro dialog).

11 In the Merge to HDR Pro dialog, click the thumbnail of the image that you want to use as the basis for removing ghosting.

When you're zoomed in on the ripples in the water, you may notice a very slight difference as you click among these thumbnails. Choose the thumbnail that offers the look you like best.

Ignore the other options in the Merge to HDR Pro dialog box. The White Point Preview slider affects only the preview in this dialog. The Complete Toning in Adobe Camera Raw check box is for a different workflow. And don't worry about the appearance of the image in this dialog; you'll adjust that soon in Lightroom.

12 Click OK to close the Merge to HDR Pro dialog box.

The merged 32-bit file appears in Photoshop. Again, don't worry about the way it looks here in Photoshop.

13 In Photoshop, do nothing to the merged image. Just choose File > Save (or press Ctrl-S/Command-S), and then choose File > Close (or press Ctrl-W/Command-W).

This saves the 32-bit floating-point merged file to the same location as the individual shots of the scene and imports this file into the Lightroom catalog so it appears in the Library module grid. The resulting file is a TIFF with -Edit-P appended to the filename (4458-Edit-P.tif), per the Lightroom External Editing preferences you set up in Lesson 1.

14 In Lightroom's Develop module, make sure that the merged file created in the preceding step, 4458-Edit-P.tif, is selected in the Filmstrip.

If your Library module grid is sorted by filename, the TIFF should appear next to its component images in the Develop module Filmstrip. If not, look for the file by name in the Filmstrip. When you select a thumbnail in the Filmstrip, its filename appears in the black bar at the top of the Filmstrip.

Note: An HDR image can be tone mapped to look realistic or super-realistic. The realistic approach brings out detail but leaves the image looking natural. The super-realistic look emphasizes local contrast and detail and is either very saturated or sometimes under-saturated for a grungy style.

You'll use the familiar controls in the Develop module to tone map the 32-bit merged file that Photoshop created. In this example, the goal is to take advantage of the large amount of detail in this merged file but keep the resulting image looking natural.

Approach the Develop module controls much as you would for any image. They work the same way on a 32-bit merged file as they do on other images, except that some of the sliders have a wider range of values. For example, the Exposure slider in the Basic panel ranges from −10 to +10, as compared to the normal −5 to +5.

15 First, make global adjustments to the merged file in the Develop module's Basic panel:

- Increase Exposure to brighten the image.

- Increase Contrast to expand the tonal range.

- Decrease Highlights quite a bit to reveal more detail in the clouds.

- Increase Shadows quite a bit to bring in more detail in the shadow areas, particularly in the vegetation behind the pond.

- Set the white and black points.

- Increase Clarity and Vibrance to add punch (but not too much if you want a realistic look).

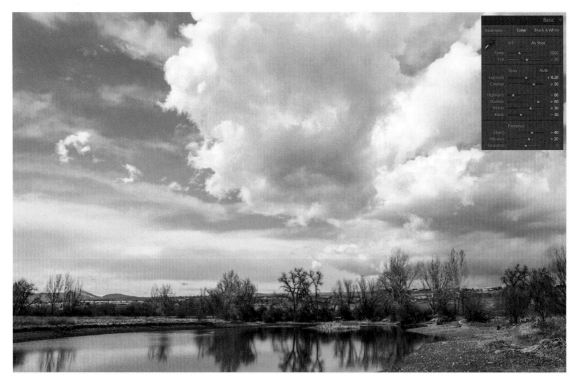

16 In the HSL panel, select the Saturation tab and drag the Blue slider to reduce the saturation in the sky. Select the Targeted Adjustment tool at the top left of the Saturation tab, and drag up on vegetation in the image to increase saturation in the orange and yellow color ranges.

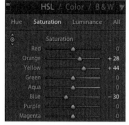

17 Select the Radial Filter tool in the tool strip beneath the Histogram panel. In the Radial Filter drop-down panel, double-click the Effect label to reset the sliders.

Note: Lesson 4 covers Lightroom's global adjustment controls and local adjustment tools in depth. Review that lesson for more detail if necessary.

18 In the Radial Filter panel, add a check mark to the Invert Mask check box so that the filter acts more like a spotlight than a vignette. Increase the Exposure, Contrast, Clarity, and Saturation sliders.

19 Drag over the right side of the pond to add a radial filter that emphasizes the reflections in the pond. Fine-tune the settings to your taste in the Radial Filter panel.

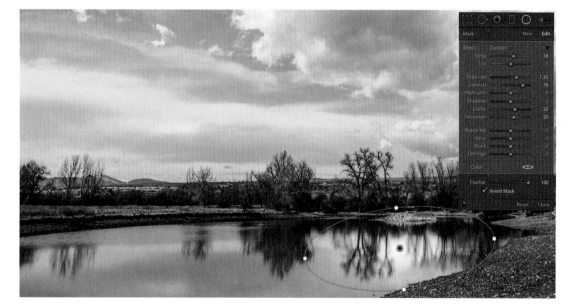

20 In the image, right-click/Control-click the pin for the radial filter on the right side of the pond and choose Duplicate. Drag the duplicate radial filter by its pin to the left side of the pond. Click Close at the bottom of the Radial Filter panel to close the panel.

21 Select the Crop tool in the tool strip under the Histogram panel. Drag one or more of the corner anchor points to resize the crop box. Drag inside the crop box to reposition the image. Press Enter/Return on the keyboard or click the Done button in the toolbar under the image to commit the crop.

Like all Lightroom adjustments, this crop is nondestructive and re-editable. Cropping the merged HDR image, rather than its component shots, gives you more flexibility to crop the final product in a different way in the future.

The final image remains in your Lightroom catalog as a 32-bit image and can be exported at different bit depths as necessary.

Merging to a panorama

Sometimes you don't have a lens that is wide enough to shoot an entire scene. In that case, you can capture multiple overlapping shots and merge them into one panoramic image in Photoshop. To pass those shots from Lightroom to Photoshop, you'll use Lightroom's Merge to Panorama in Photoshop command.

1 In Lightroom's Develop module, press F6 (or fn-F6) if the Filmstrip is not showing. In the Filmstrip, select p-1328.jpg (the first of a series of four photographs of Lake Annecy, France).

This photograph and the others in the series could use some additional contrast and removal of chromatic aberration. You'll make those Lightroom adjustments to this photograph and sync the adjustments to the other three photographs so the components of the panorama match.

▶ **Tip:** When you shoot images for a panorama, try to overlap each shot with the preceding one by about 30 percent. Set your camera to manual focus and manual exposure so those parameters don't change automatically as the camera moves from shot to shot.

PHOTOGRAPHS © JAN KABILI 2013

2 In the Develop module's Basic panel, drag the Contrast slider and the Clarity slider to the right.

3 In the Basic tab of the Lens Corrections panel, check the Remove Chromatic Aberration check box.

4 With p-1328.jpg selected in the Develop module Filmstrip, Ctrl-click/ Command-click each of the other three shots in the series: p-1329.jpg, p-1330.jpg, and p-1331.jpg.

The thumbnail with the brightest frame—the one whose settings will be synced to the others—is the one you just corrected, p-1328.jpg.

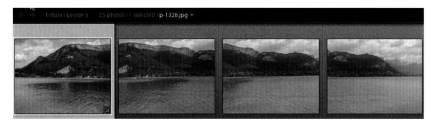

5 Click the Sync button at the bottom left of the right column in the Develop module to open the Synchronize Settings dialog. If you don't see the Sync button, click the panel switch to the left of the Auto Sync button to switch it to Sync.

6 In the Synchronize Settings dialog, click Check All. Then click Synchronize.

All the adjustments you made to the first photograph are applied to the other three in the series.

7 Make sure all four photographs are still selected in the Filmstrip, and choose Photo > Edit In > Merge to Panorama in Photoshop.

This opens Photoshop's Photomerge dialog with the four files you selected in Lightroom listed in the column labeled Source Files.

8 Leave the Auto option selected in the Layout column on the left of the Photomerge dialog.

This controls the layout method that Photoshop will use to fit the components of the panorama together. In many cases, Auto produces the best result. Sometimes, however, getting to the best result is a matter of trial and error that requires returning to this point and trying again with another method.

9 In the Photomerge dialog, make sure there is a check mark in the Blend Images Together check box.

This will cause Photoshop to blend the four images using a series of layer masks.

10 In the Photomerge dialog, leave Vignette Removal and Geometric Distortion Correction unchecked.

Shooting with a wide-angle lens can sometimes cause lens-related problems that can interfere with a panorama, such as vignetting (darkened corners) and geometric distortion. These are not issues in this case, so leave the boxes unchecked.

11 Click OK to close the Photomerge dialog.

Photoshop begins the process of combining and aligning all four images in a single document. Photoshop blends the edges of the images together by creating a complex layer mask for each layer in the document, which you can see in the Layers panel.

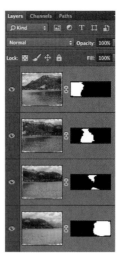

The result is a seamlessly blended panorama of the lake.

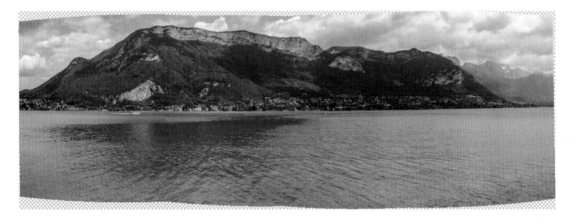

The gray and white checkerboards at the edges of the panorama are transparent pixels resulting from Photoshop's alignment of the component images.

You could try to fill the transparent pixels with content using the Content-aware fill command, or you could crop away the transparent pixels as detailed in steps 12 through 14. If you want to try the Content-aware fill method instead:

- Select the topmost layer in the Layers panel and press the keyboard shortcut Ctrl-Alt-Shift-E/Command-Option-Shift-E to create a merged layer.

- With the merged layer selected in the Layers panel, make a selection around an area of transparent pixels with any of the selection tools, including a bit of the image in the selection.

- Choose Edit > Fill, and in the Fill dialog box choose Use > Content-aware and click OK.

Photoshop attempts to replace the transparent pixels with content from the panorama. In this case, you may not get a result you like in each of the transparent areas, and you won't lose much of the image if you crop away the transparent areas instead, as in the following steps.

12 Select the Crop tool in the Tools panel, and click the image to display a crop box around the entire image.

13 Drag the edges of the crop box just inside the transparent pixels at the top and sides of the panorama to hide the transparent areas. To improve the composition of the panorama, drag the bottom line of the crop box up until the lower horizontal line in the rule-of-thirds overlay is near the horizon line.

14 Press Enter/Return on the keyboard to complete the crop.

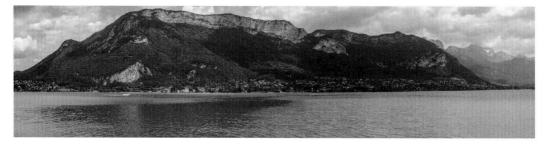

15 Choose File > Save (or press Ctrl-S/Command-S). Then choose File > Close (or press Ctrl-W/Command-W) and choose Save at the prompt.

This saves the panorama to the same location as its component images and imports it into the Lightroom catalog. The file is saved as a TIFF, with -Edit-P appended to the filename (p-1328-Edit-P.tif), in accordance with the Lightroom External Editing preferences you chose in Lesson 1.

16 Back in Lightroom, the thumbnail of the p-1328-Edit-P.tif panorama appears in the Develop module Filmstrip and in the Library module grid along with its component images.

Review questions

1 What is the Lightroom menu choice for handing off multiple files from Lightroom to Photoshop to create a multi-layered document in Photoshop?

2 What Photoshop feature would you use to blend textures with photographs?

3 If you place a raw file in a Photoshop document as an embedded Smart Object, what happens when you double-click the thumbnail on the layer that contains the embedded Smart Object?

4 On a layer mask, does black reveal or conceal?

5 If you make a change to a linked Smart Object in one Photoshop document, will the same linked Smart Object in a second Photoshop document always change automatically too?

Review answers

1 Photo > Edit In > Open as Layers in Photoshop hands off multiple files from Lightroom to Photoshop to create a multi-layered document in Photoshop.

2 Layer blend modes are useful for blending textures with photographs.

3 When you double-click the thumbnail on a layer that contains an embedded Smart Object, the Smart Object opens in Camera Raw.

4 On a layer mask, black conceals.

5 No. If you change a linked Smart Object in one Photoshop document, the same linked Smart Object in a second document will change automatically only if the second document is open in Photoshop at the time of the change.

6 LIGHTROOM TO PHOTOSHOP FOR SELECTING AND MASKING

Lesson overview

Lightroom's local adjustment tools may be all you need to bring out the beauty of individual areas in many photographs, but Photoshop's ability to isolate part of a photograph for individual treatment is unmatched.

This lesson walks you through practical scenarios in which you'll hand off photographs from Lightroom to Photoshop, use Photoshop selections and masks to work on targeted areas, and bring the results back into Lightroom.

Topics in this lesson include:

- Making precise selections with Photoshop's Quick Selection tool, Polygonal Lasso tool, Magnetic Lasso tool, and Pen tool

- Recoloring objects using selections and masks with fill layers

- Making targeted adjustments using selections with adjustment layers

- Replacing a dull sky with the Paste Into command

- Making a complex selection using a channel mask

- Selecting hair using Refine Edge

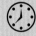 You'll probably need from 2 to 2 1/2 hours to complete this lesson.

Photographs in composite © Jason Stitt—Fotolia and
© yellowj—Fotolia

One of the main reasons to hand off a photograph
from Lightroom to Photoshop is to take advantage
of Photoshop's sophisticated selection and masking
capabilities.

Preparing for this lesson

Do the following to prepare for this lesson:

1 Make sure you've followed the instructions in the Getting Started lesson at the beginning of this book for setting up an LPCIB folder on your computer, downloading the lesson files to that LPCIB folder, and creating an LPCIB catalog in Lightroom.

2 If the Lesson 6 files are not already on your computer, download the Lesson 6 folder from your account page at www.peachpit.com to *username*/Documents/LPCIB/Lessons.

3 Open the LPCIB catalog you created in the Getting Started lesson by doing the following: Hold the Alt/Option key as you start Lightroom; then in the Select Catalog dialog, select the LPCIB Catalog.lrcat file and click the Open button.

4 Import the Lesson 6 files into the open LPCIB catalog following the bullet steps below. This is similar to the process for importing any photographs that are already on a drive (see "Importing from a drive" in Lesson 1 for more details):

 • Click the Import button in the Library module.

 • In the Import window's Source panel, navigate to *username*/Documents/LPCIB/Lessons and select the Lesson 6 folder. Make sure the Include Subfolders check box at the top of the Source panel and to the right of the Files label is checked.

 • In the Import window's workflow bar, choose Add as the import method.

 • Leave all the thumbnails in the Import window checked.

 • In the File Handling panel on the right side of the Import window, choose Build Previews > Standard. Leave the other File Handling options unchecked.

 • In the Apply During Import panel on the right side of the Import window, enter **Lesson 6** in the Keywords field.

 • Click the Import button at the bottom right of the Import window.

5 In the Library module, select the Lesson 6 subfolder in the Folders panel.

Why move to Photoshop for selecting and masking?

Why would you take a photograph from Lightroom to Photoshop to make use of selections and masks? There are two main reasons—precision and functionality.

Photoshop's many selection and masking options allow you to isolate a complex object or tonal range with more precision than Lightroom's local adjustment tools. Lightroom's Adjustment Brush tool does have an Auto Mask option that looks for image edges, but it does not give you the control or precision of selecting and masking that Photoshop does. For more detail on Lightroom's local adjustment tools—the Graduated Filter tool, Radiant Filter tool, and Adjustment Brush tool—see Lesson 4, "Processing Photos in Lightroom's Develop Module."

Lightroom's local adjustment tools also have a narrower purpose than Photoshop selections and masks. Lightroom's local tools are designed for selectively adjusting a finite set of photo qualities, which are listed in the drop-down panel for each of the local tools. A Photoshop selection or mask defines an area that can be affected by a wider variety of creative techniques and adjustments. For example, you might use a selection to fill an area with color or content, to add a stroke around an area, or to copy an object. Selections are also frequently used with masks to limit the areas affected by Photoshop's flexible adjustment layers and to replace backgrounds in composites.

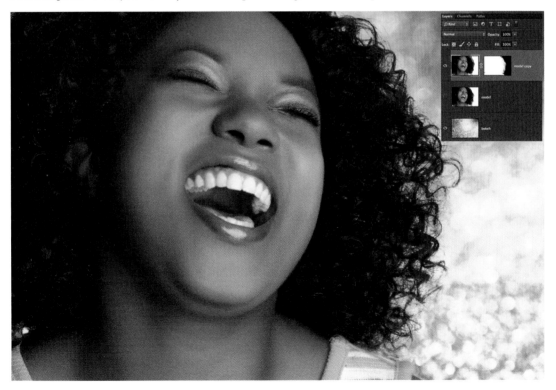

Making precise selections in Photoshop

One reason to take a photograph from Lightroom to Photoshop is to isolate a well-defined area more precisely than you can in Lightroom. The selection tools profiled in this section are those that are most useful for that purpose. This section gives you an idea of how these tools work, so you'll be ready to use them in the projects that follow. If you want to try out these techniques, open m-bottles.jpg directly into Photoshop from *username*/Documents/LPCIB/Lessons/Lesson 6.

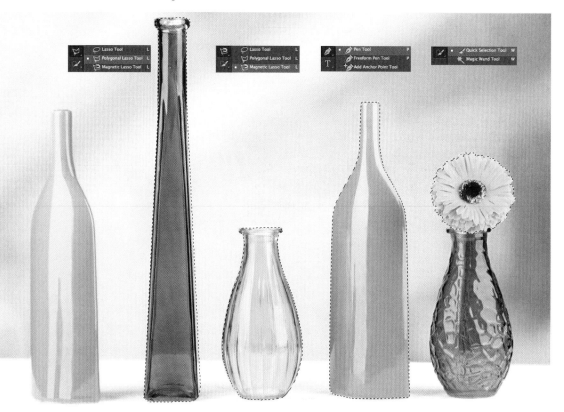

The Quick Selection tool

The Quick Selection tool is the selection tool that many reach for first, because it's so easy to apply. This tool automatically selects based on color edges in an image. The Quick Selection tool works particularly well on an object or area that has a well-defined edge.

The Quick Selection tool is located in the Tools panel with the Magic Wand tool, which also selects based on color.

To apply the Quick Selection tool, drag across the object or area you want to select. The tool continuously samples the color under your cursor and selects similar contiguous colors, stopping when it detects an edge where there is a change in color. If you want to select more, just continue to drag.

To get the best results from the Quick Selection tool, make the brush tip small by pressing the Left Bracket key ([) on the keyboard and hard by pressing Shift-Right Bracket key (]). Before applying the Quick Selection tool, go to the options bar and check Auto-Enhance. When Auto-Enhance is not checked, a selection made with this tool is likely to have a rough edge. Check Sample All Layers if there are multiple layers in a document and you want the Quick Selection tool to take account of all the layers.

The Quick Selection tool's default in the options bar is the Add to Selection icon (+), which allows you to quickly add more areas to an initial selection by dragging over those areas too. This is one of the advantages of the Quick Selection tool over other selection tools, most of which default to making a new selection rather than adding to a selection.

If you've selected too much and you want to remove areas from a selection, click the Subtract from Selection icon (−) in the Quick Selection tool's options bar; then drag over the areas you want to remove from the selection.

Selection shortcuts

There are some shortcuts that are crucial to know when you are working with selections, because you'll use them so frequently:

- To deselect, press Ctrl-D/Command-D (or choose Select > Deselect).
- To select all, press Ctrl-A/Command-A (or choose Select > All).
- To add to a selection, hold the Shift key as you select another area that is contiguous to or in a different part of the image from the initial selection (or, with a selection tool active, click the Add to Selection icon in the options bar).
- To subtract from a selection, hold the Alt/Option key as you select the area you want to remove from the selection (or, with a selection tool active, click the Subtract from Selection icon in the options bar).
- To invert a selection (to select everything except what is currently selected), press Ctrl-Shift-I/Command-Shift-I.

The Polygonal Lasso tool

The Polygonal Lasso tool is a great choice for making straight-edged selections.

To select this tool, press the Lasso tool in the Tools panel and choose Polygonal Lasso Tool from the fly-out menu.

To use this tool, click the edge of an object to create a starting point for a straight-line segment. Without pressing down, move (float) your cursor along the edge of the object. As you do, a line follows your cursor. When you reach the end of a straight area of the object, click to set an end point for the line segment.

Continue clicking around the object. If you make a mistake, you can undo attachment points one by one by pressing the Backspace/Delete key on the keyboard and moving the cursor back toward the preceding attachment point. Then continue to click forward around the object, adding attachment points. When you are near the starting attachment point, double-click to close the selection.

Note: How do you stop the Polygonal Lasso tool from following your cursor if you want to abandon a selection before it's complete? Just press the Escape key on the keyboard.

Using multiple selection tools together

You can mix and match selection tools, using more than one method to create a single selection. For example, you might make an initial selection with the Magic Wand tool and fine-tune it manually with the Lasso tool, adding to and subtracting from the selection until it is just the way you want it.

Keep in mind that most selection tools (with the exception of the Quick Selection tool) default to the New Selection option. So if you make an initial selection with one tool and then switch to a second selection tool and click the image, the initial selection will disappear.

To avoid that, with the second selection tool highlighted in the Tools panel, activate the Add to Selection icon in the options bar (or press the Shift key on the keyboard). Then click the image to continue selecting without deleting the initial selection.

The additional selection can be contiguous with or in a different part of the image than the initial selection.

To remove part of a selection with the Polygonal Lasso tool, click the Subtract from Selection icon in the options bar; then click around the area you want to remove, double-clicking when you reach your starting point.

If there is a non-straight edge to include in the selection, you can change the Polygonal Lasso tool to the Lasso tool temporarily and draw a portion of the selection freeform. To do that, press down on the mouse button, hold the Alt/Option key to switch to the Lasso tool, and drag to create a freeform segment. To switch back to the Polygon Lasso tool, release the Alt/Option key and release the mouse button. Then continue to click with the Polygonal Lasso tool to create more straight-line segments.

The Magnetic Lasso tool

The Magnetic Lasso tool is useful for selecting a complex object with a well-defined edge.

To use this tool, click a high-contrast edge of an object to set a starting anchor point. Without pressing down, float the cursor along the edge of the object. As you do, the Magnetic Lasso tool automatically adds anchor points and line segments along that edge.

If you get to an area where the tool is having trouble finding the correct edge, first undo any incorrect anchor points manually, one by one, by pressing the Backspace/Delete key on the keyboard and moving the cursor back toward the preceding anchor point.

Then move forward again, clicking along the edge to set your own anchor points manually. When you get to another place where the object edge is well-defined, continue floating the cursor around the object without pressing down, allowing the tool to add anchor points automatically, until you are near the starting point. Then double-click to close the selection.

If the tool is selecting an incorrect edge, try reducing the size of the brush tip. To see the brush tip, press the Caps Lock key on the keyboard. (You also may have to move the cursor a bit.) Press the Left Bracket key ([) on the keyboard to reduce the size of the brush tip, and keep the cursor close to the object edge as you float it around the object.

Cleaning up a selection in Quick Mask mode

Quick Mask mode converts a selection to a temporary mask, which you can use to clean up the selection.

1 After making an initial selection with any selection tools, enter Quick Mask mode by clicking the Quick Mask button ▣ near the bottom of the Tools panel (or press Q on the keyboard).

 This adds a red, semi-transparent overlay over the selected part of the image.

 If the content of the image is difficult to see under red, you can change the mask to a different color. To do that, double-click the Quick Mask button in the Tools panel, and in the Quick Mask Options dialog, double-click the color field. In the Color Picker that opens, choose a different color and click OK. Click OK again in the Quick Mask Options dialog.

2 Select the Brush tool in the Tools panel and set the brush tip to be relatively small and hard.

 Painting with the Brush tool in Quick Mask mode is an efficient way to clean up the edge of a selection. You can use a variety of other Photoshop features in Quick Mask mode too, including selection tools.

3 Press D on the keyboard to set the Foreground Color box to black, and brush over any areas not covered by the red mask that you want to add to the selection. This will extend the red overlay to these areas.

 The only colors available to paint with are black, white, and gray, because a mask is a grayscale element.

4 Press X on the keyboard to switch the Foreground Color box to white, and brush over any areas currently covered by the red mask that you want to subtract from the selection. This will remove the red overlay from these areas.

5 Click the Quick Mask button again (or press Q on the keyboard) to exit Quick Mask mode and return to the marching ants view of the selection.

Quick Mask mode gives you a more accurate view of a selection edge than the marching ants. You can switch to Quick Mask mode any time to evaluate a selection edge.

The Pen tool

The Pen tool is the most precise of all the selection tools. It can also be a frustrating tool to learn to use. But once you get the hang of it, the Pen tool will help you produce selections that are as exact as possible. This tool is ideal for selecting items with smooth, curved edges.

To use the Pen tool, select it in the Tools panel. In the options bar, make sure the first drop-down menu in the options bar is set to Path. Click the gear icon and check the Rubber Band check box. The Rubber Band option allows you to preview a path segment before you set its ending anchor point.

By default the Pen tool creates a vector path that is composed of curved and straight-line segments connected by anchor points. After you've created a path with the Pen tool, you can convert it into a selection.

Click the edge of an object in the image to set a starting anchor point. To create a straight-line segment, move to a spot along the object edge and click.

To create a curved segment, move to the next spot where the object edge changes direction. This time, instead of clicking, drag in the direction you want the curved segment to go. This creates an anchor point with two handles. The direction and length of the handles determine the shape of the curved segment. Continue around the object, creating curved and straight segments.

If you set some anchor points incorrectly, press Ctrl-Z/Command-Z to undo the last anchor point; press Alt-Ctrl-Z/Option-Command-Z to undo preceding points.

If you get to a place on the object edge where you need to change direction, set the ending anchor point for the preceding segment, as you've been doing; then Alt-click/Option-click that anchor point to convert it into a corner point. Continue in the new direction, creating segments as before.

When you arrive back where you started the path, hover over the starting anchor point until a small circle appears near the cursor; then click the anchor point to close the path.

To convert the active path into a selection, with the Pen tool selected in the Tools panel, go to the options bar and choose the Selection button from the Make options (or right-click/Control-click the Path and choose Make Selection).

In the Make Selection dialog that opens, leave the options at their default settings, as in the illustration, and click OK.

There is now a selection around the object, represented by marching ants.

The Pen tool is a powerful selection tool, but selecting isn't all it does. For more detail on the Pen tool and working with the paths it creates, see the section "About paths and the Pen tool" in Chapter 8 of *Adobe Photoshop CC Classroom in a Book*.

Changing the color of objects with fill layers

One of the many practical reasons to take a photograph from Lightroom to Photoshop is to use selections and masks to change the color of part of the photograph. This is particularly useful if you use photographs in design or business. For example, you might want to recolor an item you're marketing to show it off in different colors.

In this exercise, you'll take photographs from Lightroom to Photoshop to use Solid Color fill layers and Gradient fill layers with selections and masks to create colorful designs in parts of the photographs.

Recoloring with a Solid Color fill layer

Solid Color fill layers are useful for changing the color of individual areas in a photograph.

1 In Lightroom's Library module, select the Lesson 6 folder in the Folders panel.

2 Select cr-train.jpg in the Library module grid, and press D on the keyboard to switch to the Develop module.

3 In the Develop module's Basic panel, make adjustments to color and tone as you see fit. The exact adjustments and values you choose don't matter for this exercise.

4 Choose Photo > Edit In > Edit in Adobe Photoshop CC (or press Ctrl-E/Command-E on the keyboard).

5 In the Edit Photo with Adobe Photoshop CC dialog, choose Edit a Copy with Lightroom Adjustments, and click Edit.

6 In Photoshop, select the Polygonal Lasso tool from the fly-out menu of lasso tools in the Tools panel.

7 With the Polygonal Lasso tool, make a rectangular selection around a decorative stripe on the side of the train. If you select too much, click the Subtract from Selection icon in the options bar and remove that area from the selection.

For more detail on how to use the Polygonal Lasso tool, see the section "The Polygonal Lasso tool" earlier in this lesson.

8 With the selection active, go to the bottom of the Layers panel, click the Create New Fill or Adjustment Layer icon, and choose Solid Color (or choose Layer > New Fill Layer > Solid Color).

● **Note:** Every fill layer comes with its own layer mask. If a selection is active when the fill layer is created, the selected area is white on the mask, revealing the content of the fill layer, and the non-selected area is black on the mask, concealing the fill layer.

9 In the Color Picker that opens, select a color and click OK.

This fills the selection with solid color and creates a Solid Color fill layer, Color Fill 1, in the Layers panel. The Solid Color fill layer has an automatic layer mask that is white inside the area you selected and black outside that area.

10 With the Color Fill 1 layer selected in the Layers panel, choose Color from the blend mode menu at the top left of the Layers panel (the menu labeled Normal by default).

The Color blend mode changes the solid color in the area you had selected to a tint, which allows the tonal values of the photograph to show through for a realistic look.

11 You can select and recolor other parts of this image the same way. When you're finished, choose File > Save (or press Ctrl-S/Command-S). Then choose File > Close (or press Ctrl-W/Command-W) to close the image in Photoshop.

This saves the edited photo to the same folder as the original and imports it into Lightroom. The saved copy is a TIFF, with the filename cr-train-Edited-P.tif, in accordance with the Lightroom External Editing preferences you set in Lesson 1.

Designing with a Gradient fill layer

1 Back in Lightroom, select cr-engine.jpg from the Filmstrip in the Develop module or from the grid in the Library module.

2 Press Ctrl-E/Command-E, and in the dialog that opens choose Edit a Copy with Lightroom Adjustments and click Edit.

3 In Photoshop, select the Pen tool and create a path around the yellow area on the engine. Then go to the options bar and click the Selection button in the Make options to convert the path into a selection.

For more details on how to use the Pen tool, see the section "The Pen tool" earlier in this lesson.

Alternatively, you could use the Magnetic Lasso tool or the Quick Selection tool to select the yellow area. See the sections "The Magnetic Lasso tool" and "The Quick Selection tool" earlier in this lesson for details.

4 Select the Rectangular Marquee tool in the Tools panel, and select the Subtract from Selection option for that tool in the options bar.

5 In the image, drag from just above the upper-left corner of the door down and to the right to remove the door from the selection, so that the selection resembles the illustration.

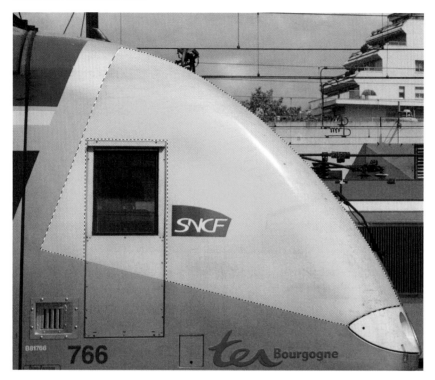

If you click the image with the Rectangular Marquee tool before switching to the Subtract from Selection option, your initial selection may move or disappear, depending on where you click. If that happens, press Ctrl-Z/ Command-Z.

6 Click the Create New Fill or Adjustment Layer icon at the bottom of the Layers panel and choose Gradient (or choose Layer > New Fill Layer > Gradient, and click OK).

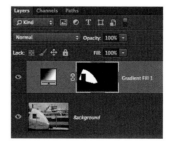

This fills the selection with a gradient and creates a Gradient fill layer, Gradient Fill 1, in the Layers panel. The Gradient fill layer has an automatic layer mask that is white inside the area you selected and black outside that area.

7 In the Gradient Fill dialog, click the Gradient field to open the Gradient Editor.

8 In the Gradient Editor, select the Yellow, Violet, Orange, Blue gradient preset and click OK.

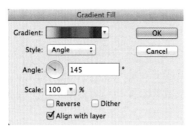

9 In the Gradient Fill dialog, choose Angle from the Style menu and enter **145** in the Angle field. Click OK.

10 With the Gradient Fill 1 layer selected in the Layers panel, choose the Color Burn blend mode to blend the colors of the gradient with the train engine and retain the engine's photographic shading.

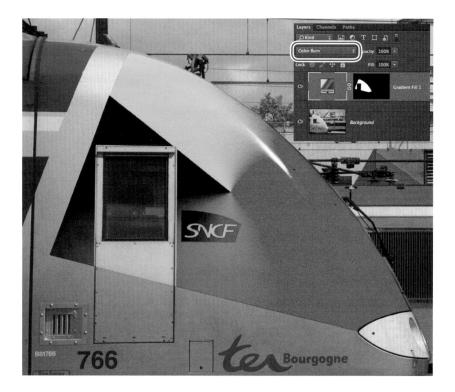

11 Choose File > Save (or press Ctrl-S/Command-S). Then choose File > Close (or press Ctrl-W/Command-W) to close the image in Photoshop.

This saves the edited photo to the same folder as the original and imports it into Lightroom. The saved copy is a TIFF, with the filename cr-engine-Edited-P.tif, in accordance with the Lightroom External Editing preferences you set in Lesson 1.

Thumbnails of the recolored TIFF copies of the train and engine photographs are visible in the grid in Lightroom's Library module.

PHOTOGRAPHS © JAN KABILI 2012

Making selective adjustments with adjustment layers

Photoshop's selection tools are particularly useful when you want to make separate adjustments to objects that have complex but well-defined shapes. Using selections with Photoshop adjustment layers allows you to apply independent adjustments to precisely targeted objects in a photograph.

Starting in Lightroom

This improperly exposed raw file can be improved by global adjustments in Lightroom, along with adjustment layers and selections in Photoshop. Start by applying some adjustments in Lightroom that affect the entire photograph.

1 In Lightroom's Library module, with the Lesson 6 folder selected, select adj-statue.dng. Press D to open this image in the Develop module.

2 In the Develop module's Basic panel, increase the Exposure slider about half a stop (+.50) so you can get a better look at this underexposed photograph.

3 In the Basic tab of the Lens Corrections panel, check the Enable Profile Corrections check box.

This corrects for the dark corners (vignetting) and slight geometric distortion caused by the lens with which this photograph was shot. If you don't see improvements in the image when you check Enable Profile Corrections, click the Profile tab in the Lens Corrections panel and choose Nikon from the Make menu. This may trigger Lightroom to find and apply the correct lens profile.

4 Check the Remove Chromatic Aberration check box in the Basic tab of the Lens Corrections panel.

This removes some green fringing along the edge of the stonework in the photograph.

5 In the Presets panel on the left side of the Develop module, click the triangle to the left of the Lightroom General Presets folder and select Sharpen - Scenic.

This preset sets the controls in the Sharpening section of the Detail panel to values designed for photographs with lots of detail.

6 In the Detail panel, hold the Alt/Option key as you drag the Masking slider to the right until the sky looks black.

This creates a mask that protects non-detail areas of the image from sharpening.

For more information about sharpening and lens corrections in the Develop module, see the sections "Capture sharpening in the Detail panel" and "Making lens corrections" in Lesson 4.

Now that you've made some global adjustments in Lightroom, you'll pass the photograph to Photoshop so you can select the foreground elements and apply targeted corrections to them.

7 Press Ctrl-E/Command-E to pass this raw file from Lightroom to Photoshop.

Making an inverted selection in Photoshop

The focal point of this photograph is the bronze statue, an object with a complex but well-defined edge. In this section, you'll make a precise selection of the statue so that you can correct it independently of the rest of the photograph.

Sometimes the simplest way to select a complex object is to select everything except the object, as you'll do here.

1 Select the Magic Wand tool in the Tools panel. If it is not showing, press the Quick Selection tool in the Tools panel and select Magic Wand Tool from the fly-out menu.

2 In the options bar for the Magic Wand tool, uncheck the Contiguous check box and leave the other options at their default values.

> **Tip:** To set any Photoshop tool to its default values, select the tool in the Tools panel, right-click/ Control-click the tool icon on the far left of the options bar, and choose Reset Tool.

With the Contiguous option unchecked, the Magic Wand tool can select areas of similar color that are separated by other colors. This capability, along with the fact that there is not much variation in the sky in this photograph, makes the Magic Wand tool a good choice for selecting the sky in this image.

3 With the Magic Wand tool, click the sky close to the statue.

4 If the Magic Wand tool does not select all the sky, click the Add to Selection icon in the options bar (or hold the Shift key) and click non-selected pixels until the entire sky is selected.

5 Choose Select > Save Selection. In the Save Selection dialog, enter **sky** in the Name field, leave the other options at their default values, and click OK. Leave the marching ants selection active.

When you make a relatively complex selection, it's a good idea to save the selection for future use or as backup. Once you've saved a selection, you can

access the selection at any time, even after you've saved, closed, and reopened the image in Photoshop, as long as you saved the file in a format that retains alpha channels (such as TIFF or PSD, but not JPEG or PNG) and checked the Save: Alpha Channels option in the Save dialog.

To bring back a saved selection, choose Select > Load Selection. In the Load Selection dialog, choose the selection in the Channel menu and click OK.

6 Press the Magic Wand tool in the Tools panel and choose the Quick Selection tool from the fly-out menu. (Pressing down on the mouse button and waiting a second causes the fly-out menu to appear.) In the options bar for the Quick Selection tool, make sure the Add to Selection icon is selected, which is the default.

7 Drag over all the stonework in the image to add the stonework to the initial selection of the sky.

If you deselected the selection of the sky by mistake, load it again as explained in step 5.

8 Zoom in and pan around the image to make sure that everything is selected except the bronze statue, including small areas of sky behind the statue.

If you need to add to or subtract from the selection, you can do that with any selection tool set to its Add to Selection option or Subtract from Selection option, or you can work in Quick Mask mode, as described earlier in this lesson in the sidebar "Cleaning up a selection in Quick Mask mode."

9 Choose Select > Inverse (or press Ctrl-Shift-I/Command-Shift-I on the keyboard). This inverts the selection so only the statue is selected.

10 Choose Select > Save Selection. In the Save Selection dialog, enter **statue** in the Name field and click OK.

11 Keep the selection of the statue active for the next part of this exercise.

Creating adjustment layers with selections

In this section, you'll use selections to isolate the effects of adjustment layers.

1 If the Adjustments panel isn't open, choose Window > Adjustments.

2 With the selection of the statue active, click the Levels icon in the Adjustments panel.

This creates a Levels adjustment layer in the Layers panel. Like all adjustment layers, this one comes with a layer mask.

> **Tip:** For a larger preview of the adjustment layer mask, Alt-click/Option-click the layer mask thumbnail in the Layers panel to open the layer mask in the Document window. Alt-click/Option-click the layer mask thumbnail again to exit this view.

When you create an adjustment layer with a selection active, the marching ants disappear from view, but the selection is still present in a different form on the layer mask. On the layer mask, the area you selected is white, the non-selected area is black, and the transitional edge is gray. This determines which parts of the image will be affected by the adjustment.

3 If the Properties panel is not open, choose Window > Properties.

4 In the Properties panel, drag the white input triangle to the left and the black input triangle slightly to the right. This sets the values of the brightest and darkest pixels in the statue, adding contrast to the statue. If you want to change the overall brightness of the statue, drag the gray input triangle.

> **Note:** As you drag the white or black input triangle, you can hold the Alt/Option key to see which pixels are being pushed to white or black, respectively. In this case, the only pixels of concern are those in the statue.

These Levels adjustments affect only the statue. The rest of the photograph is protected from these changes by the black area of the adjustment layer mask. On an adjustment layer, the black area of the layer mask conceals the adjustment, the white area of the mask reveals the adjustment, and gray on the mask partially conceals the adjustment.

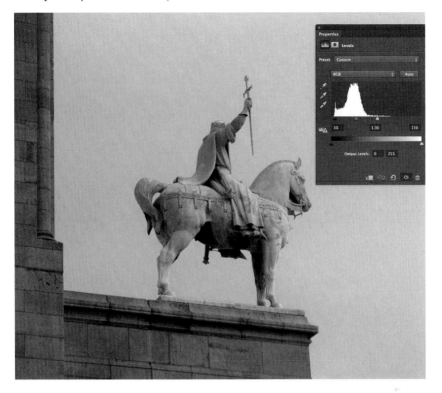

5 In the Layers panel, click the layer mask thumbnail on the Levels 1 adjustment layer. This causes the open Properties panel to display options for the mask on this layer, rather than for the Levels adjustment.

To access mask options for an adjustment layer when the Properties panel is not open, double-click the layer mask thumbnail on the adjustment layer. This opens the Properties panel and displays its mask options.

6 In the Properties panel, drag the Feather slider slightly to the right to soften the edge of the layer mask on the Levels 1 layer. This creates a softer transition between the area affected by this Levels adjustment and the rest of the image.

Feathering blurs the edge of a mask. For a live preview of the effect of feathering, press the Backslash (\) key on your keyboard. This displays the mask as a red overlay whose edge becomes more or less blurry as you drag the Feather slider in the mask panel. Press the Backslash key again.

Next you'll select another area of the photograph and apply different adjustments to that area.

7 Select the Quick Selection tool in the Tools panel. In the options bar, check the Sample All Layers check box.

8 With the Quick Selection tool, drag over all the stonework in the image to select it.

9 With the selection of the stonework active, click the Brightness/Contrast icon in the Adjustments panel.

This creates a Brightness/Contrast adjustment layer in the Layers panel with a mask that represents the selection of the stonework.

10 In the Properties panel, drag the Brightness and Contrast sliders to the right.

Only the stonework is affected by these adjustments, because the black area of the adjustment layer mask hides these changes from the rest of the image.

Next, you'll add another adjustment layer with the same layer mask as the Brightness/Contrast 1 adjustment layer. This technique is used to apply multiple adjustments to a single isolated area in Photoshop.

11 In the Layers panel, Ctrl-click/Command-click the layer mask thumbnail on the Brightness/Contrast 1 adjustment layer to reload the selection around the stonework.

This is a useful technique for reusing the same layer mask on multiple adjustment layers.

12 Click the Hue/Saturation icon in the Adjustments panel.

This creates a Hue/Saturation layer in the Layers panel with the same layer mask as the Brightness/Contrast 1 adjustment layer.

13 With the Hue/Saturation 1 layer selected in the Layers panel, in the Properties panel, drag the Saturation slider to the right to increase saturation in the stonework.

The adjustment on the Hue/Saturation 1 layer, like the adjustment on the Brightness/Contrast 1 layer, appears only on the stonework in the image, because black on this layer mask is concealing part of the Hue/Saturation adjustment.

▶ **Tip:** To compare
Before and After views
of the effect of a single
adjustment layer, toggle
the eye icon to the left
of that adjustment layer.

14 To compare Before and After views of the image with all your targeted
adjustments to the statue and the stonework, Alt-click/Option-click the eye
icon to the left of the Background layer. This makes all other layers invisible, so
you see the before view. Then Alt-click/Option-click the same eye icon again to
make all layers visible again for the after view.

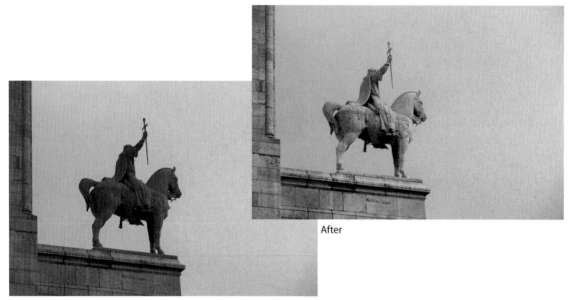

After

Before

15 Choose File > Save (or press Ctrl-S/Command-S on the keyboard). Then choose
File > Close (or press Ctrl-W/Command-W on the keyboard) to close the image
in Photoshop.

This saves the edited photo back to the same folder as the original and imports
it into Lightroom. The saved copy is a TIFF, with the filename adj-statue-
Edited-P.tif, in accordance with the Lightroom External Editing preferences you
set in Lesson 1.

The TIFF with all your Lightroom
and Photoshop adjustments, as
well as the original DNG with
just your Lightroom adjust-
ments, is visible in Lightroom.
You can make more adjustments
to both files in Lightroom. If you
want to make further changes to

the TIFF in Photoshop, you can re-open it into Photoshop with all its layers intact
by pressing Ctrl-E/Command-E and choosing Edit Original.

The sky in the image is still bland, so in the next section you'll replace it with a
more interesting sky using a selection in Photoshop.

Replacing a dull sky

When you shoot a photograph under bright conditions, the sky often looks featureless, with too little variation in color. In this section, you'll replace a dull sky in one photograph with a more dramatic sky from another photograph by using Photoshop's Paste Into command. This technique uses Photoshop selections and layer masks, and it results in a composite. You'll pass photographs from Lightroom to Photoshop to apply this technique.

1 In Lightroom's Library module grid, select adj-statue-Edit-P.tif, which is the file you saved at the end of the last section, "Making selective adjustments with adjustment layers."

Alternatively, select the sk-statue.tif lesson file, which is same image, including all the Lightroom and Photoshop adjustments from the last section.

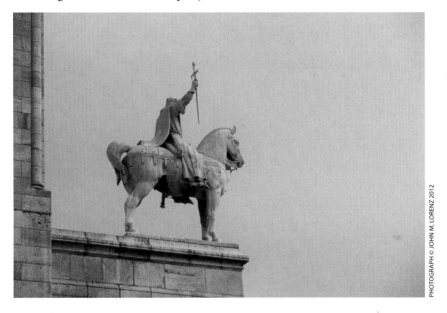

PHOTOGRAPH © JOHN M. LORENZ 2012

2 In the Library module grid, Ctrl-click/Command-click sk-sky.tif.

PHOTOGRAPH © KATRINA THOMAS—FOTOLIA

3 With these two thumbnails selected in the grid, press Ctrl-E/Command-E and choose Edit Original to pass both images from Lightroom to Photoshop.

The two photographs open as separate documents in Photoshop.

4 In Photoshop, click the document tab for sk-sky.tif, the photograph of the dramatic sky.

5 In the photograph of the dramatic sky, choose Select > All (or press Ctrl-A/Command-A). Then choose Edit > Copy (or press Ctrl-C/Command-C) to copy the entire photograph of the dramatic sky into your computer's memory.

6 In Photoshop, click the document tab for the photograph of the statue.

7 In the statue image, choose Select > Load Selection; then in the Load Selection dialog, choose sky in the Channel menu and click OK.

If you don't have a sky option in the Channel menu in the Load Selection dialog, there is no saved selection of the sky in the statue image you're using. In that case, make a new selection of the dull sky in the statue image using a selection tool of your choosing, like the Magic Wand tool with its Contiguous option unchecked in the options bar.

8 In the statue image, select the topmost layer in the Layers panel.

9 With the statue image still open and the selection of the dull sky active in the statue image, choose Edit > Paste Special > Paste Into.

This pastes the selection of the entire dramatic sky image from your computer's memory into the selection of the dull sky in the statue image.

10 In the Layers panel of the statue image, a new layer with a layer mask has been created automatically for the dramatic sky. Click the default layer name on this layer and type **dramatic sky** as the layer name instead. Press Enter/Return.

The layer mask on the dramatic sky layer represents the selection of the dull sky from step 7. The white area on the mask is the selection of the dull sky; the black area on the mask is the non-selected area. In the image, the dramatic sky is visible only where the dull sky was, because black on the layer mask is hiding the rest of the dramatic sky from view.

11 In the statue image, make sure the dramatic sky layer is selected in the Layers panel.

12 Select the Move tool in the Tools panel (or press V on the keyboard) and drag the dramatic sky to position it to your taste.

The photograph of the dramatic sky is larger than the original dull sky in the statue image, so you have a lot of leeway to move the dramatic sky around until you like the result.

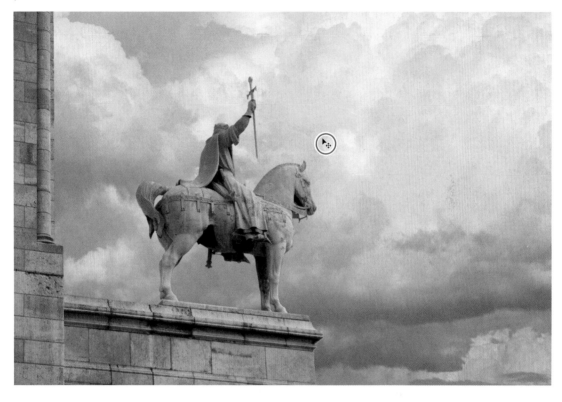

When you drag with the Move tool, the image on the dramatic sky layer moves independently of the layer mask on the same layer. That's because there is no link icon between the layer mask thumbnail and the image thumbnail on a layer created by the Paste Into command.

(When you create a layer mask the more common way—by clicking the Add Layer Mask icon at the bottom of the Layers panel—there is a link icon between the layer mask thumbnail and the image thumbnail on the masked layer.)

13 In the photograph of the statue, choose File > Save (or press Ctrl-S/Command-S). Then choose File > Close (or press Ctrl-W/Command-W) to close the image of the statue in Photoshop. Close the image of the sky without saving.

This updates the TIFF of the statue (sk-statue.tif or adj-statue-Edit-P.tif, depending on which of these files you chose to edit at the beginning of this exercise) in Lightroom. The thumbnail of that TIFF in Lightroom's Library module now displays the dramatic sky instead of the dull sky.

Isolating a complex object with a channel mask

Sometimes the easiest way to make a tricky selection is to let the image do the work for you. In this section, you'll learn how to use information in a channel to make a channel mask in Photoshop. You'll take a photograph from Lightroom to Photoshop to create a channel mask that hides a studio backdrop and reveals a more natural background. As a bonus, you'll learn how to use a mask to add faux grass to a composite.

1 In Lightroom's Library module, with the Lesson 6 folder selected in the Folders panel, select c-dog.tif and c-outside.tif in the grid.

PHOTOGRAPH OF DOG © WILLEE COLE, FOTOLIA.
PHOTOGRAPH OF NATURAL BACKGROUND © POWERSTOCK, FOTOLIA

2 Choose Photo > Edit In > Open as Layers in Photoshop.

The two photographs open as separate layers in a single document in Photoshop. Make sure the layer named c-dog.tif is at the top of the layer stack.

3 Click the Channels tab, which is in the same panel group as the Layers tab, to open the Channels panel.

The first step in creating a channel mask is to evaluate the Red, Green, and Blue color channels to identify the channel you'll use as the basis for the channel mask.

4 Make sure the c-dog.tiff layer is selected in the Layers panel. In the Channels panel, select the Red channel to display a grayscale representation of that channel in the document window. Evaluate the amount of contrast in the Red channel between the item you want to select (the dog) and the rest of the image (the studio backdrop).

▶ **Tip:** To select a channel, click a blank area of the channel, rather than the channel's eye icon or thumbnail.

The greater the contrast, the easier it usually is to create a good channel mask.

An introduction to channels

In the Layers panel, click the eye icon to the left of the c-dog.tif layer to make that layer temporarily invisible so you can use the more colorful layer beneath it, the c-grass.tif layer, to learn about color channels. Then click the tab on the Channels panel.

An RGB image contains three color channels—the Red, Green, and Blue channels—each of which is a grayscale representation of a different color of light in the image. The RGB channel at the top of the Channels panel is a combination of the Red, Green, and Blue channels. When the RGB channel is enabled, the image appears in full color in the document window.

In the Channels panel, select each of the Red, Green, and Blue channels separately in order to view that channel in grayscale in the document window. In each color channel, the brightness of the tones indicates the amount of that color in the image. For example, the blue channel in this illustration is brightest where there is the most blue in the image (the sky).

Notice that the channels vary in contrast (the amount of difference between the tones in a channel). In this case, the channel with the most contrast between the grass and the background is the blue channel. So this would be the best channel to use as the basis for a channel mask if your goal is to isolate the grass from its background.

5 Make sure the c-dog.tif layer is visible and selected in the Layers panel. Repeat step 4 on the Green channel and the Blue channel, looking for the channel you think has the most contrast between the item you want to select (the dog) and the background. We chose the Red channel.

6 In the Channels panel, drag the Red channel onto the Create New Channel icon ▣ at the bottom of the Channels panel.

This creates a Red copy layer at the bottom of the Channels panel. The Red copy layer is not a color channel; it is a special kind of channel called an alpha channel.

Next you'll add contrast to the Red copy channel so it makes a better mask.

7 With the Red copy channel selected in the Channels panel, choose Image > Adjustments > Levels (or press Ctrl-L/Command-L on the keyboard) to open the Levels dialog.

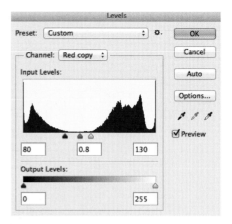

8 In the Levels dialog, drag the white input triangle to the left to make bright areas of the Red copy channel whiter on the mask. Drag the black input triangle to the right to make dark areas of the channel blacker. Drag the gray input slider to adjust transition areas.

Fine-tune the Levels input triangles. Your goal is to make the black mask on the dog as dense as possible, while maintaining the integrity of the edge around the dog. If you drag the triangles too far, the edge erodes.

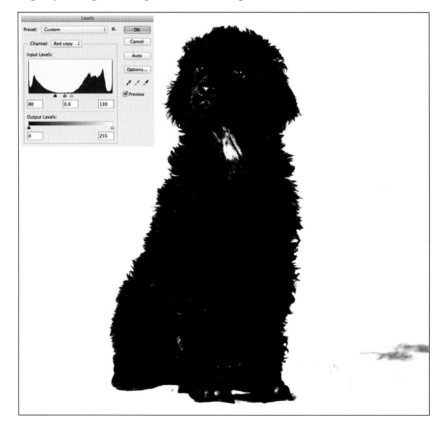

9 Select the Lasso tool in the Tools panel. Drag around the inside of the dog, without touching the outside edges of his fur, to make a selection.

10 If the Foreground Color box in the Tools panel is not set to black, press X on the keyboard. Then press Alt-Backspace/Option-Delete to fill the selection on the mask with black.

▶ **Tip:** Another way to fill the selection on the mask with black is to choose Edit > Fill, in the Fill dialog choose Use: Black, and click OK.

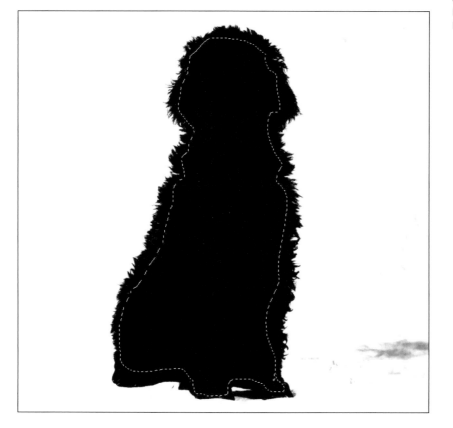

11 Use the Lasso tool to select areas of gray on the white backdrop. Press X on the keyboard to switch the foreground color to white. Then press Alt-Backspace/ Option-Delete to fill those areas with white.

12 Select the Brush tool, press X on the keyboard, and paint with black on the mask over any remaining non-black areas of the dog.

If you were cleaning up a hard-edged mask, you could try setting the Brush tool blend mode to Overlay and brushing along the edge with white or black. The Overlay blend mode lightens or darkens gray but protects existing areas of white and black on the mask. In this case, leaving some gray at the edge of the mask is useful to soften the edge of the selection.

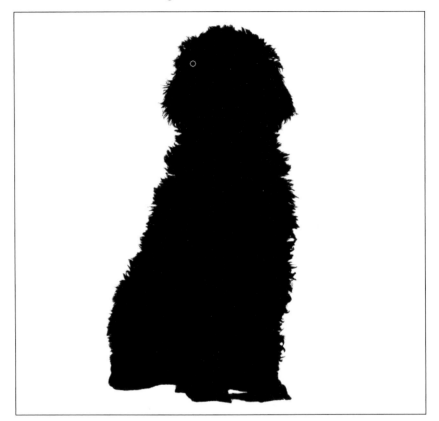

13 Ctrl-click/Command-click the Red copy channel (or click the Load Channel as Selection button at the bottom of the Channels panel) to load a selection of the white part of the mask.

This generates a selection from the channel mask you built.

14 Choose Select > Inverse (or press Shift-Ctrl-I/Shift-Command-I) to invert the selection so the dog is selected on the mask.

15 Click the Layers tab to switch to the Layers panel.

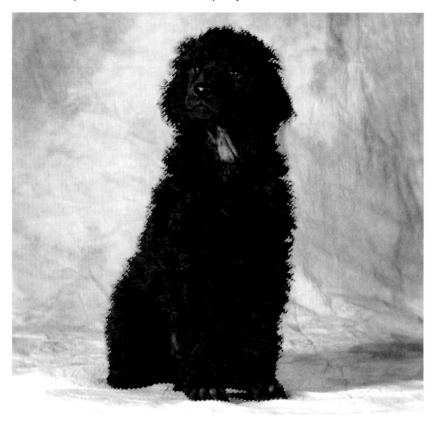

The dog is surrounded by marching ants, but they don't give you a precise view of this complex selection.

16 In the Layers panel, with the c-dog.tif layer selected and the selection you made from the channel mask active, click the Add Layer Mask icon at the bottom of the Layers panel (or choose Layer > Layer Mask > Reveal Selection).

The layer mask that is added to the c-dog.tif layer reflects the selection generated from the channel mask. The white area of the layer mask is the selection of the dog, the black area of the layer mask is the non-selected backdrop, and any gray on the layer mask is the transition.

The black part of the layer mask hides the c-dog.tif layer so that you can see down through that area to the grassy scene on the layer below.

So far you've built a mask from the information in a color channel, generated a selection based on that mask, and converted the selection into a layer mask to isolate the dog and hide the original backdrop while maintaining the complex edge of the dog's fur. To make the composite more realistic, next you'll add grass to the front of the image.

17 In the Layers panel, right-click/Control-click the c-grass.tif layer, choose Duplicate Layer, and click OK.

18 Drag the c-grass.tif copy layer to the top of the layer stack so it's above the c-dog.tif layer.

19 With the c-grass.tif copy layer selected, Alt-click/Option-click the Add Layer Mask icon at the bottom of the Layers panel (or choose Layer > Layer Mask > Hide All).

This creates a layer mask on the c-grass.tif copy layer that is filled with black, completely hiding that layer from view.

Next you'll paint with shades of gray on the c-grass.tif copy layer mask with a grass-shaped brush.

20 Select the Brush tool in the Tools panel (or press B on the keyboard). In the options bar, click the Brush Preset Picker icon. In the Brush Preset Picker, scroll down and select the Grass brush.

21 If the Background Color box in the Tools panel is not set to white, press X on the keyboard. Click the Foreground Color box to open the Color Picker, choose a light gray, and click OK.

22 In the Layers panel, make sure the layer mask thumbnail (not the image thumbnail) on the c-grass.tif copy layer is highlighted.

23 Press the Right Bracket key (]) to increase the brush tip to about 400 pixels (as reported in the Brush tip picker icon in the options bar). Then brush on the layer mask to cover the dog's paws with grass in the image. As you paint, you can change the size of the brush by pressing the Left Bracket key ([) or Right Bracket key (]) on the keyboard.

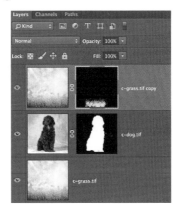

This brush paints with varying shades of gray on the layer mask, partially revealing the grass on the c-grass.tif copy layer.

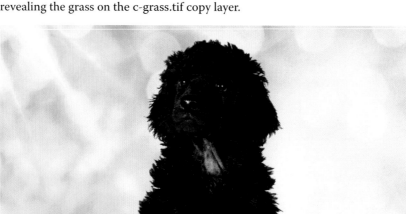

24 Choose File > Save (or press Ctrl-S/Command-S). Then choose File > Close (or press Ctrl-W/Command-W) to close the image in Photoshop.

This saves the edited photo back to the same folder as the original and imports it into Lightroom. The saved copy is a TIFF, with the filename c-dog-Edited-P.tif, in accordance with the Lightroom External Editing preferences you set in Lesson 1.

Selecting hair

Hair and objects with soft edges are among the most difficult items to isolate in a photograph. Photoshop's Refine Edge feature can often help with this task. In this section, you will pass photographs from Lightroom to Photoshop to make a selection of this model's curly hair so you can replace her white surroundings with the gold background from another image.

1 In Lightroom's Library module, with the Lesson 6 folder selected in the Folders panel, select h-hair.psd and h-bokeh.psd in the grid.

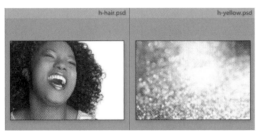

PHOTOGRAPH OF WOMAN WITH CURLY HAIR © JASON STITT, FOTOLIA.
PHOTOGRAPH OF GOLD BACKGROUND © YELLOWJ, FOTOLIA

2 Choose Photo > Edit In > Edit in Adobe Photoshop CC, and choose Edit Original.

The two photographs open as separate documents in Photoshop. You'll combine them into one document in the next steps. (The reason for this workflow is to preserve the saved selection in h-hair.psd for use in this exercise.)

3 Select the Move tool in the Tools panel.

4 Choose Window > Arrange > Tile.

5 Shift-drag h-bokeh.psd into h-hair.psd (not the other way around), and close h-bokeh.psd.

If you see a message about the depth of the documents, click Yes to proceed.

6 In the Layers panel, drag the model layer above the bokeh layer.

7 Choose Select > Load Selection. In the Load Selection dialog, choose Start from the Channel menu and click OK.

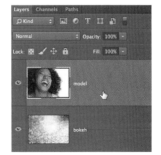

This loads a selection named Start, which is included in the lesson file h-hair.psd.

Alternatively, use the Lasso tool to create your own selection, omitting the edges of the hair through which the white background is showing.

Select the Subtract from Selection icon in the options bar and drag around the small areas inside the hair through which the white background is showing, as in the illustration.

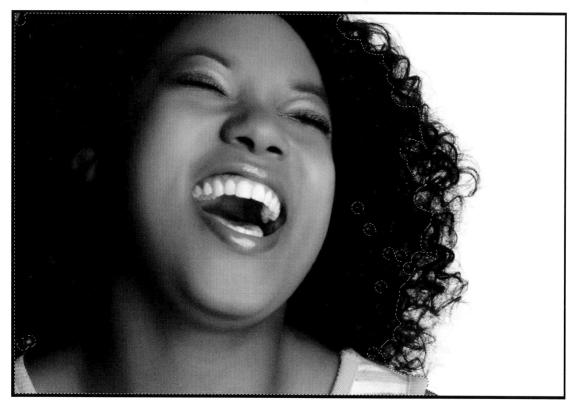

8 Choose Select > Refine Edge (or click the Refine Edge button you'll find in the options bar for each selection tool) to open the Refine Edge dialog.

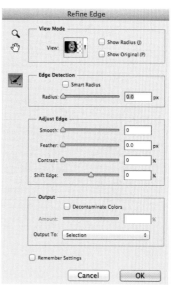

9 In the Refine Edge dialog, click the View menu and choose On Layers. Click outside the View menu to close it.

The live On Layers preview will show you the selection of the hair against the layer below as you adjust the controls in the Refine Edge dialog.

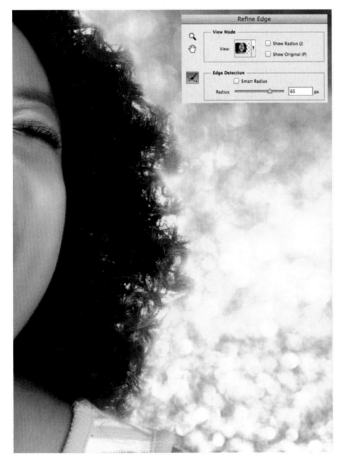

▶ **Tip:** To cycle through Refine Edge views, press F on the keyboard with the Refine Edge dialog open. The most useful view depends on the image and the purpose of the selection you're making.

10 In the Refine Edge dialog, drag the Radius slider to the right, revealing more hair detail at the edge of the selection.

Increasing the radius widens the area you're telling Photoshop to take into consideration as it refines the selection edge (the area of consideration). To view that area, check the Show Radius check box at the top right of the Refine Edge dialog. Then uncheck the Show Radius check box.

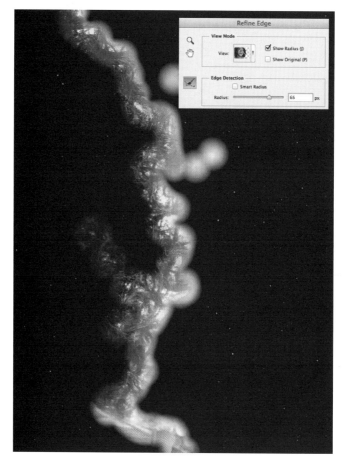

11 Check the Smart Radius check box in the Refine Edge dialog.

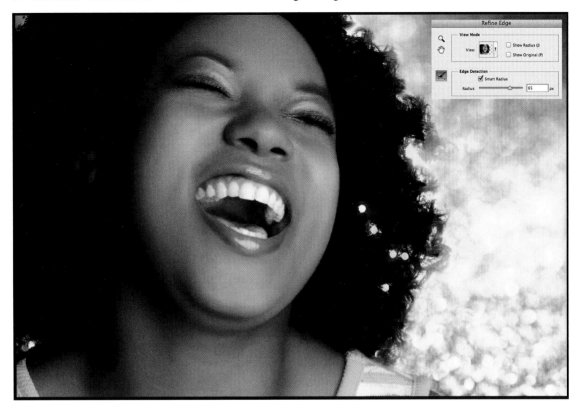

Checking the Smart Radius check box tells Photoshop to adjust the radius for both the hard edge (the left shoulder) and the soft edges (the hair). If there were no hard edges in this image, you could leave this box unchecked.

12 Click the tool icon on the left side of the Refine Edge dialog, and choose the Refine Radius tool (or press E on the keyboard).

13 Press the Right Bracket key (]) to increase the size of the Refine Radius tool brush tip. Then brush over the edges of the hair to widen the area of consideration, which reveals more hair detail.

Brushing with the Refine Radius tool identifies areas you want Photoshop to include in the area of consideration.

If too much is included in the area of consideration, parts of the image may become translucent. If that happens, brush over those areas with the Erase Refinements tool, which is located in the same fly-out menu as the Refine Radius tool. You can select the Erase Refinements tool from the fly-out menu, or press Alt/Option to switch from the Refine Radius tool to the Erase Refinements tool temporarily.

14 With the Refine Edge tool, also brush over areas inside the hair where white background is showing through.

If you look closely, you'll see some light-colored contamination around the edge of the hair from the white surroundings in the original photograph.

To reduce that color contamination, in the Output section of the Refine Edge dialog, check the Decontaminate Colors check box and drag the Amount slider to the right.

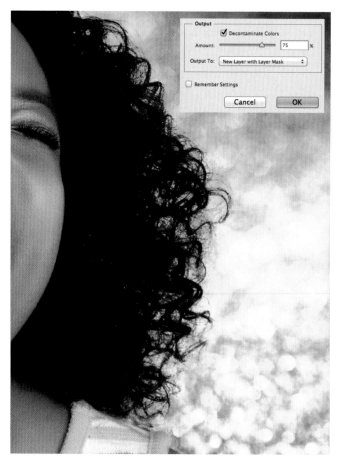

Note: The options to output as a Selection or as a Layer Mask are not available in the Output To menu when the Decontaminate Colors option is activated in the Refine Edge dialog.

15 In the Output section of the Refine Edge dialog, choose New Layer with Layer Mask from the Output To menu.

16 Click OK to close the Refine Edge dialog.

In the Layers panel there is a new layer—a copy of the model layer—with a layer mask. The layer mask on this layer represents the selection of the model with the refinements you made to the selection in the Refine Edge dialog. The black part of the layer mask, generated by the non-selected area, hides the plain surroundings on this layer, revealing the sparkling gold background on the bokeh layer below.

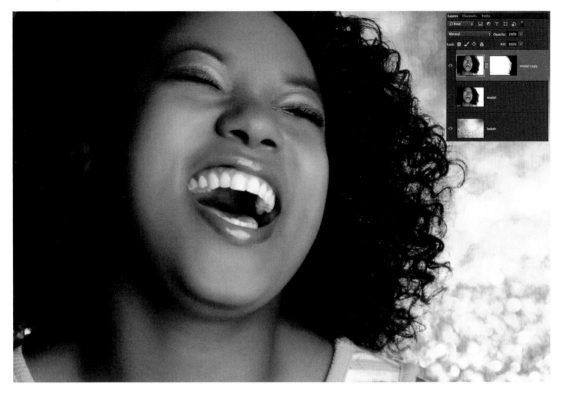

The original model layer is not visible in the image because its eye icon is off. This layer may come in handy in the future to clone back areas that were permanently changed on the model copy layer by the Decontaminate Colors option. So it's a good idea to leave the model layer in the file.

17 Choose File > Save (or press Ctrl-S/Command-S). Then choose File > Close (or press Ctrl-W/Command-W) to close the image in Photoshop.

This saves the edited photo, h-hair.psd, over the original of that image (because you chose the Edit Original option when you opened the image at the beginning of this exercise). The thumbnail of h-hair.psd appears in Lightroom with the edits you made to it in Photoshop and can be reopened from Lightroom into Photoshop again with layers intact using the Edit Original option.

Review questions

1 What is the keyboard shortcut for adding to a selection with one of Photoshop's selection tools?

2 What is the keyboard shortcut for subtracting from a selection with one of Photoshop's selection tools?

3 What does the layer mask on an adjustment layer do?

4 How and why would you save a selection?

5 How many color channels does an RGB image have?

Review answers

1 To add to a selection, hold the Shift key as you apply a selection tool.

2 To subtract from a selection, hold the Alt/Option key as you apply a selection tool.

3 The layer mask that comes with an adjustment layer determines where the adjustment affects the image. White on the layer mask reveals the adjustment, black conceals the adjustment, and gray partially conceals the adjustment.

4 To save a selection, choose Select > Save Selection. In the Save Selection dialog, give the selection a name and click OK. Saving a complex selection allows you to quickly load it so you can use it again, even after you've saved and closed a file. To load a selection, choose Select > Load Selection.

5 An RGB image contains three color channels: the Red channel, the Blue channel, and the Green channel.

7 LIGHTROOM TO PHOTOSHOP FOR RETOUCHING

Lesson overview

Photoshop is renowned for its retouching capabilities. It can do everything from intricate portrait refinements to larger scale content removal. You'll often pass photographs from Lightroom to Photoshop for retouching projects, as you'll do in this lesson. Topics in this lesson include:

- Removing and moving objects
- Sculpting a portrait with the Liquify filter
- Creating tilt-shift and iris blur effects

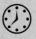 You'll probably need from 1 to 1 1/2 hours to complete this lesson.

Photograph © petarpaunchev—Fotolia, with
Photoshop iris blur added

When your goal is to change the content of a
photograph, take the photograph from Lightroom
to Photoshop to use Photoshop's sophisticated
retouching capabilities.

Preparing for this lesson

Do the following to prepare for this lesson:

1. Make sure you've followed the instructions in the Getting Started lesson at the beginning of this book for setting up an LPCIB folder on your computer, downloading the lesson files to that LPCIB folder, and creating an LPCIB catalog in Lightroom.

2. If the Lesson 7 files are not already on your computer, download the Lesson 7 folder from your account page at www.peachpit.com to *username*/Documents/LPCIB/Lessons.

3. Open the LPCIB catalog you created in the Getting Started lesson by doing the following: Hold the Alt/Option key as you start Lightroom; then in the Select Catalog dialog, select the LPCIB Catalog.lrcat file, and click the Open button.

4. Import the Lesson 7 files into the open LPCIB catalog following the bullet steps below. This is similar to the process for importing any photographs that are already on a drive (see "Importing from a drive" in Lesson 1 for more details):

 • Click the Import button in the Library module.

 • In the Import window's Source panel, navigate to *username*/Documents/LPCIB/Lessons and select the Lesson 7 folder. Make sure the Include Subfolders check box at the top of the Source panel and to the right of the Files label is checked.

 • In the Import window's workflow bar, choose Add as the import method.

 • Leave all the thumbnails in the Import window checked.

 • In the File Handling panel on the right side of the Import window, choose Build Previews > Standard. Leave the other File Handling options unchecked.

 • In the Apply During Import panel on the right side of the Import window, enter **Lesson 7** in the Keywords field.

 • Click the Import button at the bottom right of the Import window.

5. In the Library module, select the Lesson 7 subfolder in the Folders panel.

Removing and moving objects

In this section, you'll start in Lightroom and then pass a photograph to Photoshop to use a variety of Photoshop's retouching features to alter content.

Starting in Lightroom

Lightroom's Spot Removal tool allows you to hide dust spots, as well as some non-circular content, as you learned in the Lesson 4 section "Retouching with the Spot Removal tool." In some cases, this may be all you need, but for more serious retouching take your photographs from Lightroom to Photoshop.

1 In Lightroom's Library module, with the Lesson 7 folder selected in the Folders panel, select sheep.psd in the grid. Press D on the keyboard to open this image in Lightroom's Develop module.

2 In the Develop module, select the Spot Removal tool from the tool strip under the Histogram panel. Brush over a few of the small dirt clods to hide them. Then click Close at the bottom of the Spot Removal panel.

PHOTOGRAPH BY © CHRISLOFOTOS—FOTOLIA

The Spot Removal tool does a credible job with this task. But when it comes to making significant changes to content, Photoshop offers more flexibility to get the result you want, and Photoshop can do some things Lightroom cannot do—like moving objects from one place to another in a photograph.

3 Choose Photo > Edit In > Edit in Adobe Photoshop CC. In the Edit in Adobe Photoshop CC dialog, choose Edit a Copy with Lightroom Adjustments.

Moving content in Photoshop

You can literally recompose a photograph by moving objects with Photoshop's Content-Aware Move tool.

Tip: Storing individual edits on separate layers is a good practice that gives you maximum flexibility as you retouch a photograph.

1 In Photoshop, click the Create New Layer icon at the bottom of the Layers panel. Double-click the layer name on the new layer, name it **Move**, and press Enter/Return. Leave the Move layer selected.

You'll use the Move layer for the edits you're about to make with the Content-Aware Move tool.

2 In Photoshop, choose the Content-Aware Move tool from the fly-out menu of retouching tools.

Tip: The Extend option for the Content-Aware Move tool is for stretching part of an image. One use for this option is to extend a background to fill added canvas.

3 In the options bar, make sure the Mode menu is set to Move rather than Extend, leave Adaptation set to its default of Medium to start with, and make sure Sample All Layers is checked.

The Adaptation option influences how pixels are blended when you apply the Content-Aware Move tool. Checking Sample All Layers allows you to store the result on a separate layer from the photograph.

Tip: The Content-Aware Move tool works best if the surrounding area has a fairly uniform texture, like the grass in this photograph.

4 With the Content-Aware Move tool, drag a loose, freeform selection around one of the lambs in the image, including the lamb's shadow. It's important to include some of the surrounding grass in the selection too, because Photoshop will use that to blend the moved object with its new background.

You can modify your initial selection using the Add to Selection and Subtract from Selection options in the options bar (Shift-select and Alt/Option-select, respectively).

Alternatively, you could use the Lasso tool or any selection tool or method to make a selection to use with the Content-Aware Move tool.

5 Drag to the left from inside the selection to move the lamb and its shadow. You'll get the best result if you drag only a short distance.

As you drag, you'll see the original lamb and a copy.

Shortly after you release your mouse button, you'll see only a single lamb in its new location.

Photoshop moves a copy of the lamb and blends it with the background at its new location. In addition, Photoshop automatically and intelligently fills the area where the lamb had been with content that matches and blends with the surroundings.

6 Leave the selection active (don't click outside the selection) so that you can change the adaptation option in the next step.

7 If the blending is imperfect or if the lamb looks distorted, with the selection active, try out other adaptation options in the Adaptation menu in the options bar.

The adaptation method controls how strict Photoshop will be about using the actual background or pulling texture from surrounding areas as it blends repositioned pixels into their surroundings. As long as the selection is active, each time you choose a different adaptation option Photoshop re-analyzes the content and produces a different result.

In this illustration, the lamb's nose is slightly distorted when Adaptation is set to its default of Medium. The result is more natural-looking with Adaptation set to Strict. Your results may vary depending on the selection you made and where you moved the lamb.

8 Choose Select > Deselect (or press Ctrl-D/Command-D).

9 In the Layers panel, Alt-click/Option-click the eye icon in the visibility field to the left of the Move layer to display only the contents of the Move layer.

In this view, you can see the result of using the Content-Aware Move tool. The lamb is in its new position on the left, and the content-aware fill that covers where the lamb had been is on the right.

10 Alt-click/Option-click the visibility field to the left of the Move layer to make all the layers visible again.

11 Leave this photograph open in Photoshop for the next exercise.

Removing content in Photoshop

Photoshop offers a variety of content-aware features for removing content from a photograph, including the Content-Aware Fill command, the Patch tool, the Spot Healing Brush tool, and the Healing Brush tool, each of which you'll try out in this exercise.

Content-Aware Fill

Start by using the Content-Aware Fill command to remove the blue numbers from the sheep on the left side of the photograph.

1 Select the Background layer that contains the photograph in the Layers panel.

2 Select the Lasso tool in the Tools panel and drag a freeform selection around the blue numbers on the sheep. Include some of the fleece around the blue numbers.

Note: When the selected layer is not a Background layer, the shortcut for opening the Fill dialog is Shift-Backspace/ Shift-Delete.

3 Choose Edit > Fill to open the Fill dialog (or press the Backspace/Delete key).

4 In the Fill dialog, choose Content-Aware in the Use menu and click OK.

Photoshop fills the selection with content it samples from outside the selection, hiding the blue numbers, and blends that content with the surrounding fleece.

5 Press D on the keyboard to deselect.

The Patch tool

Next, you'll use the Patch tool to remove the lamb at the lower-right corner of the photograph.

1 Choose the Patch tool from the fly-out menu of retouching tools in the Tools panel.

2 Click the Create New Layer icon at the bottom of the Layers panel (or choose Layer > New > Layer) to make a new layer. Name this layer **Patch** and leave it selected.

3 In the options bar for the Patch tool, choose Content-Aware from the Patch menu. Then check the Sample All Layers check box.

 If you don't see the Sample All Layers check box, it's because the Patch menu in the options bar is not set to Content-Aware. Sample All Layers is only available in Content-Aware mode.

4 With the Patch tool, drag a selection around the lamb at the lower right of the photograph. Include some of the area surrounding the lamb in the selection.

 Alternatively, you can use another selection method, like the Lasso tool, to make a selection to use with the Patch tool.

● **Note:** The Patch tool often produces the best results when it is set to Content-Aware, but Content-Aware is not the default and is not visible on the face of the options bar. So it's up to you to remember to switch the Patch menu in the options bar to Content-Aware.

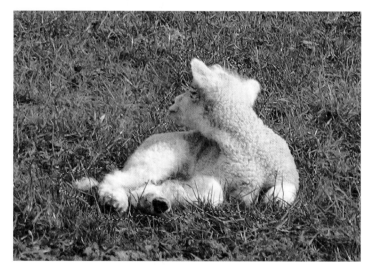

5 Drag from inside the selection to an area of the grass that the Patch tool will use as the source.

As you drag, a preview of the potential source area appears inside the selection. When you release your mouse button, Photoshop blends the source into the selection, creating a patch on the Patch layer that hides the lamb from view.

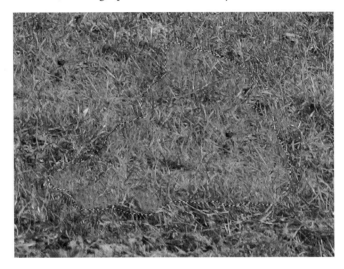

▶ **Tip:** To get a better view of the selection edge as you try out adaptation methods, toggle Window > View Extras off and on.

6 With the selection still active, in the options bar for the Patch tool, go to the Adaptation menu and experiment with the adaptation options to make the patch look as natural as possible. Choose the option that looks best to you.

For more detail about the Adaptation menu, see the preceding section "Moving content in Photoshop."

7 Choose Select > Deselect (or press Ctrl-D/Command-D).

▶ **Tip:** If you find the edges of the patch too obvious, try toning them down with another healing tool, like the Clone Stamp tool with its Sample option set to All Layers.

The healing tools

You'll use the Spot Healing Brush tool and the Healing Brush tool often as you're retouching.

1 Make another new layer in the Layers panel, name it **Heal**, and leave it selected.

2 Select the Spot Healing Brush tool in the Tools panel.

You'll use the Spot Healing Brush tool to remove sticks from the field.

3 In the options bar for the Spot Healing Brush tool, make sure Type is set to Content-Aware, check the Sample All Layers check box, and leave the other settings at their default values.

Checking Sample All Layers allows you to place the healing pixels on a separate layer from the photograph for editing flexibility.

4 Hover over a stick you'd like to remove from the photograph and use the Left Bracket ([) and Right Bracket (]) keys on the keyboard to size the brush tip so it is slightly larger than the width of the stick.

5 Drag over the stick with the Spot Healing Brush tool.

The Spot Healing Brush tool automatically samples pixels from a nearby source area, applies them where you are brushing, and blends them with the texture and shading of the surroundings.

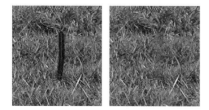

If you don't like a result that you get with the Spot Healing Brush tool, undo and try the Clone Stamp tool, which applies source pixels to the destination area without blending, or the Healing Brush tool, which gives you more control over the source point.

6 Select the Healing Brush tool in the Tools panel.

You'll use the Healing Brush tool to remove unwanted material from the face of the sheep on the left side of the photograph.

The Healing Brush tool is similar to the Spot Healing Brush tool, except that it allows you to control the source point from which pixels are sampled. The Healing Brush tool samples pixels continuously, starting at a sample point you specify. It applies those pixels as you brush over the destination area, blending the source pixels with the texture and shading of the destination.

7 In the options bar for the Healing Brush tool, choose Sample > All Layers and leave the other options at their default values.

With Aligned unchecked, the Healing Brush tool will return to the original sample point whenever you release your mouse button and start another stroke.

Setting the Sample menu to All Layers causes the tool to sample source pixels from all layers in the image and place them on the Heal layer. This gives you the flexibility to erase, delete, or lower the layer opacity of the healing pixels.

The Healing Brush tool works well with its default hard-edged brush tip.

8 Zoom in to the sheep's face. Hold the Alt/Option key to change the cursor to a target icon, and click a clean area of fleece to set the initial sample point.

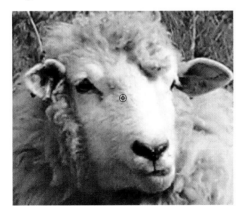

9 Hover over the destination area, and line up the preview of the source pixels that appears inside the brush tip with the destination area.

10 Brush over the destination area to remove unwanted material from that area.

The small plus icon in the image indicates the source from which pixels are sampled as you brush. The Healing Brush tool applies those pixels to the destination and blends them with the surrounding fleece.

11 Choose File > Save (or press Ctrl-S/Command-S). Then choose File > Close (or press Ctrl-W/Command-W) to close the image in Photoshop.

▶ **Tip:** Alt-click/ Option-click to set sample points from different source areas as you apply the Healing Brush tool for a natural look and to avoid producing a repeating pattern.

This saves the edited photo back to the same folder as the original and imports it into Lightroom. The saved copy is a TIFF, with the filename sheep-Edited-P.tif, in accordance with the Lightroom External Editing preferences you set in Lesson 1.

Sculpting a portrait

You can do some retouching in Lightroom, but serious portrait retouching is best done in Photoshop, which offers a variety of powerful retouching tools that give you maximum flexibility when it comes to intricate portrait work. One thing Photoshop can do that Lightroom cannot is move pixels, which you'll do in this section as you sculpt a portrait with Photoshop's Liquify filter.

Starting in Lightroom

Lightroom's Adjustment Brush tool can be useful for some basic enhancements before passing a portrait to Photoshop for more complex retouching.

1 In Lightroom's Library module, with the Lesson 7 folder selected in the Folders panel, select closeup.psd in the grid. Press D on the keyboard to open this image in Lightroom's Develop module.

PHOTOGRAPH © WARREN GOLDSWAIN—FOTOLIA

2 In the Develop module, select the Adjustment Brush tool from the tool strip under the Histogram panel.

3 Double-click the Effect label in the Adjustment Brush drop-down panel to reset the effect sliders to their defaults.

4 In the Adjustment Brush panel, drag the Clarity slider to the left to set it to negative clarity and drag the Feather slider to the left for a harder brush tip.

5 Check the Show Selected Mask Overlay check box in the toolbar at the bottom of the screen.

If the toolbar isn't showing, press T on the keyboard.

6 Brush over the face, adding a red mask to the area affected by this adjustment brush.

7 Hold the Alt/Option key to switch to an eraser brush (or click the Erase option in the Brush section of the drop-down panel) and drag over the eyes, brows, lips, and nostrils to remove them from the masked area.

8 Uncheck the Show Selected Mask Overlay check box in the toolbar.

9 Toggle the panel switch at the bottom right of the Adjustment Brush panel to compare Before and After views of this negative Clarity adjustment, which softens the model's skin without affecting the rest of the image.

10 Click the New label at the top right of the Adjustment Brush panel to create a new adjustment brush. Double-click the Effect label in the panel to set the sliders for this brush to their defaults.

You'll use this adjustment brush to brighten and reveal detail in the eyes.

11 Brush over the whites of the eyes and the irises.

12 To fine-tune the mask on the eyes, enable Show Selected Mask Overlay in the toolbar and Alt/Option-drag to remove any extra bits from the edge of the mask. Then disable Show Selected Mask Overlay.

13 Drag the Shadows slider to the right to lighten the eyes and show detail and color in the irises. Drag the Saturation slider to the right to intensify the eye color. Drag the Sharpness slider to the right to add creative sharpening to the eyes.

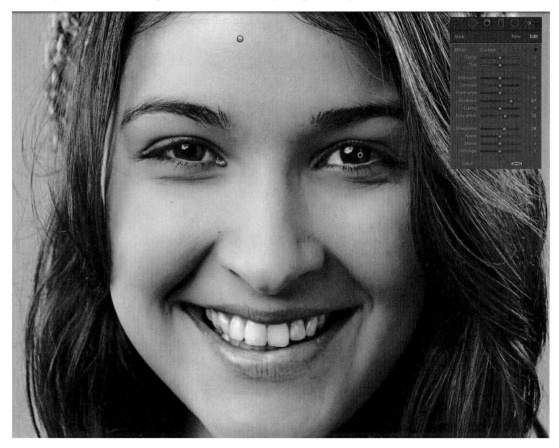

Use the same approach to experiment with adjustment brushes on other parts of the portrait, like the teeth, brows, and hair. Then pass the photograph from Lightroom to Photoshop.

14 Press Ctrl-E/Command-E and choose Edit a Copy with Lightroom Adjustments.

Applying the Liquify filter in Photoshop

You can manipulate the shape of features in a portrait using the Liquify filter in Photoshop. When you apply the Liquify filter as a Smart Filter, it is nondestructive of the photograph in Photoshop and can be re-edited.

1 In Photoshop, with the Background layer selected in the Layers panel, choose Filter > Convert for Smart Filters and click OK at the prompt.

This converts the photograph into a Smart Object so that you can add re-editable, nondestructive smart filters, including the Liquify filter.

2 Choose Filter > Liquify to open the photograph in the Liquify dialog.

Note: The Liquify filter is applied to a single layer. If you have multiple layers to affect, first merge them into a composite layer by selecting the layers in the Layers panel and pressing Alt-Shift-Ctrl-E/Option-Shift-Command-E. Apply the Liquify filter to the composite layer.

3 In the Liquify dialog, check the Advanced Mode check box on the right side of the dialog to reveal additional tools on the left side of the dialog.

4 In the toolbar on the left side of the Liquify dialog, select the Freeze Mask tool (or press F on the keyboard).

5 With the Freeze Mask tool, brush over the lower part of the face, below the nose, to protect that area from warping.

> **Tip:** If the Freeze Mask tool is missing from the left side of the Liquify dialog, it's because you neglected to check the Advanced Mode check box in the column on the right side of the dialog.

6 Select the Forward Warp tool in the Liquify toolbar (or press W on the keyboard).

7 Use the Left ([) and Right (]) Bracket keys (or the Brush Size slider on the right side of the Liquify dialog) to increase or decrease brush size so the brush tip is slightly larger than the lower part of the model's nose (around 300 pixels works well). Position the cursor near the tip of the model's nose and drag upward to tilt the tip of her nose up slightly.

The Forward Warp tool pushes pixels in the direction of your brush strokes. This tool works well if you use a large brush tip and make multiple conservative moves to build up the warping effect.

> **Tip:** To undo changes you've made in the Liquify dialog, either select the Reconstruct tool (R) from the left side of the dialog and paint over the changed area, or use the undo commands (Ctrl-Z/Command-Z and then Alt-Ctrl-Z/Option-Command-Z).

8 Select the Thaw Mask tool on the left side of the Liquify dialog (or press D on the keyboard).

Thaw Mask Tool (D)

9 With the Thaw Mask tool, brush over the red mask on the image to remove the mask.

This unfreezes the lower part of the face so it will not be protected from other changes you make in Liquify.

The model's right eye appears smaller than her left eye. You'll use Liquify's Forward Warp tool to correct that in the next step.

10 Press the Left Bracket key ([) to decrease the size of the brush tip to around 60 pixels. Position the cursor in the model's right eye and drag downward slightly to warp the right eye to make it slightly bigger.

You can use the Forward Warp tool in other subtle ways on a portrait. Experiment with using it to lift up the model's cheeks slightly, or to move the hairline (which works best if you protect the forehead with the Freeze Mask tool first, move the hair with the Forward Warp tool, and then unfreeze the face with the Thaw Mask tool).

In the next step, you'll use another Liquify tool—the Pucker tool—to narrow the bridge of the model's nose.

11 Select the Pucker tool on the left side of the Liquify dialog (or press S on the keyboard).

12 With the Pucker tool and a large brush tip, click several times on the bridge of the model's nose to narrow it.

13 Click OK at the top right of the Liquify dialog to close the dialog.

The changes you made in the Liquify dialog appear in the image in Photoshop.

14 To see Before and After views of your Liquify edits, toggle the eye icon to the left of the Liquify Smart Filter in the Layers panel.

15 To re-edit this Liquify filter, double-click the Liquify Smart Filter in the Layers panel.

This re-opens the Liquify dialog, where you can change edits you've made and make additional edits.

16 In the Liquify dialog, select the Reconstruct tool (or press R on the keyboard) and brush over the bridge of the model's nose to remove the narrowing effect you added earlier with the Pucker tool.

17 Click OK to close the Liquify dialog. Your re-edit is reflected in the image in Photoshop.

The Liquify filter is re-editable because you applied it as a Smart Filter.

18 Leave this photograph open in Photoshop for the next exercise.

Retouching after applying Liquify as a Smart Filter

To apply Liquify as a Smart Filter, the photograph was converted into a Smart Object. You cannot make pixel-based changes directly to a Smart Object. So to perform further work with Photoshop's retouching tools, you must open the Smart Object in a separate document window.

1 Double-click the Smart Object thumbnail (the photo thumbnail on Layer 0 in the illustration).

This opens the photograph, which is an embedded Smart Object, in a separate Photoshop document with a .psb extension (the PSB document). Edit the photograph in the PSB document just as you would any image in Photoshop.

2 In the PSB document, click the Create a New Layer icon at the bottom of the Layers panel to make a new layer. Name that layer **Heal** and leave it selected.

3 Select the Healing Brush tool in the Tools panel. In the options bar, set the Mode menu to Lighten so that the repair lightens the dark areas under the model's eyes. Make sure the Sample menu is set to All Layers or to Current & Below.

4 Alt/Option-click on unblemished skin below the model's right eye to set the initial sampling point.

5 Drag over the puffy skin under the model's right eye. When you release your mouse button, the repair is blended with the surrounding skin. Repeat this under the left eye, sampling from an unblemished source near that location.

6 With the Heal layer still selected in the PSB document, scrub the layer Opacity control at the top of the Layers panel to the left to make the repairs on this layer look more natural.

Continue retouching fine details in the model's face. For example, try using the Spot Healing Brush to remove blemishes and stray hairs and the Clone Stamp tool to trim the brows, hide stains on the teeth, and fill in cracks in the lips.

7 When you finish retouching in the PSB document, choose File > Save (or press Ctrl-S/Command-S).

It's important not to change the name, location, or format as you save the PSB file.

8 Choose File > Close (or press Ctrl-W/ Command-W) to close the PSB document and return to the PSD, which is still open in Photoshop.

The PSD in Photoshop displays the repairs made to the embedded Smart Object in the PSB document, along with the changes made in the PSD document with the Liquify filter.

9 In the PSD, Choose File > Save (or press Ctrl-S/Command-S). Then choose File > Close (or press Ctrl-W/ Command-W).

This saves the portrait photograph, with all your edits, back to the same folder as the original and imports it into Lightroom. The saved copy is a TIFF, with the filename closeup-Edited-P.tif, in accordance with the Lightroom External Editing preferences you set in Lesson 1. The PSD displays the Lightroom edits only.

In this illustration, the original portrait, with no edits, is on the left. The version with all the edits suggested in this section is on the right.

Adding complex blur

Special effects are among Photoshop's strengths. Photoshop's Blur filters allow you to add complex photographic blur effects, including tilt-shift, shallow depth of field, and multiple focal points.

Applying iris blur

Photoshop's Iris Blur filter allows you to simulate a shallow depth of field and add multiple points of focus for an effect that can't be achieved in camera.

1 In Lightroom's Library module, with the Lesson 7 folder selected in the Folders panel, select beach.psd.

2 Press Ctrl-E/Command-E and choose Edit a Copy with Lightroom Adjustments.

PHOTOGRAPH © PETARPAUNCHEV—FOTOLIA

3 Choose Filter > Convert for Smart Filters. This converts the photograph to a Smart Object.

4 Choose Filter > Blur > Iris Blur to open the Blur Gallery dialog with the default iris blur—a single pin surrounded by an elliptical boundary.

The blur is fully applied outside the elliptical boundary, decreases gradually in the transition area between the boundary and the white dots, and is not applied between the white dots and the center pin.

5 Drag the pin near the sandals in the foreground to place the focal point there.

6 Drag any of the handles on the boundary to change the shape of the blur.

▶ **Tip:** To view the image temporarily without the pin and the other elements of the iris blur overlay, press H on your keyboard.

The square handle changes the shape of the boundary from elliptical to oval.

7 Hover outside one of the round handles on the boundary to change the cursor to a curved double-pointed arrow. Then drag to rotate the boundary that controls the shape of the blur.

8 Drag any of the four dots inside the boundary to change the amount of fade from sharp to blurred in the transition area.

▶ **Tip:** If you have multiple layers in a file, you can view them from inside the Blur Gallery dialog by choosing Window > Layers.

9 Drag the inner circle around the pin counterclockwise to decrease the amount of blur to taste.

Alternatively, go to the Iris Blur section of the Blur Tools panel on the right side of the Blur Gallery dialog and drag the Blur slider to the left.

Tip: To see the mask that defines the blurred area, press M on the keyboard. If you want to save that mask as an alpha channel that you can access when you exit the Blur Gallery, check the Save Mask to Channels check box in the Blur Gallery options bar.

10 To compare Before and After views, toggle the Preview check box in the options bar at the top of the Blur Gallery dialog (or toggle P on the keyboard).

If you like this shallow depth of field effect, you can accept it by skipping to step 13. Or, if you'd like to try another effect that creates multiple focal points, continue to the next step.

11 Click the woman in the red dress to add a second pin with another focal point. Adjust the shape and blur amount of that pin.

This creates a multi-focal point effect that would be impossible to achieve in the camera.

12 Select the pin near the sandals and further adjust the blur on that pin until you're satisfied with the overall look of the image.

13 Click OK in the options bar to close the Blur Gallery dialog.

In Photoshop, the photograph displays the multi-focal point blurs you created in the Blur Gallery dialog.

Because you applied the blur as a Smart Filter, you can open it at any time for re-editing by double-clicking the Smart Object thumbnail on the photo layer.

If you want to make pixel-based edits to the photo, double-click the Smart Object thumbnail to open the embedded Smart Object in a separate PSB document, and make your edits there—just as in the preceding section "Retouching after applying Liquify as a Smart Filter."

14 Choose File > Save (or press Ctrl-S/Command-S). Then choose File > Close (or press Ctrl-W/Command-W).

This saves the photograph back to the same folder as the original and imports it into Lightroom. The saved copy is a TIFF, with the filename beach-Edited-P.tif, in accordance with the Lightroom External Editing preferences you set in Lesson 1.

Creating tilt-shift blur

Tilt-shift blur is a fun effect that can make large objects in a scene look like miniatures.

1 In Lightroom's Library module, with the Lesson 7 folder selected in the Folders panel, select nyc.psd.

2 Press Ctrl-E/Command-E and choose Edit a Copy with Lightroom Adjustments.

PHOTOGRAPH © JOVANNIG—FOTOLIA

3 Choose Filter > Convert for Smart Filters. This converts the photograph to a Smart Object.

4 Choose Filter > Blur > Tilt-Shift to open the image in the Blur Gallery dialog with the default tilt-shift blur.

The blur is fully applied outside the dashed lines, decreases gradually in the transition area between the dashed white lines and the solid white lines, and is not applied between the solid lines.

5 Drag the blur by its center pin to change its location.

6 Hover near either of the dots on the solid white lines to change the cursor to a curved double-pointed arrow, and drag slightly to rotate the blur.

7 Drag either of the dashed lines to change the size of the transition area. Drag either of the solid white lines to change the size of the area that is in focus.

Be careful not to click in the image, which will add another pin for a separate tilt-shift blur (unless of course you want another blur).

8 In the options bar at the top of the screen, decrease the Focus setting to throw the area between the solid white lines slightly out of focus too.

9 In the Tilt-Shift section of the Blur Tools panel, drag the Distortion slider to the right to add some very subtle distortion to the blurred area at the bottom of the image.

If you want to distort the blurred area at the top of the image too, check the Symmetric Distortion check box in the Blur Tools panel.

10 Drag the inner circle around the pin counterclockwise to decrease the amount of blur slightly.

Alternatively, go to the Tilt-Shift section of the Blur Tools panel on the right side of the Blur Gallery dialog and drag the Blur slider to the left.

11 To compare Before and After views, toggle the Preview check box in the options bar at the top of the dialog (or toggle P on the keyboard).

Tip: If there are specular highlights in a photograph, experiment with adding bokeh using the controls in the Blur Effects section of the Blur Gallery dialog.

12 Click OK in the options bar at the top of the Blur Gallery dialog to close the dialog.

In Photoshop, the photograph displays the tilt-shift effect you created in the Blur Gallery dialog.

This blur was applied as a Smart Filter, so it can be re-edited at any time, as detailed in the earlier section "Retouching after applying Liquify as a Smart Filter."

13 Choose File > Save (or press Ctrl-S/Command-S). Then choose File > Close (or press Ctrl-W/Command-W).

This saves the photograph back to the same folder as the original and imports it into Lightroom. The saved copy is a TIFF, with the filename nyc-Edited-P.tif, in accordance with the Lightroom External Editing preferences you set in Lesson 1.

Review questions

1 What does the Content-Aware Move tool do when you use it to move an object?

2 How does the Healing Brush tool differ from the Spot Healing Brush tool?

3 Can you apply Photoshop's retouching tools to the content of a layer you converted for use with Smart Filters?

4 What Blur Gallery filter would you apply to create multiple focal points in a photograph?

5 Where would you go to apply a miniaturizing tilt-shift effect to a photograph?

Review answers

1 The Content-Aware Move tool moves a copy of the selected object and blends the moved object with its new background. It also fills the area where the object had been with content that matches and blends with the surroundings.

2 The Healing Brush tool and the Spot Healing Brush tool both sample pixels from a source area and use them to cover content in a destination area, blending them with the surroundings. The main difference between these tools is that the Healing Brush tool allows you to choose the source area; the Spot Healing Brush tool does not.

3 Yes. To apply Photoshop's retouching tools to the content of a layer converted for Smart Filters (a Smart Object), double-click the layer thumbnail to open the Smart Object in a separate PSB file, edit it there, and save.

4 The Iris Blur filter creates multiple focal points and shallow depth of field effects.

5 Photoshop's Blur Gallery is the place to go to apply a tilt-shift effect to a photograph.

8 LIGHTROOM TO PHOTOSHOP FOR SPECIAL EFFECTS

Lesson overview

In previous chapters you learned some of the essential Photoshop skills for combining images, making selections, and retouching photos. This lesson covers using Lightroom and Photoshop together to add text, graphics, and special effects to your photographs. You'll be able to apply several of the techniques covered in earlier chapters as you work through the five projects in this lesson.

Topics in this lesson include:

- Creating a composite for a book cover design in Photoshop

- Styling text in Photoshop with blend modes and clipping masks

- Adding a vector graphic to an image

- Creating and editing type along a path in Photoshop

- Exploring some of Photoshop's many filter effects

 You'll probably need from 2 to 2 1/2 hours to complete this lesson.

Photograph © Seán Duggan

Photoshop provides great flexibility for combining
text, graphics, and images, and it offers a variety of
filter effects.

Preparing for this lesson

Do the following to prepare for this lesson:

1 Make sure you've followed the instructions in the Getting Started lesson at the beginning of this book for setting up an LPCIB folder on your computer, downloading the lesson files to that LPCIB folder, and creating an LPCIB catalog in Lightroom.

2 If the Lesson 8 files are not already on your computer, download the Lesson 8 folder from your account page at www.peachpit.com to *username*/Documents/LPCIB/Lessons

3 Open the LPCIB catalog you created in the Getting Started lesson by doing the following: Hold the Alt/Option key as you start Lightroom; then in the Select Catalog dialog, select the LPCIB Catalog.lrcat file and click the Open button.

4 Import the Lesson 8 files into the open LPCIB catalog following the bullet steps below. This is similar to the process for importing any photographs that are already on a drive (see "Importing from a drive" in Lesson 1 for more details):

 • Click the Import button in the Library module.

 • In the Import window's Source panel, navigate to *username*/Documents/LPCIB/Lessons, and select the Lesson 8 folder. Make sure the Include Subfolders check box at the top of the Source panel and to the right of the Files label is checked.

 • In the Import window's workflow bar, choose Add as the import method.

 • Leave all the thumbnails in the Import window checked.

 • In the File Handling panel on the right side of the Import window, choose Build Previews > Standard. Leave the other File Handling options unchecked.

 • In the Apply During Import panel on the right side of the Import window, enter **Lesson 8** in the Keywords field.

 • Click the Import button at the bottom right of the Import window.

5 In the Library module, select the Lesson 8 subfolder in the Folders panel.

Combining text and images

In this section, you'll use Lightroom's Open as Layers in Photoshop command to bring photographs into Photoshop to create an image for a book cover design. You will make a simple layered composite and then add different text layers and use layer masks, blend modes, and layer clipping masks to integrate the text into the underlying image.

Using Lightroom's Open as Layers in Photoshop command

The images for the book cover composite have already been adjusted for this project, so you can start by opening the files into Photoshop. If you know that the files you're working with will be used in a composite, the easiest way to make the trip into Photoshop is to use Lightroom's Open as Layers in Photoshop command to create a single layered file of the selected images automatically.

1 Select long_road.dng in the Filmstrip in Lightroom's Develop module or in the grid in Lightroom's Library module. Then Ctrl-click/Command-click two more images: razorwire.dng and texture.dng.

2 Choose Photo > Edit In > Open as Layers in Photoshop.

All three images open into a single document in Photoshop, each on a separate layer.

3 Leave this layered document open in Photoshop for the next section.

Creating a book cover composite in Photoshop

Before adding and customizing the text for the book cover design, you'll set up the basic look of the composite.

1 Double-check the Layers panel to verify that the layer order is arranged as follows from top to bottom: razorwire, texture, and long_road. If they are not in this order, rearrange the stacking order of the layers so that the long_road layer is on the bottom, the texture is in the middle, and the razorwire fence is at the top.

2 In the Layers panel, right-click/Control-click the razorwire layer and choose Convert to Smart Object. This is the only layer that needs to be converted into a Smart Object.

 Later in the project, you will transform the razorwire layer to make it smaller. Converting the layer to a Smart Object will keep it nondestructive. The other layers do not need to be Smart Objects because no transformations will be applied to them.

3 For now turn the visibility of the razorwire layer off by clicking the eye icon for that layer in the Layers panel. You will use this layer a bit later in the project.

4 Click the texture layer to make it active, open the blend mode menu at the top of the Layers panel, and set the blend mode to Multiply.

5 Use the Move tool (V) to reposition this layer so that the top edge aligns with the bright area in the distance of the long_road layer. Arrange the horizontal position of the layer as you like, as long as it extends all the way off the left side of the composition.

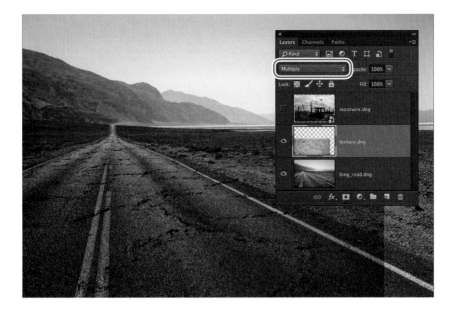

6 Make a copy of the texture layer by choosing Layer > Duplicate Layer (or press Ctrl-J/Command-J). Change the blend mode for the duplicate texture layer to Overlay.

7 With the duplicate texture layer active in the Layers panel, Ctrl-click/Command-click the first texture layer to select it as well.

8 Click the small chain link button at the bottom of the Layers panel to link these two layers together.

Since these two layers create the texture effect on the road, it is important that they stay aligned with each other.

Next you'll crop the image to the size of the book cover. To preserve options for re-positioning the images, the cropping will be applied nondestructively.

9 Choose the Crop tool (C) from the Tools panel. In the options bar, choose Ratio from the menu in the upper left and enter **6.25** and **9.25** in the two ratio value fields. Press Enter to apply these settings. Make sure that the check box for Delete Cropped Pixels is unchecked. This will apply the crop nondestructively.

10 A cropping box in the correct aspect ratio should appear on top of the image. If it doesn't, you can simply drag on the image to define a new crop box. Drag the corner crop handles to make the crop box smaller so that there is less blue sky included in the box. Size the crop box so it is approximately 2675 pixels high, as shown in the info display that appears by your cursor.

11 Once you have the size of the crop box established, drag the image to re-position it within the crop box. The center yellow line of the road should be positioned on the left side of the crop box, as shown in the illustration.

12 Apply the crop by pressing Enter/Return, double-clicking inside the crop box, or clicking the checkmark button in the options bar.

Since the cropped pixels were not deleted, they still exist outside the visible bounds of the image, and they can easily be re-positioned in case the design process calls for a different arrangement of the layered elements.

13 Choose File > Save (or press Ctrl-S/Command-S). This saves the layered composite back to the Lesson 8 folder as a TIFF with -Edit-P added to the filename (long_road-Edit-P.tif), in accordance with the Lightroom External Editing preferences you chose back in Lesson 1.

Adding and styling type layers

Next you'll create the text elements for the book cover. Once these are in place you'll blend them into the landscape image using a variety of effects, including layer masks, blend modes, and layer clipping groups.

1 Press D on the keyboard to set the default colors (black in the foreground and white in the background), and then press X to exchange the colors so that white is in the foreground swatch.

2 Make the Type tool (T) active. In the options bar, set the typeface to Arial Black and the size to **165** points (there is no menu choice for that size so you'll have to type the number in the Size field).

You can use any font you want for this project, but for the look of this book cover, we are using a large sans serif typeface because it will work better for showing the effects that will be added later.

3 Click in the top center section of the image, above the distant road, and type **AREA**. Press Ctrl-Enter/Command-Return to commit the new type and exit the text-editing mode. Switch to the Move tool (V), and position the type so that it is centered from left to right over the mountains.

4 Add a new type layer by clicking on the road below the mountains. Use the same type options as you did when entering AREA. Type **271**. Press Ctrl-Enter/Command-Return to commit the new type and exit the text-editing mode. Switch to the Move tool (V), and position the type so that the number 2 is centered over the road, as shown in the illustration.

Now you'll create a layer mask to modify the shape of the AREA type layer so that it takes on the shape of the mountains.

5 Choose the Quick Selection tool (W) from the Tools panel. In the options bar, set the Brush Size to 200 and uncheck Sample All Layers.

6 Click the long_road layer to make it active, and drag across the sky with the Quick Selection tool to select it.

7 Click the AREA type layer to make it active, and choose Layer > Layer Mask > Hide Selection (or Alt/Option-click the Add Layer Mask button at the bottom of the Layers panel).

This will create a layer mask for the AREA type layer that hides the text that extends above the edge of the mountains.

8 Click the chain link icon between the type layer thumbnail and the new layer mask to unlink the layer from the mask. Click the type layer thumbnail until you see the highlight border around it. This indicates that the layer, and not its mask, is the active part of the layer. Switch to the Move tool (V) to move the type layer, and the layer mask will stay aligned with the actual mountain in the image.

Layer and layer mask linked. Layer mask is active.

Layer and layer mask unlinked. Layer mask is active.

Layer and layer mask unlinked. Type layer is active.

9 Click the Layer Effects button at the bottom of the Layers panel (it looks like a small fx) and choose Drop Shadow. In the Layer Style dialog, set the Distance to **10** and the Size to **20**. The Angle should be set to match any other obvious shadows in the image. In this case, a setting of 135 degrees matches the shadows being cast by the texture ridges in the texture image.

Note: Alternatively (as well as simply and expediently), Alt/Option-clicking the layer's Effects list and dragging it to the other layer(s) will make a duplicate of the effects (layer style) there.

10 Right-click the AREA type layer in the Layers panel and choose Copy Layer Style. Right-click the 271 type layer and choose Paste Layer Style. Set the blend mode for both type layers to Overlay.

11 Click the long_road layer to make it active, and use the Eyedropper tool (I) to sample the yellow/brown color in the dry grass along the side of the road. You'll use this sampled color to add a tint to the top part of the image.

12 Use the Rectangular Marquee tool (M) to make a selection of the top part of the image, down to about the middle of the number 271. Hold down the Alt/Option key, click the Create New Fill or Adjustment Layer button in the bottom of the Layers panel, and choose Solid Color. Using the Alt/Option modifier key when clicking will prompt the New Layer dialog to appear. In the Mode menu in the New Layer dialog, choose Color, and click OK to display the Color Picker dialog.

13 The initial color is based on the foreground color that you sampled from the image. Fine-tune the color to your taste. For this example, the values are Red=240, Green=225, Blue=180. Click OK to close the dialog.

The Color blend mode allows only the hue and saturation values of the chosen color to affect the image. The luminosity values come from the underlying image layers.

14 Click the thumbnail of the Color Fill layer mask to make it active, and then open the Properties panel. Click the layer mask button near the top of this panel, and adjust the Feather slider for the layer mask to about 120 pixels to create a soft, gradual transition.

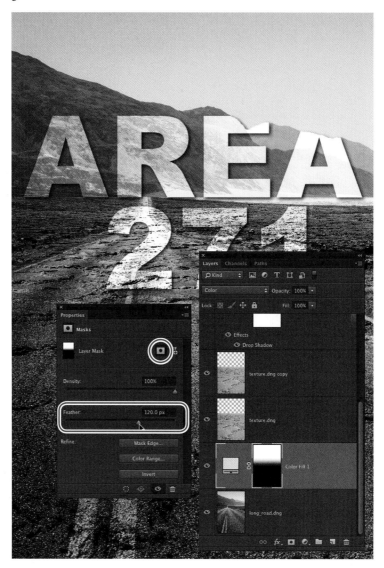

15 Click the razorwire layer to make it active, and click the empty well where the eye icon appears to show this layer. Drag the layer down in the Layers panel to place it immediately above the AREA type layer.

16 Choose Layer > Create Clipping Mask to clip the razorwire image to the outlines of the text layer (you can also Alt/Option-click the border between two layers in the Layers panel to create a layer clipping mask).

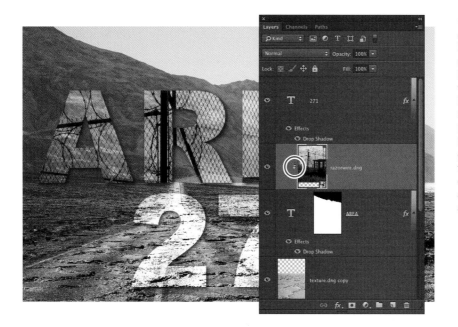

Note: When a clipping mask is created between two layers, the shape of the bottom layer determines the visibility for the top layer. This arrangement is also referred to as a layer clipping group. In a layer clipping group, the outline of the bottommost layer determines the shape of all the layers above that are clipped to it.

17 With the razorwire layer active, choose Edit > Free Transform. If you cannot see the entire transform bounding box, choose View > Fit on Screen. In the options bar, enter **50.00%** for the Width, and then click the chain link button to set the same value for the Height. Press Enter to apply the transformation.

18 Use the Move tool (V) to fine-tune the position of the razorwire within the letters of the type layer.

19 Save your work (press Ctrl-S/Command-S) and leave the file open in Photoshop for the next section.

You can be very creative when pairing text with images. By using some core Photoshop techniques involving layer masks, blend modes, and layer clipping groups, you can combine text very effectively with the underlying composite.

Adding a vector graphic

In this section, you'll use the same book cover file to work with vector shape layers and add a warning symbol to the design. You'll also finish up the composition with a couple of additional text layers.

1 In the Layers panel, click the texture.dng copy layer to make it active. In the Tools panel, click the foreground color swatch to open the Color Picker. Enter the following RGB values: R=255, G=220, B=120. Click OK.

2 In the Tools panel, choose the Custom Shape tool (it's located just above the Hand tool; click and hold the tool icon to show the fly-out menu with the additional shape tools).

3 In the options bar, click the Shape menu to display the available shapes. Click the small gear button in the upper-right corner of the Shapes panel, and choose Symbols from the fly-out menu. You will be asked whether you want to replace the current shapes or append the new shapes onto the existing ones. Choose Append.

4 Select the radioactive warning symbol. In the options bar, set the menu on the far left side to Shape. The Fill color should show as your foreground color. If it doesn't, you can open this panel and select it from the Recently Used Colors list. Make sure the Stroke is set to None.

5 Drag on the image to create the shape. Hold down the Shift key as you drag to constrain the proportions. As you drag, you'll see a size display next to your cursor. Drag the shape until it's about 1200 pixels wide, release the mouse button, then release the Shift key.

You must release the mouse button before releasing the Shift key; otherwise, the constrain command will be canceled.

6 Change the blend mode of the warning symbol shape layer to Overlay. You can now experiment with different placements for it within the overall design. For the example shown here, the center circle in the symbol is placed right under the number 2.

7 If you need to resize the shape layer, choose Edit > Free Transform. To constrain the proportions, hold down the Shift key while dragging a corner handle. Press Enter or click the checkmark button in the options bar to apply the transformation.

8 Copy the layer style from the AREA type layer by Alt/Option-dragging the layer style icon on the right side of the layer down to the symbol shape layer.

For a final touch, you'll add a couple of adjustment layers to complete the design, as well as two final text layers for the author's name and a short tagline for the book.

9 Click the texture copy layer to make it active. Choose the Lasso tool (L) from the Tools panel. In the options bar, set the Feather to 0. Use the Lasso tool to draw a selection of the lower-right corner of the book's cover. Start about halfway up the right side and then move the tool diagonally down toward the lower-left corner, then loop back around to where you started. Add a Color Fill layer and set the color to black.

10 In the Properties panel, set the Feather for the layer mask to about **250** pixels.

This will create a soft, gradual edge for the darkening effect.

11 Now use the Elliptical Marquee tool to make a circular selection in the upper-right corner. Hold the Shift key as you drag the selection to constrain it to a circle. Refer to the info display size next to the cursor as you drag, and make the selection about 470 pixels. With this selection active, add another Color Fill layer, but this time use white as the color. Click the layer mask to make sure it is active, and in the Properties panel set the mask Feather to **100** pixels.

12 Select the Type tool and set the font color to white. Add a text layer for the author's name, as well as one for a tagline for the book. You can make up your own author and tagline or use the ones shown in this example. For the tagline, we used Myriad Pro, Light at 30 points; for the author's name, we used Myriad Pro, Regular at 56 points, with a bright yellow color.

13 Once you are finished, press Ctrl-S/Command-S to save the file so it is updated to the Lightroom catalog, and close the file.

Creating type on a path

In the previous section, you used layer masks, blend modes, and layer clipping groups to integrate type with an image. In this section, you'll open a JPEG file from Lightroom into Photoshop and place type on a vector path so that it conforms to a shape in the photograph.

Vector paths and shapes are different from pixel-based image elements because they are defined by the coordinates of anchor points and the straight or curved line segments that connect them. Because they are shapes defined by numeric point coordinates instead of actual pixels, they are resolution-independent, meaning they can easily be scaled much larger than their original size with no loss in quality.

Editable type in Photoshop is vector-based, as are the vector shapes (you used a vector shape for the warning symbol in the previous exercise). You can use the Pen tools to define your own vector paths and shapes. For the following exercise, you'll start with a simple vector shape, add type so that it follows the path that defines the shape, and then make some simple edits to the shape.

Creating a rounded border in Lightroom

In this exercise, you'll work with a hot air balloon photo. Before bringing it into Photoshop and adding type, you'll apply a border effect and some simple color adjustments in Lightroom.

1 Select balloon_flight.jpg in the grid or Filmstrip in Lightroom's Library module, and then press D to switch to the Develop module.

2 In the Effects panel, set the Post-Crop Vignetting sliders as follows: Amount = 100, Midpoint = 35, Roundness = −85, and Feather = 0. This adds a rounded-corner border effect.

3 Open the Basic panel and set the Exposure to +0.20, the Clarity to +25, and the Vibrance to +10.

4 In the HSL panel, click Luminance and lower the Blue slider to −20.

Now you'll bring the image into Photoshop with the Lightroom adjustments applied.

5 Choose Photo > Edit In > Edit in Adobe Photoshop CC (or press Ctrl-E/ Command-E). In the dialog that appears asking you what to edit, click the button for the first choice: Edit a Copy with Lightroom Adjustments.

Using vector shapes to place type on a path

The goal is to create an image that could be used as a promotional photo for a hot air balloon company. You will use circular vector shapes to add two lines of type above and below the balloon.

1 Choose the Ellipse tool from the shape tools located just above the Hand tool. In the options bar, make sure the menu on the far left is set to Path.

2 Place your cursor on the center of the balloon (right between the diagonal rows of green and blue color patches), and begin to drag out the shape. After you start dragging, hold the Alt/Option key to force the shape to be drawn from the center out. As you drag (with the Alt/Option key still down), you can press and hold the spacebar, which will temporarily interrupt the shape creation process and allow you to re-position the shape as you draw it.

The goal here is to create a curved arc above the balloon that approximately matches the curvature of the top of the balloon.

3 To finish drawing the shape, release the mouse button before you release the Alt/Option key.

4 Make the Paths panel visible. You will see a work path. Double-click it and name it **Curve Above Balloon**.

5 With the path still active, select the Type tool (T) in the Tools panel. In the options bar, select a serif typeface (the example uses Minion Pro), and set the size to **48** points. Use a bright color that will contrast well with the dark blue sky, such as yellow or white. Set the alignment to left justified.

6 Position your type cursor over the line of the path in approximately the 10 o'clock position on the circle. As you do this, you will see it change from the I-beam text insertion cursor to the I-beam type-on-a-path cursor over a dotted curved line. Click, and type **BALLOONS**.

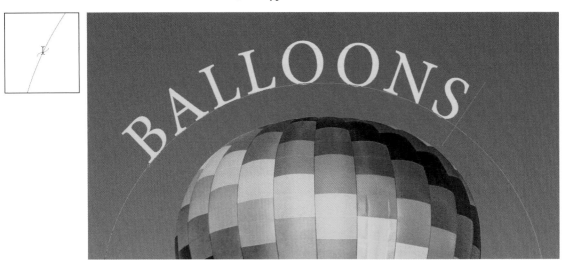

Adjusting the position of type on a path

When type is placed on a path, it often needs to be adjusted to get the position just right. Let's explore some techniques for getting the type placed just the way you want it.

1 To adjust the placement of the type on the curve, switch to the Path Selection tool (the black arrow tool below the Type tool). Place this cursor at the beginning of the word and you will see it change to an I-beam with a small black direction triangle. Drag in the direction you want to move the text.

Be careful not to cross over the path; if you do that, you will flip the type to the underside of the curve. This can be useful, but it's not what we want for this step. You will explore this with the next line of text you create.

2 Click the Background layer to make it active.

You will create a new path for the next line of type, and having the first path active could cause the new path to be added to it rather than being created as a separate path.

3 Switch to the Ellipse tool (U), and repeat steps 1 through 3 from the previous section to draw a new elliptical shape over the balloon. Hold Alt/Option-Shift as you drag to draw the shape from the center and constrain the shape to a circle.

The next line of type will be placed on the inside of this circular path, so leave plenty of room beneath the gondola.

4 In the Paths panel, double-click the new work path and rename it **Curve Below Balloon**.

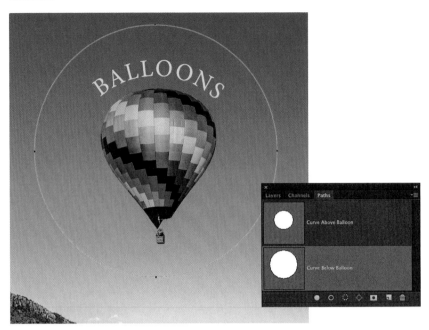

5 Select the Type tool and position the cursor over the left side of the lower curved line of the path. When you see the type-on-a-path cursor, click and enter **ABOVE the VALLEY**.

The type will appear on the outside of the line. You will fix this in the next step.

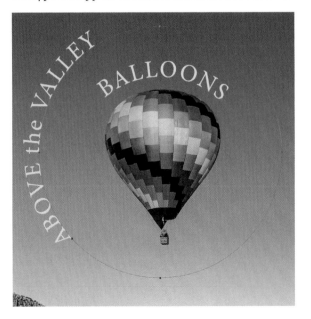

6 Select the Path Selection tool. Position it between the A and the B in the word
 ABOVE. Drag to cross the line of the path to flip the type so it is inside the circle.

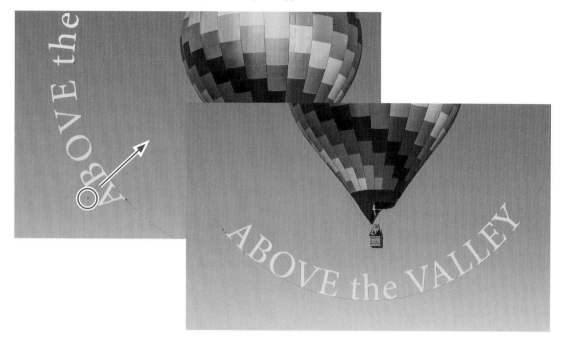

7 Notice that there is a small dot on the line near the beginning of the text (after
 you've flipped the type to the inside of the circle, it should be just to the left of
 the letter A).

 Depending on how you drag (either to re-position type on a path or to flip it to
 the other side of the line), it's possible that the type will not be visible or that
 some of it will be cut off.

 If that is the case, look for the small round dot. This marks the end of the visible
 text area. Using the Path Selection tool, drag this dot along the path until the
 missing text appears.

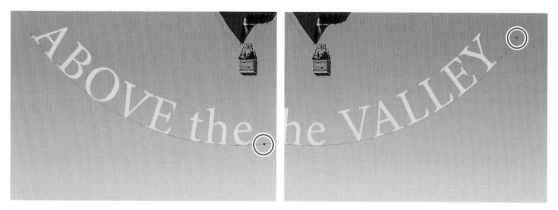

Changing the size of a type path

Sometimes, after placing type on a path, you may decide that the text needs to be larger. This is the case with the type on the balloon flight image. Text can be made larger, of course, by changing the point size in the options bar, but it will still be on the same sized path, and this can sometimes cause problems. For instance, with text on a circle, as in this example, making the type larger will cause it to re-flow on the same circle, leading to a different visual look that will likely appear too crowded. The solution is to re-size the path first and then re-size the type.

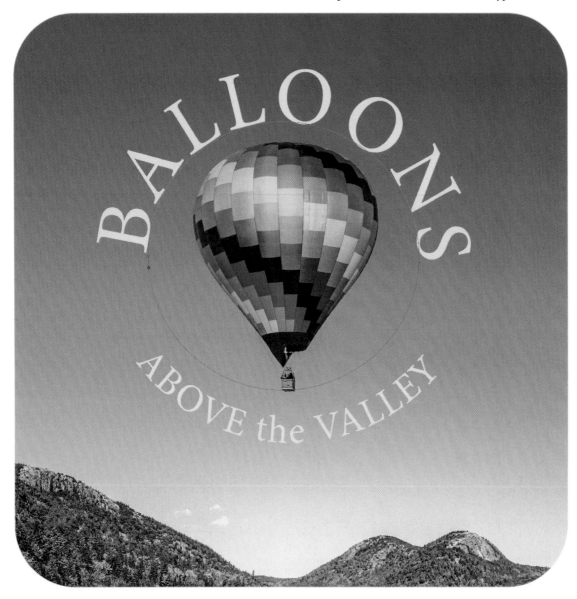

1 Choose the Path Selection tool. In the Layers panel, click the BALLOONS type layer to make it active. Open the Paths panel, and click the path named BALLOONS Type Path to make it the active path.

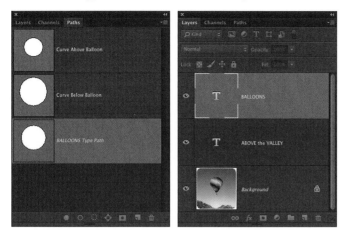

2 Choose Edit > Free Transform Path. Hold down Alt/Option-Shift and drag outward on one of the corner handles.

Alt/Option forces the transform to take place from the center point, and Shift constrains the proportions of the shape as it is transformed.

3 Scale the path larger until the top curve is above the word BALLOONS.

4 To apply the transformation, click the check mark in the options bar or press Enter.

The text will be re-positioned once the transform is applied.

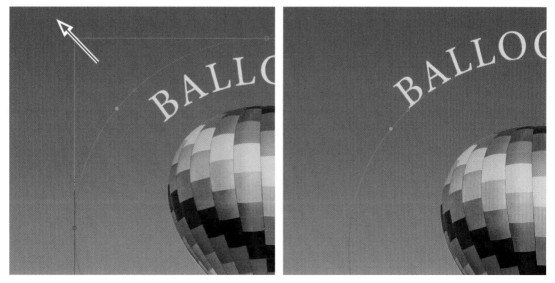

Now you can make the text larger and it will fit better on the newly re-sized path.

5 Double-click the layer thumbnail for the BALLOONS type layer to highlight the text. In the options bar, change the size to **80** points.

6 Switch to the Path Selection tool, and drag on the front of the type to adjust the placement of the text as needed.

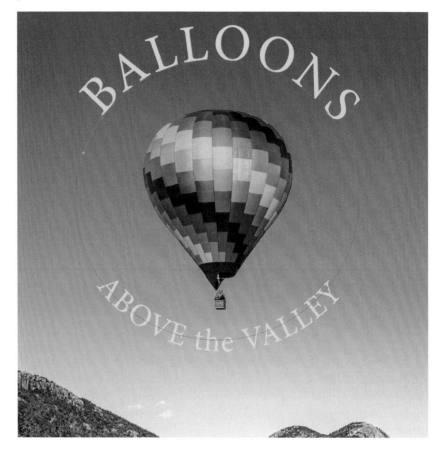

7 In the Layers panel, click the ABOVE the VALLEY type layer to make it active. Open the Paths panel, and click the path named ABOVE the VALLEY Type Path. Repeat steps 2 and 4 to resize the type path, and then re-size the text to **80** points.

8 If the text is cut off, look for the small round dot and use the Path Selection tool to drag the dot along the circular path until the type reappears. Re-position the text if necessary so it is centered below the balloon.

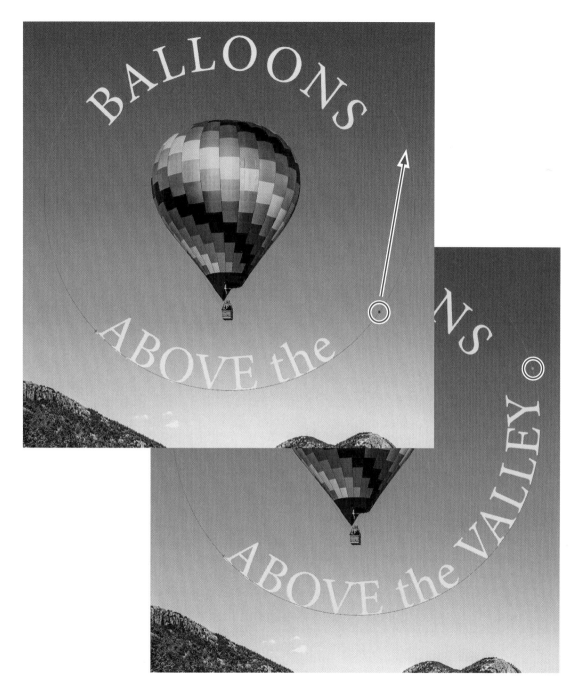

9 Click the Layer Effects button at the bottom of the Layers panel, and add a Drop Shadow to both type layers to help make the text stand out better against the sky.

Making the type paths larger, as well as the type itself, fills the space around the balloon better and makes for a more balanced design.

10 Once you are finished, press Ctrl-S/Command-S to save the file so it is updated to the Lightroom catalog. Then choose File > Close (or press Ctrl-W/Command-W) to close the image in Photoshop.

Applying artistic filters

● **Note:** If you ever notice that some of the filters are grayed out and unavailable, the most likely explanation is that you're working with a 16-bit file. Certain filters, such as the entire collection in the Filter Gallery, can be used only with 8-bit files. You can convert to 8 bits by choosing Image > Mode > 8 Bits/Channel.

Lightroom is great for improving and enhancing your photographs. And although you can create interpretations of your images that are very different from the original, for the most part the results you get remain rooted firmly in the photographic. Photoshop allows you to venture beyond the boundaries of the image you photographed and transform it many other ways. As you have already seen in earlier exercises in this book, using layers, layer masks, and blending modes allows you to transform an image in ways that are not possible in Lightroom. Another way to indulge in creative flights of fancy in Photoshop is by exploring its extensive filter menu. In this section, you'll experiment with a few of the many filter effects that are possible in Photoshop.

Creating a radial motion blur

Photoshop offers several ways to blur an image or parts of an image. Earlier in the book, you explored the Tilt-Shift Blur, Iris Blur, and Field Blur filters. For this exercise, you'll apply a motion blur to a specific area in a photo to suggest that an object is spinning.

1 In Lightroom, select satellite_inn.dng in the grid or Filmstrip in Lightroom's Library module, and then press D to move to the Develop module. The image already has a square crop applied to it, but it needs a few adjustments.

2 In the Basic panel, set Contrast to +5, Clarity to +30, and Vibrance to +25. In the HSL panel, click on Luminance and lower the Blue slider to −50, then activate the Saturation controls in the same panel and increase the Blue value to +45.

Next you'll retouch the cable connecting the atom to the sign.

3 Click the image to zoom in to a 1:1 view. Select the Spot Removal tool (Q), and double-check that it is set to Heal. Set the brush Size to 25, the Feather to 75, and the Opacity to 100.

4 Beginning near the top where the cable meets the atom, drag over it until you get to just before the top of the sign.

The reason to remove this is that we don't want it to be part of the image when the spinning effect is applied in Photoshop. Any further retouching of this cable (and its shadow on the sign) is beyond the capabilities of Lightroom's feature set and would require additional work in Photoshop.

5 Click the Spot Removal tool again to close its control panel.

 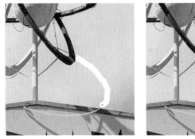

6 Press Ctrl-E/Command-E to open the image into Photoshop.

7 In the Tools panel, select the Elliptical Marquee tool and drag a selection around the atom on top of the sign. Choose Layer > New > Layer via Copy (or press Crtl-J/Command-J) to copy the selected pixels to a new layer. Double-click the layer name and rename it **Atom for Radial Blur**.

8 Right-click/Control-click the new layer in the Layers panel, and choose Convert to Smart Object.

This will allow you to apply certain filters nondestructively as Smart Filters.

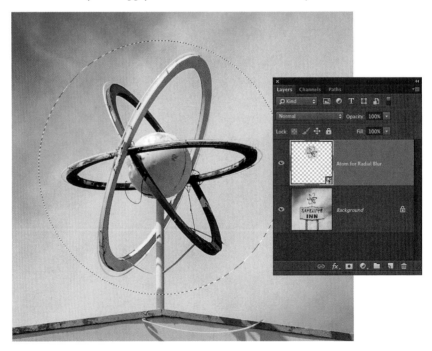

9 Choose Filter > Blur > Radial Blur. In the Radial Blur dialog, set Amount to **25**, Blur Method to Spin, and Quality to Good. The Blur Center diagram determines the central point around which the radial blur is created.

10 Drag the Blur Center diagram to reposition it so that the center point is over the top center section of the image (where the atom is).

Unfortunately, there is no live preview of the effect in the image window, and this centering guide takes the entire image into account and not just the selected layer, so getting it positioned right might take a couple of tries.

11 Click OK to apply the blur.

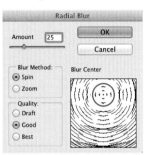

12 If the blur is not centered on the atom, double-click the name of the filter in the Layers panel and modify the Blur Center diagram.

The beauty of using Smart Filters is that filter effects can always be modified as needed.

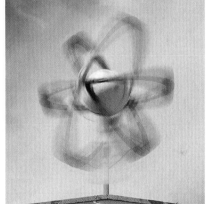

100% opacity

85% opacity

13 Lower the opacity of the blurred layer to 85%, and then click the Add Layer Mask button in the bottom of the Layers panel to add a layer mask.

14 Since the layer mask is now the active element, the foreground color should be set to black. If this is not the case, press X to exchange the colors so that black is in the foreground swatch. Select the Brush tool (B). Click the Brush Picker in the options bar, and make sure that a soft-edged brush tip is selected.

Double-check that the layer mask is active (look for the highlight border around its thumbnail), and paint around the edges of the blurred atom to mask out the parts where you can see the edge of the circle from the original selection.

15 The blur has reduced the contrast of the atom. To fix that, click the Create New Fill or Adjustment Layer button in the bottom of the Layers panel and choose Levels. In the Properties panel, click the Clipping Mask button (first button on the left along the bottom of the panel). This will apply the Levels adjustment only to the layer immediately below and will not affect the rest of the image. Adjust the middle gamma slider under the histogram to **0.65**.

After making the Levels adjustment, if you notice any darker areas outside the blurred atom, you may need to apply additional touch-ups to the layer mask on the blur layer.

At this point, you may also want to double-click the name of the Smart Filter in the Layers panel and experiment with different Amount settings for the radial blur.

16 When you are satisfied with the effect, choose File > Close and save the file when prompted. The completed file will be added back to the Lightroom catalog.

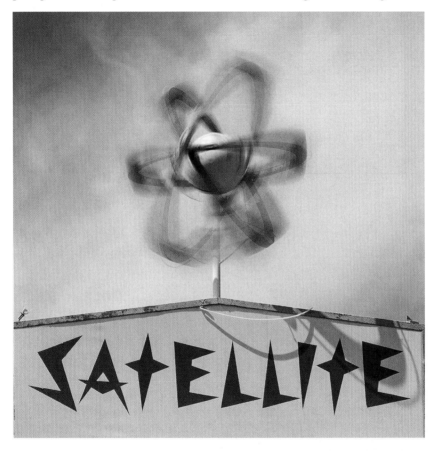

Creating a custom blend of the Oil Paint filter

Many filters in Photoshop, particularly those in the Filter Gallery, apply analog painting or sketching effects to a photo. Some are more useful than others, and, depending on your artistic sensibilities, some may seem a bit too much like canned digital effects. But when you combine them with some of Photoshop's other core functionality, such as layers and layer masks, you can add a degree of customization to some of these filters.

In this exercise you'll create two interpretations of an image in Lightroom, apply different variations of the Oil Paint filter to each layer, and combine them into a single image using layer masks.

1 In Lightroom, select spring_tulips.dng in the grid or Filmstrip in Lightroom's Library module, and then press D to move to the Develop module.

2 The file is a bit dark, so in the Basic panel, set Exposure to +0.50, Shadows to +40, Clarity to +35, and Vibrance to +35. Since it was an overcast day when this was shot, the color temperature is a bit cool, so warm it up slightly by moving the Temp slider to 5200.

3 Create a snapshot of this adjustment so you can easily return to it if needed. In the left panel of the Develop module, click the Plus icon next to the Snapshots pane. Give the snapshot a descriptive name, such as **Basic Color Version**. Now open the file into Photoshop by pressing Ctrl-E/Command-E.

4 Choose Filter > Convert for Smart Filters to turn the layer into a Smart Object.
 Then choose Filter > Oil Paint. Experiment with the six control settings to see
 how they affect the image. To duplicate the version shown in the illustrations,
 use the following settings: Stylization = 10, Cleanliness = 10, Scale = 8, Bristle
 Detail = 8, Angular Direction = 120, and Shine = 4. Since the filter is being
 applied to a Smart Object layer, these can easily be modified if necessary. Click
 OK to apply the filter.

Overall, the effect is very good, and the filter has created an interesting look that
works well for this particular image. The texture in the background is a bit too
busy, however, and it would be nice if there were some color in the sky. With
some additional adjustments in Lightroom, you can easily create a new version
to combine with the first one.

5 Press Ctrl-S/Command-S to save the file and add it into the Lightroom catalog. Leave the oil painted version open in Photoshop and head back to Lightroom. Using the same original image (spring_tulips.dng), make the following changes in the Basic panel: Exposure = +0.90, Shadows = +50, Clarity = −100, and Vibrance = +50.

These adjustments will lighten the darker parts of the image, particularly the large expanse of darker tones in the background, and create a very soft, diffused look for it. Lowering the Clarity setting is what causes the latter effect. Next, you'll use the Adjustment Brush tool to add some color into the sky.

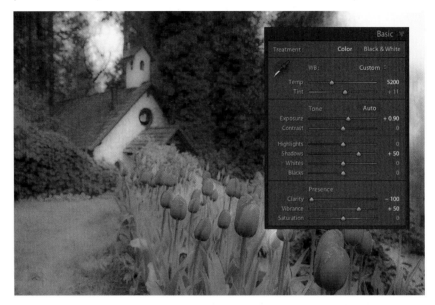

6 Click the icon for the Adjustment Brush tool above the Basic panel (the one on the far right that looks like a paintbrush). First you'll configure the settings and then apply them to the image. Lower the Exposure to −1.85. Click in the Color swatch in the lower part of the panel and choose a blue color. The exact blue color you use is not critical, but use something similar to what is shown in the illustration.

7 Use a brush with a Size of about 15, a Feather value of 50 to 60, and a Flow and Density of 100. Make sure that Auto Mask is checked.

8 Click the white sky on the right side of the image, and brush over that area to darken the tones and add the blue tint. Brush over any area where you want to modify the sky in this way.

The result may look a bit funky when the image is evaluated on purely photographic terms, but since the Oil Paint filter will be applied to it, none of that matters.

9 Click the Plus icon next to the Snapshots panel to save a snapshot of this version of the image. Name it **Blue Sky for Oil Paint2** (since it will be for the second oil paint version of the image).

10 Open the file into Photoshop by pressing Ctrl-E/Command-E. Choose Select > All, and then Edit > Copy. Switch to the first oil paint version and choose Edit > Paste to add it as a new layer into that file. Since the images are the same size, they align perfectly. Right-click/Control-click the new layer and choose Convert to Smart Object.

11 Choose Filter > Oil Paint. The dialog will open with the same settings that were applied the last time the filter was used. Change the Scale to 2.5 and the Shine to 1.5. Leave the other settings as is. Click OK to apply the filter.

12 Double-click each layer's name to rename them. Name the top layer **Version 2** and the bottom layer **Version 1**. Press Ctrl-S/ Command-S to save the file.

Now let's combine different parts of each layer with a layer mask to create a single composite. For the background areas in the scene, you'll use the Version 2 layer, and for the row of tulips and the grass on the left side, you'll use the Version 1 layer.

13 With the top layer (Version 2) active, click the Add Layer Mask button at the bottom of the Layers panel. Choose the Brush tool (B) in the Tools panel, and verify in the options bar that it's set to 100% opacity. Click the Brush Picker button and choose a large, soft-edged brush.

For this example, the brush size was 700 pixels. Since the layer mask is the active element, the foreground color should already be set to black. If this is not the case, press X to exchange the colors and make black the foreground color.

14 Make sure that the layer mask is active (look for the highlighted border around the mask thumbnail), and paint with black over the row of tulips, as well as the grass and bush on the left side.

This will hide those areas on the Version 2 layer and let the detail from the Version 1 layer show through.

For this example, the mask was modified to also show the background flowers on the right side of Version 1. Painting on the mask with the brush set to 50% opacity also allowed some of the stronger detail on the front of the building to show through.

15 If you find you need to reverse any of the painting on the layer mask, switch the foreground and background colors (X) and paint with white to bring back more of the Version 2 layer.

16 When you are satisfied with the edits to the layer mask, choose File > Close and save the file when prompted.

The completed file will be added back to the Lightroom catalog. At this point you can also close the second version of the oil paint image. You do not need to save that file.

By combining two different Lightroom-adjusted versions of the photo, as well as two different applications of the Oil Paint filter, you can create a more customized look for the finished image. The high-contrast and more-defined flowers from Version 1 create a greater sense of depth in the scene. And because the lower-contrast and lighter Version 2 was used for the background, it is not as dark and distracting as it is in the first oil paint version.

You can also use the same basic techniques shown in this lesson to create a blend of a filtered version with the normal image. This is what was done with the following image, "Into the Painting." A version of the file that had been modified with the Oil Paint filter was combined with an unfiltered version to show a girl jumping into a painting. As with the spring tulips photo, layer masks were used to combine the two different versions of the image to create this surreal scene.

● **Note:** For additional filters that replicate the look of paintings and sketches, check out the selection in Filter > Filter Gallery. The Sketch filters in this collection base their colors on the foreground and background colors.

Exploring the Solarize filter for black and white images

The Solarize filter reproduces a phenomenon from the traditional chemical dark-room that is one of the oldest known photographic effects. If an exposed and par-tially developed print is exposed to light (often due to accidentally turning on the darkroom light), it creates a partial reversal of the tonality in the scene. White areas turn black, and any tone that is brighter than middle gray will also reverse. Middle gray and darker tones typically exhibit no change, resulting in a partial "negative" effect. With color images, the color values will also be reversed, which can lead so some intriguing color shifts.

As with the previous example of the Oil Paint filter, by using layers, adjustment layers, and sometimes blend modes, you can modify the basic filter effect to create something different. In this exercise, you'll explore some possibilities of the Solarize filter on a black and white photograph.

1 In Lightroom, select espresso_cafe.dng in the grid or Filmstrip in Lightroom's Library module.

This is a color file that has had a black and white look applied in the Develop module. For this example, no changes will be made in Lightroom.

2 Open the file into Photoshop by pressing Ctrl-E/Command-E.

3 In Photoshop, make a copy of the Background layer by choosing Layer > New > Layer via Copy (or press Ctrl-J/Command-J).

4 Double-click the layer name and rename it **Solarize Filter**. Right-click/Control-click it and choose Convert to Smart Object.

5 Choose Filter > Stylize > Solarize.

Turn the filtered layer off and on several times by clicking its eye icon. If you examine the tones in the image, you'll see that the darkest tones have not changed (and some of the tones that do appear to have changed actually have not; it just seems that they have because the tonal values surrounding them have changed). Whites have become black and lighter tones have become darker. While this is an interesting effect, with a little modification we can take it a bit further.

6 Click the Create New Fill or Adjustment Layer button at the bottom of the Layers panel and choose Levels. If you look at the histogram in the Properties panel you can see that there are no tonal values brighter than 50% gray in the image.

7 Move the highlights slider immediately under the right side of the histogram over to the left, to just before where the mountain shape of the histogram ends (about level 150). Next, move the midpoint gamma slider to the right to about level 0.85.

By modifying the solarized results using a Levels adjustment layer as shown above, it creates a version that's just a little bit "off." Whites and brighter tones are still reversed, but the Levels adjustment has created a more balanced blend of all the tones. For some scenes, especially those in black and white, this could be an effect that works well. Keep in mind, however, that the success of this effect really depends on the image you use it on. For some images it may not work well.

● **Note:** Because the Solarize filter remaps all the tonal values in the image to middle gray or darker, it is best to use this filter on 16-bit images, especially if further tonal adjustments will be applied to the solarized layer. The significantly greater tonal values in a 16-bit file will prevent the rough and uneven tonal transitions that would occur on an 8-bit file.

8 When you are satisfied with the edits you've made to this version, press Ctrl-W/ Command-W and save the file when prompted.

The completed file will be added back to the Lightroom catalog.

Depending on your taste for images with strangely modified color palettes, you may like the solarize effect on some color photos. The espresso_cafe.dng file has a snapshot of the color version of the image so you can easily give it a test drive. The same steps outlined above produce a very different result, since, in addition to the tonal brightness, some of the color values in the scene are reversed as well.

Next steps

Now that you know how Lightroom and Photoshop work together, apply this information to your own post-processing workflow. If you're a Photoshop user who doesn't have much experience with Lightroom, use the information in this book to organize your photographs, import them into Lightroom, and integrate Lightroom's asset management and photo processing capabilities with your Photoshop skills. If you're primarily a Lightroom user, single out those photographs in your Lightroom catalog that can benefit from what Photoshop has to offer, and give the Lightroom– Photoshop roundtrip workflow a try.

Whether you're a professional photographer or a casual shooter, knowing how to use Lightroom and Photoshop together will streamline your workflow and help you bring out the best in your photographs.

Review questions

1 What Photoshop shortcut is an easy way to duplicate a layer or turn a selection into a new layer?

2 In Photoshop, how can you move a layer independently of its layer mask?

3 What is the term in Photoshop to describe when the shape of a layer determines the visibility of the layer above it?

4 What Photoshop tool do you use to adjust the position of type on a path?

5 In Photoshop, what happens when you choose Filter > Convert for Smart Filters?

Review answers

1 Ctrl-J/Command-J, which can also be found under Layer > New > Layer via Copy.

2 Unlink the layer from the layer mask by clicking the link icon between the layer and mask thumbnails in the Layers panel.

3 Layer clipping mask, or layer clipping group, refers to when a layer or multiple layers are "clipped" to an underlying layer. The shape of the underlying layer determines the visibility of the layers that are clipped to it.

4 You can move type on a path using the Path Selection tool.

5 The active layer is converted into a Smart Object. This allows you to apply filters nondestructively and also lets you easily modify the filter settings.

INDEX

NUMBERS

1:1 previews
 about, 19
 adjusting capture sharpening in, 162
 zooming to before opening Detail panel, 160
32-bit HDR images, 226–233
 bracketing multiple exposures for, 226
 cropping, 232
 tone mapping, 230–231

A

about this book
 meaning of RGB files, 26
 prerequisites for lessons, 8
adjusting photos. *See also* Adjustment Brush tool; global adjustments; local adjustments
 comparing Before and After views, 131–133
 creating adjustment layers, 264–270
 evaluating in Histogram panel before, 136–137
 fine-tuning HDR images for merging, 227
 keeping snapshot of adjustments, 130
 Lightroom vs. Photoshop for, 3
 order of, 137
 white balancing, 137–141, 189
Adjustment Brush tool (Lightroom), 178–181
 about, 178

adjusting portraits in, 312–315
checking Before and After views of multiple brushes, 181
control available with, 243
resetting effects sliders to defaults, 195
saving local adjustments as preset, 176
touching up Photoshop edit with, 372–373
adjustment layers, 258–270
 advantages of Photoshop's, 243
 comparing effects with Before and After views, 270
 creating, 264–270
 layer masks on, 265–266, 297
 previewing masks on, 264
 saving, 270
Adobe Authorized Training Centers, 9
Adobe Camera Raw. *See* Camera Raw; raw files
Adobe Creative Cloud, 38
Adobe Photoshop. *See* Photoshop
Adobe Photoshop Elements, 32
Adobe Photoshop Lightroom. *See* Lightroom
aligning layers, 200
alpha channel, 262, 279–280
Apply During Import panel, 18, 20
archiving photographs, 18
Attribute filters, 95
Auto Dismiss check box, 139

B

backgrounds
 color of, 285
 replacing behind complex objects, 276–286
 replacing behind hair, 287–296

Basic panel, 134–153
 Auto adjustments for tone, 141
 Clarity slider, 150–151
 controlling color saturation, 151–153
 evaluating photographs first, 136–137
 Exposure and Contrast sliders in, 142–143
 Highlights and Shadows sliders, 144–146
 sliders of, 134–135
 Vibrance and Saturation sliders, 151–153
 WB controls for, 137
 Whites and Blacks sliders, 147–149
 workflow for adjusting photos, 137

batch processing
 about Lightroom's, 3, 119
 adding copyright data to imported photos, 20
 Lightroom Sync vs. Photoshop, 194
 moving folders and files outside Lightroom, 112

Before and After views
 checking effects on adjustment layers, 270
 checking for multiple adjustment brushes, 181
 comparing photos with, 131–133
 reviewing Basic panel adjustments with, 135
 toolbar buttons for, 132–133
 using single slider adjustment, 134
 viewing for graduated filters, 177

bit depth preferences, 27–28, 30

black-and-white images
 converting from RGB to, 51, 54
 HSL panel for converting color to, 157
 solarizing, 377–380

Blacks slider, 148–149

blending
 automatic adjustments with Content-Aware Move tool, 304
 Overlay blend mode for, 282
 textures with layer blend modes, 211–212, 239

Blur filters (Photoshop), 323–332
 applying Iris Blur, 323–328, 333
 Tilt-Shift Blur, 328–332, 333
 using radial motion blur, 365–369

Blur Gallery (Photoshop), 326, 331, 333

bokeh, 287, 295, 331

book cover composite, 338–341.
 See also type
 adding texture to, 338–339
 applying gradient to texture, 351
 cropping, 339–340
 inserting type on cover, 352–353
 type for, 341–348
 vector graphic added to, 348–350

bracketing multiple image exposures, 226

brightness
 creating adjustment layers for, 267–268
 fine-tuning contrast and, 154–156

brushes. *See also* Adjustment Brush tool; Healing Brush tool; Spot Healing Brush tool
 adjusting size of, 247, 285, 317
 Before and After views for multiple, 181
 corrections with local adjustment, 180
 selecting options for adjustment, 178–179
 when to use Photoshop healing, 166

Build Previews menu options, 18, 19

C

exposure

 adjusting in Basic panel, 134, 142–143, 189

 bracketing multiple image, 226

Extend option (Content-Aware Move tool), 302

external drives

 importing photos from, 16–17, 21

 storing photo folders on dedicated, 14

external editors

 configuring primary, 26–28

 file naming preferences for, 34–35

 Photoshop as primary and secondary, 29

 Photoshop Elements as, 32

 selecting additional, 28–31

 setting Lightroom preferences for, 25–31

 stacking preference settings for, 33–34

F

feathering layer mask edges, 266

Filename Template Editor

 customizing template in, 24–25

 setting conventions for external editors, 34–35

files. *See also* derivative files; lesson files; raw files; *and specific file formats*

 choosing folders for imported camera, 23

 copying in DNG format, 17

 customizing filename template for, 24–25

 derivative, 33, 58–59, 65–66

 formats retaining alpha channels, 262

 moving outside Lightroom, 112

 moving within Library module, 110–111

 opening multiple Lightroom files in Photoshop, 239

 preferences for naming, 24–25, 34–35

re-linking missing, 112, 113–114

renaming, 24

saving metadata to, 119, 187

saving Photoshop RGB file to Lightroom, 50–51, 55

source, 33, 64

working with proprietary camera, 43

fill

 adding mask with black, 281

 adding to type, 345–346

 changing color with layer of, 250–253

 gradient, 253–257, 351

 layer masks for every layer of, 252

 removing content with content-aware, 305–306

 solarizing, 379

Filmstrip

 finding merged HDR images on, 229

 hiding/showing, 45

 using, 86, 121

Filter Gallery (Photoshop), 364, 369, 376

filtering photographs. *See* ranking photographs

filters. *See also* Smart Filters; *and specific filters*

 applying gradient masks with, 174–177

 artistic, 364

 availability of Photoshop, 364

 customizing Oil Paint, 369–376

 Iris Blur, 323–328, 333

 Liquify, 316–322, 333

 nondestructive application of, 381

 Oil Paint, 371, 374–375

 replicating paintings, 376

 Solarize, 377–380

 sorting photos with Attribute, 95

 Tilt-Shift Blur, 328–332, 333

 working with radial, 182–186

flags, 93–96, 101–103

illustrated, 79

importing standard previews into, 19

information panels of, 81–83

keywords in, 103–110

lesson files for, 78

moving files inside, 110–111

rating photos with stars, 96–98

reviewing thumbnails in, 18

selecting preview in, 88–90

source panels of, 79

switching to other modules, 86

toolbar, 83–86, 115

using, 77

zooming and panning images in, 87

Lightroom. *See also* Lightroom–
 Photoshop roundtrips; preparing
 Lightroom for Photoshop files; *and
 specific modules*

adjusting Photoshop edits in, 67–79

alternative workflows for Photoshop
 roundtrips, 74

appearance of transparent pixels in,
 220

capture sharpening presets for, 164

catalogs in, 13–14

editing original linked Smart Objects,
 224–225

editing RGB copy with, 56–59

exporting files, 69–73, 75

features of, 2–3

file compatibility with Photoshop,
 36–37

help resources for, 8–9

local adjustments in, 120, 173–174,
 189, 193

making RGB edits without Lightroom
 adjustments, 59–62

opening multiple images as Photoshop
 layers, 196

parametric editing system in, 2, 119, 189

Photoshop features vs., 1–2

process version of, 136

processing multiple photos in, 3, 119

raw file adjustments in, 3, 43–45, 51,
 258–260

rendering mismatched files in, 52

rounding edge of photo in, 354–355

saving Photoshop layered composite
 in, 204

setting external editing preferences,
 25–31

synchronizing spot removal, 167

updating Camera Raw plug-in, 37–38

video editing in, 14

workflow strengths of, 2–3

working with virtual copies, 188

Lightroom–Photoshop roundtrips.
 See also combining Lightroom–
 Photoshop photos; preparing
 Lightroom for Photoshop files

adjusting edits in Lightroom, 67–79

alternative workflows for, 74

completing workflow in Lightroom, 67

configuring Photoshop color settings,
 35–36

editing photos in Photoshop, 46–49

editing RGB copies with Lightroom,
 56–59

lesson files for, 42

maximizing compatibility of
 Photoshop files, 36–37

mismatched files in, 52

Photoshop editing for RGB originals,
 53–56, 75

raw file adjustments in Lightroom,
 3, 43–45, 51, 258–260

rendering raw file in Photoshop,
 45–46, 75

saving Photoshop RGB to Lightroom,
 50–51, 55

typical workflow for, 40, 41

using JPEG source files, 62–66

working with RGB files in, 53

Z

zooming

 and panning images, 87, 124–126

 shortcuts for, 165

 warning icon when, 160